It's a lot to
UNPACK

Dina Honour

SCYLLA
PRESS

It's a lot to unpack

Published by Scylla Press, USA

Cover design: Rebecca Kirch for Tinge Design
Tingedesign.com
Cover image: Karen Honour
Author photo: Richard Steggall

ISBN: 8-9891100-0-1
ISBN-979-8-9891100-0-1

To the women who labor without pay, thanks, or acknowledgment, who doubt the value in what you do—I see you.

And for Áine, who never liked goodbyes.

It's a Lot to Unpack

CONTENTS

It's a Lot to Unpack

Acknowledgments

Books are really just paper houses for stories, and while the stories housed in this one are mine, they were influenced, enhanced, and inspired by countless others along the way. From grade school teachers to brand new friends, from blog readers to our favorite Sunday Dinner companions, Covid Co-Bubblers, and my very own group of Wonder Women.

To the conversation starters, the talkers, and the soul-barers, thank you. Special thanks to Annabel, whose question about being a "thing" was the genesis of this book. To the friends who have hosted me countless times as I revisit the cities of my heart, you have my undying gratitude. I hope I never overstay my welcome.

Thank you to my sister, Karen, for the perfect pink boots, the illustration around which everything magically coalesced.

To the few brave enough to read various versions of the almost finished product, especially Tanya, Sunny, and Sehrish — tusind tak and vielen Dank.

To Rowan and Reed, who continue to astound me, and to the best of husbands, best of men—thank you for your quiet encouragement and for overlooking the marathon sessions in the green chair when inspiration strikes and dinner is forgotten. After all, if it weren't for you and your dumb job, I would not have been able to build the room of my own where all this hoopla happens.

Most of all, thank you for having an answer when people ask, so what *does* Dina do?

It's a Lot to Unpack

AUTHOR'S NOTE

Though I set out to write a linear story from beginning to end it didn't take me long to realize that life is not a straight line as much as a dance. You take two steps forward, but sometimes the magic happens on the back foot.

If there are jumps forward or backward in time, it's because sometimes the lessons were late in coming.

Memory is a funny, and sometimes faulty resource. Things get jumbled together and sometimes in the process of untangling the knots, you lose a thread. Events get compressed, and conversations confused. The recollections, descriptions, and conversations described are teased and pulled from my personal archives, notes, experiences, and from my increasingly aging brain. If there are mistakes or misrepresentations, the responsibility is mine. Unless otherwise noted, the views, observations, theories, hot takes, and musings are also mine.

Some excerpts of this book, in whole or part, were originally published on Wine and Cheese (Doodles) or under my byline on sites such as Medium. All work, unless otherwise cited, is my own.

Most names have been changed, other than my fifth-grade teacher, who, frankly, deserves to have her name known, and my husband's. In the case of my husband, it felt strange to be wedded to an unfamiliar name, even in a paper house.

On a final note: The experience of living abroad is personal. It's unique to the individual. That said, it would be wrong and harmful not to acknowledge the privilege with which I have walked in these expat shoes. I am white and

English-speaking, educated, and middle-class. In our European postings, I have been able to blend in and get lost in the crowd. Even the terminology I use to describe myself—expat—rests on a foundation of colonialism, classism, and racism. Navigating a new culture or country is never easy, but my privilege grants me a level of freedom and safety not afforded to those who don't look or sound like me.

I try very hard not to take that for granted.

I hear a wind
Whistling air
Whispering
In my ear

Boy Mercury shooting through every degree
Oh girl dancing down those dirty and dusty trails
Take it hip to hip, rocket through the wilderness
Around the world the trip begins with a kiss

Roam if you want to
Roam around the world
Roam if you want to
Without wings, without wheels

Roam, the B-52s

THESE DREAMS

I start like a song—just a small-town girl.

Let's split open the past and pull it apart, scoop out the bits we throw aside anyway. There I am, a girl child, pushing my baby doll in a navy blue carriage. I'm making blanket forts and holding dance recitals on a pretend stage in the basement and running through arcing sprinkler sprays. Let's speed up a little. Now I'm dressing Barbies in black lamé and smoking candy cigarettes playing house. I am splashing in the pool, diving for rings, collecting them on my arm, and pretending they are mermaid bracelets. A montage: *The Best of Times* by Styx is playing as we travel through time, frame by frame. Look, there I am drawing chalk hearts on the street and playing kick the can. I'm in the woods smoking a real cigarette. There I am on my ten-speed, cycling in the autumn foliage to Josie's house. I'm tap dancing on a stage, sequin and sparkle. The music fades and there I am, crying over a boy whose name is thoroughly unimportant. Now I'm cutting out Tiger Beat pages and the music begins again, slower, this time, a self-indulgent melody; maybe The Smiths. I'm lining my eyes with thick black eyeliner and depleting the Ozone with Aquanet. There is my best friend Katie and we are arm in arm, two girl magnets who

attract and repel, attract and repel. Then I'm in English class, writing band names on my brown paper bag book covers, pretending not to care; let's zoom out just a little to include a teacher's hand holding an essay with a bold red 'A' in the corner. Now I'm sitting down by the bridge with Deanna, drinking wine coolers and we're scanning the ink-black sky for shooting stars to wish on. We're laughing, checking each other's breath before we go home.

Home was the blue house before you reached the little circle, the one with the maple tree in the yard.

Now I am graduating and the dreams have changed from Barbie Corvette to a boy in a Corvette to big city lights and skyscraper nights. I took a midnight train going anywhere.

No, wrong song, wrong movie.

Ah, there I am in New York City, looking up at the skyline in awe and those little town blues are melting away. There I am crisscrossing streets and stomping up and down the avenues. If you're quick, you can catch a look of thoughtfulness on a downtown 6. I'm scribbling in a notebook. Oh…now I am bent over, back hunched, crying. I pick up the pieces of a broken heart. I'm in a blackened whirlwind of thoughts. I'm standing, wiping at my eyes. I'm surrounded by open books. I'm graduating college. Now you see me, a poet in a smoky room, the smell of beer and mid-range perfume. What? We have no music? Let's cue *Bittersweet Symphony* while we pan up the side of a skyscraper and then a flying shot across the Brooklyn Bridge. There is the sound of laughter then a doorbell rings. Now you see me, holding a glass of wine, opening the door. There's a tall, dark stranger there. It's Thanksgiving. There's pumpkin pie. A kiss. I'm on a plane. I'm in a wedding dress. I'm in the hospital delivery room and someone hands me a boy. And then another.

End song. Fade to black.

Here I am waking up in the city that never sleeps. The sounds of Brooklyn are in the background, the reveille of distant sirens and the voices of old Italian ladies on their way to church, an argument in front of the bodega. I'm in a sunny bedroom. The man from Thanksgiving is next to me. It is a Sunday. The two boys are still asleep. Everything is about to change.

And that's where this story begins.

I CAN'T GO FOR THAT (NO CAN DO)

Once upon a time, I lived in New York

"So there's this job," my husband said, turning to face me in bed.

"Sssshhhh." I put my finger to my lips. It was a rare slice of blissful quiet, a parenthetical in the normal chaos of life with two young children. Any false move could set the entire house of cards tumbling down.

"There's a job," he said in an exaggerated stage whisper.

I stretched awake, blinking away the sunlight that filtered through the curtains before I turned to look at him. I wondered if he would get up to make the coffee or if I would have to do it again.

"Ok, and?" I sat up a little higher, propping myself up on my elbow.

The 'and' was that the job he was about to tell me about was not just *any* job. It was the job of jobs. The big Kahuna of jobs. It was an unexpected vacancy in a place where vacancies were unusual and rare, a career unicorn. A gem of a…well, you get the picture.

It also happened to be the one job in the one place outside of New York I had said I would consider if it ever came up. Nay, not just outside of New York, but outside of the US entirely. Why did I say that? Excellent question. Primarily to get him to shut up about it but also because it seemed like a reasonably safe way to placate my husband's adventurousness. Never, not for one hot minute, did I think it would materialize into anything beyond a wild pipe dream.

My husband has a stash of wild pipe dreams that live rent-free in his head. It's one of the things I love about him. It also happens to be one of the things that exasperates me the most. I had assumed—naively it appeared—that the far-away job was just another in a long line of fantasy scenarios, up there with the mountain chalet and the pied-à-terre in London. Or the hundred times he suggested that we quit our jobs, give up the apartment, and travel around the world. Once, after a particularly monstrous day at the office, I had stormed home and told him to book the first flight out of JFK. That time it was he who balked, mumbling something about health insurance. As it turns out, even pipe dreams need a pension plan.

"You did say you wished we could travel more," he said. His toe grazed my calf.

"I meant to the beach or maybe to Italy," I said, pulling my leg away. The baby stirred in the bassinet at the end of the bed. "On *vacation*," I emphasized.

"This would be like one big vacation," he said.

I stared at him, trying to figure out if he was being serious, or if he was merely testing the waters for some crazy fantasy idea he would spring on me later. Let's join the circus. Let's buy a camper van and travel across the US. Let's learn to surf in New Zealand.

Surely one of my children would wake up at any moment and put a natural end to this bizarre conversation, no?

Nope. On the baby snuffled, on the older one snored. Honestly, universe? Out of all the days, today is the day they are sleeping in? I was mildly put out.

"Come on," my husband said. "What do you think?" He blinked his big, brown doe eyes at me. Outside, someone shouted, just an echo reaching us on the third floor.

"What do I think about *what*?" Was my husband seriously asking if I thought we should pack our home and lives and family into cardboard boxes and move across the world?

"About the job. What do you think about us all moving to Cyprus?" There was something in his voice that made me sit up and really look at him. Was that…hope? Was he hopeful?

Shit. He *was* serious.

They say every journey begins with a single step, but in this case, it started with my husband's dumb job.

■ ■ ■ ■ ■ ■ ■ ■ ■ ■

Richard has always been more adventurous than me. He is the Indiana Jones to my Annie Hall. He is *let's go and we'll figure it out later* while I am *we need plans A through F, in writing and preferably notarized*. While I was more or less happily tripping down the cobblestones of New York City, he was more or less happily traveling solo in Southeast Asia, deejaying his way through Indonesia. I was tightly bound to the concrete jungle where dreams are made of, trying not to lose my empire state of mind. He was London calling, sweet-talking those West End girls. He is a risk taker and I am a risk averse-er. He is the best-case guy and I have a running list of worst-case scenarios, including what to do if I'm in a sinking car or if we are being followed by a swarm of angry bees.

He also had some prior experience moving across an ocean. A decade before that warm Brooklyn Sunday he had quit his job selling flowers to fancy women on the King's Road, packed his belongings in a giant, green duffel bag, and moved abroad for a very different reason: Me.

This time the driving force wasn't a crazy little thing called love, it was something else entirely. Part of it was scratching his adventurous itches, yes, but more than anything, it was an escape from an increasingly dead-end career conundrum that had us both scratching our heads.

The job that had started years before as a means to an end — in our case, a visa that let him stay with me in the US — had turned into a career. No one was more surprised than the backpacking young man who swore he'd never work in an office. Yet work he had, steadily and upward to get where he presently was, which was bumping up against a very hard ceiling. Taking a job abroad opened a potential loophole to an over-complicated, byzantine system of promotions and levels. It was also a possible answer to the question every New Yorker asks themselves from time to time: *Should we move out of the city?* It was, as he craftily pointed out, a way to spend more time with the kids while they were young. He could help out more, he could be present, he could take them places, coach things. It would be the difference between family dinner on a Sunday versus family dinner every night.

He can be sneaky, that man of mine.

So, what did I think?

I thought he was out of his mind.

That sunny Sunday has, over the last fifteen years, taken on near-mythical proportions. That day, his dumb job, is the heart of our expat origin story, but the truth is, conversations about

our family's future had been humming and buzzing in the background for a while. With two young children, we were quickly outgrowing our Williamsburg apartment. Our pain-in-the-ass frat boy neighbors were constantly banging on the ceiling whenever our toddler breathed too loudly. Our relatively affordable rent meant we were priced out of our neighborhood, which we loved. If we moved out of the city, Richard was looking at a soul-crushing daily commute. He was already frustrated, adding a grinding commute just might be the end of him. There was the question of school, a notoriously thorny one in New York City. There were a thousand *ifs, ands, and buts* that all took place in the nebulous future.

The thing was, my idea of the future had always revolved around New York. The city was the sun I had been orbiting for twenty years. No tarot card or crystal ball had said anything about a small island nation a few continents away. It wasn't in my plans, my tea leaves, or my dreams. It wasn't something I'd ever even really thought about. My vagabond shoes weren't longing to stray. Oh sure, I moaned and complained about the city, *but that's what New Yorkers do.* Then we go away, complain about the people and the pizza, and run back home with a renewed love for the greatest city in the world. I had no desire to leave.

So, why did I say yes?

■ ■ ■ ■ ■ ■ ■ ■ ■ ■

Most of us have a decent idea of who we are, or at least who we think we are. I can rattle off a list of characteristics, preferences, attributes, and my blood type. Thanks to Buzzfeed and the early days of social media, I can tell you which flower I'd be (Lily), which Star Wars character's profile I most

resemble (Darth Vader), and where the sorting hat would place me at Hogwarts (Hufflepuff). I know what I like and what makes my skin crawl. I have goals and fears and a phrase I use for most of my passwords. That's the easy stuff, though, the stuff of checklists and online security questions. But what about my identity? The way that others see me, sure, but even more importantly, the way I see myself?

There are a thousand things that make up the map of who I am, traits and quirks, decisions and luck. Some I had no control over, like the color of my eyes or where I was born. Some are choices I've made, like deciding to get married or start a family. Still others are born of a single moment on a sunny Sunday morning when your husband tells you about a job seven time zones away.

On that May morning back in 2008, I thought I had a pretty good idea of who I was. If I opened the cup of my palms, what greeted me would not be surprising. Woman, daughter, sister, wife, mother, New Yorker, freelancer, used-to-be writer.

My heart pumped my defining stories through my blood. I was the eight-year-old girl who had offered to give up her Christmas gifts for starving children on the other side of the world. I was the high school goth who didn't get asked to prom. I was the poet who used to do spoken word performances in back rooms and bars. I was the young woman who chased the thief down a Brooklyn street with a cigarette hanging from her lips. I was a New Yorker who could surf the L train with a full cup of coffee and not spill a drop. I was the Brooklyn mother who was managing two kids and a sweet part-time job. I was the woman with tattoos, who stomped around in motorcycle boots, who could *just about* fit back into a pair of pre-kid leather pants.

And then *poof!*—with one job opening, one question, and

one decision, something new was added, something I'd never expected to be: an expat spouse.

In all the scenes that played out at the beginning of my story, all the Barbie dream house scenarios, the hopes, the poems scribbled on napkins…not a single one of them prepared me for the idea of giving up everything I knew to follow someone else's job around the world.

So, why did I say yes?

Maybe I was sleep-drunk after more than three hours of consecutive shuteye. At the time, our second son was only two months old, there wasn't a whole lot of sleep in our lives. Maybe there was something in my husband's voice that made me sit up and take notice. Maybe our asshole neighbors had banged on the ceiling one too many times. Or maybe I remembered another time I said yes to something unexpected, to something risky.

After I had opened the door to that tall, dark stranger once upon a Thanksgiving, he had wisely tucked himself in a corner. He was an interloper, a party-crasher—at least he had the decency to stay out of my way. Did I mention he was tall and dark? And very cute? After my initial annoyance at having to dig out an extra plate and set of cutlery subsided, I sidled over with a slice of pumpkin pie and sat down. Up close he was even cuter—and shyer. He politely pretended to like the pie while I poked at his shyness like a kid prodding a wasp's nest. I fired a barrage of questions at him. I had no shame.

I also had no ulterior motive. Not long before, I'd fought my way out of a hole of depression and glued a broken heart together. I wasn't looking for anything more than a cheap wine buzz and someone to do the stack of dishes piling up on my kitchen counter. I made an offhand comment about Ophelia,

no doubt to dazzle him with my literary prowess and damn if he didn't come right back at me with a quip about Hamlet. And that was it. That's all it took to seal my fate. A Shakespearean pickup line.

We talked all night and as the sun came up the next morning, we were still talking. In that smooth London voice, he told me I'd cast a spell on him. I might have actually swooned. That afternoon, I took him to the subway station for his flight back to London. As the doors closed I turned to my sister and said, "That's the man I'm going to marry."

My sister rolled her eyes so hard I thought she was in danger of spraining them

The party-crasher and I spent the next month talking on the phone, sharing her-stories and histories. It was an old-fashioned courtship, conducted over copper telephone wires that ran under the Atlantic, and it was during one of those calls that he invited me to spend Christmas with him in London.

I remember thinking it would be nuts to go.

I remember thinking that my mother would kill me if I missed both Thanksgiving and Christmas.

And most of all I remember thinking that I didn't want to wake up in five years and wonder what would have happened if I had said *yes*.

I bought a plane ticket the next day.

Now that risky bet was sitting up in bed next to me talking to me about leaving New York.

Perhaps I said yes because I was worried my husband would resent me if I said no. What if I said no and he slowly withered away in our ok but not huge Brooklyn apartment, spending his days looking at travel brochures and dreaming of a more adventurous wife? In marriage, resentment cards are a

form of relationship currency–resenting *him* for asking me to move was preferable to him resenting *me* for not going. I could put that card in my back pocket for later.

Or…maybe I said yes because I was afraid of letting myself down.

I had moved to New York City because I wanted more than I could wring out of that small town. I wanted more excitement, more energy, more streets, more buildings, more types of people. At sixteen, seventeen, and eighteen the two things I feared the most were accidentally getting pregnant and being seen as boring. I didn't want to walk, I wanted to soar. After twenty years, I had paid my Gotham dues in full. I was a card-carrying New Yorker. I fancied myself Big Apple tough, Ramones cool, Alphabet City edgy.

But was I? How could I be any of those things if I was scared to take a risk? How could I let a little something like moving 7,000 miles away put me off?

If I said no, what did that say about me? What did it say about who I thought I was?

In hindsight, wanting your husband to think you're cool or trying to prove to yourself that you're not boring is probably not the best motivation for moving your family across the world.

There's one more possibility of course. Marriage is also about taking your partner's dreams seriously, even if they're not the same dreams as yours.

■ ■ ■ ■ ■ ■ ■ ■ ■ ■

"It's just for two years," I promised my mother. *Because that's how my husband sold it to me.* Two or three years, he said. I'll get the promotion I need, he said. We'll come back with some money in the bank, a wicked tan, and some great stories. We'll

pick up right where we left off. It'll be a lark! An adventure!

It was not for two years.

It wasn't just my family I was packing up and leaving behind, of course. I was leaving work—which I had just gone back to—and therefore any semblance of financial independence. I was leaving behind the Fourth of July and Thanksgiving. I was leaving behind bagels. I was leaving behind the city streets I adored. I was leaving behind my friends. My pre-marriage friends, my bar-stool friends, my Mama friends. I was leaving behind my rent-stabilized apartment. I was leaving behind favorite restaurants and familiarity, comfort zones, and twenty years of institutional knowledge.

And, perhaps most importantly I was leaving behind the woman in the motorcycle boots who could just about fit into those leather pants.

I knew that moving to another country was going to be challenging. I knew many things would be difficult, knew there were many things I would miss. We hadn't even hit the end of the George Washington Bridge before I missed the skyline that was quickly receding in the rearview mirror. What I didn't fully understand, not for a long time, was how thoroughly moving to another country would turn me inside out.

Once we took that first step every aspect of our lives changed. Every, single one. Once I slapped *expat* on my forehead, all the things I took for granted, all the things I could count on, all the ways I had previously done things faded from sight as quickly as those skyscrapers in our rearview mirror.

Once I was an expat, my ability to hold a paying job was left in the hands of the foreign bureaucracies, or as we call them, Ministries of Magic. Over the years and the countries

I've lost count of the number of women I know—and an increasing number of men—who have given up careers, jobs, projects, and passions, all to follow a partner's job around the globe, toting kids and pets and household goods like a traveling circus.

Living in someone else's homeland affects my relationships. It affects my marriage. For others it can dictate whether or not they have to *get* married to be resident in the same country, opening a whole same-sex can of worms for some couples. Living abroad affects the way I parent, how we raise our kids, where and how they go to school, what *type* of schools they go to.

It affects how I view and understand my home country. With one decision I was suddenly an outsider looking in rather than an insider looking out.

Being an expat affects what I eat, how I shop, what shoes I wear. It affects how I spend my free time, where and how I travel, how I spend vacations. It affects my relationship with family, nuclear and extended. It affects my friendships, it affects the way I make new ones and maintain old ones.

It affects how others see me, what they think of me, and the judgments they make about who I am.

It blew a world-shaped hole in the way I saw myself.

I was really close to fitting back into those leather pants.

Then suddenly I felt like I was wearing a clown suit.

In our sunny bedroom, I was still waiting for the baby to stir, an excuse to get out of bed and put this conversation *to* bed. I didn't like where all this talk about moving was headed.

"Honestly though, D. What do you think about the idea of us moving?" *He used my nickname—God, he was sneaky.* He was

looking me in the eye. Slow blink.

The traitorous children slept on while outside our window the world went on.

"I'll be back in a second," I said, slipping out of bed.

When I had flown across the ocean on Christmas Day a few years before, the tall, dark, still mostly a stranger had met me at the airport. As soon as I burst into the arrivals hall with my bag and a stomach full of butterflies, I saw him there, draped over a railing. In that moment, I knew that I had made the right decision. By the end of my trip, we were shyly confessing those gooey feelings to one another. Still, the first time he said *I love you* I was so overcome that I thought I was going to vomit. I excused myself and sat on a tiled floor in a strange bathroom with my head between my knees, gathering myself.

In Brooklyn, I walked past the bassinet, resisting the urge to poke the sleeping baby awake. I padded down the hall and squashed the desire to stomp and wake the frat boys out of spite.

In the bathroom, I sat on the edge of the tub and gathered myself. I splashed some cold water on my face and glanced up at my reflection.

Mirror, mirror on the wall, if you take the gal out of NYC is she even the same gal at all?

ROAD TO NOWHERE

Go catch your whale

Our Cyprus Air flight touched down at Larnaca Airport in the late afternoon. A Mediterranean sun hung suspended in the sky, orange and otherworldly. Richard had gone ahead of us to start his new job and our new lives while I tied up loose ends in the US. As the pilot turned the seatbelt sign off, I gathered up the packable detritus of our lives: baby carrier, diaper bag, toys, kids. I strapped the baby to my chest. The flight attendant handed me my folded Maclaren. The four-year-took everything in, wide-eyed. Our bedraggled crew wove through a series of unfamiliar corridors, then immigration, on to baggage claim, more corridors, and then customs.

The sign above the doorway blinked at me: *This way if you have anything to declare.*

Had anyone asked, I would have declared plenty.

"Here, take the kids, they're cute but the little one doesn't sleep. Their father is out there somewhere. They look like him, you'll figure it out. Tell him I'm going home, back to NYC. Back to bagels and sidewalks and English. Tell him I said...*good luck with it all.*"

19

No one asked.

Instead, we pushed through the doors to the arrivals area and took the first step into our new life.

It was mid-October and the Cypriot summer had been long and hot. When we walked outside it wasn't the warm Mediterranean balm I'd been expecting, but a searing slap to the face. I stood and blinked away the sunlight, trying to get my bearings. Outside of the airport, dressed in clothes I'd put on that morning in foggy London, I felt like someone had opened a hot oven and shoved me inside, trapping me like a Thanksgiving turkey. Heat like that is built up, pent up. It doesn't matter whether you're counting in Fahrenheit or Celsius or Kelvin because it's just *hot*.

We'd been warned that the island was in the throes of a water crisis, but even the forewarning didn't prepare me for what a drought really looks like—mile upon mile of dry, caked earth, patterned like animal skin, as if the land had dressed in military fatigues. Green highway signs blurred by. Dali. Latsia. Geri. Bleached, like a vampire sun had sucked the color right out of the landscape. More signs. Strovolos. Athalassa.

Even the olive trees that lined sections of the highway, starkly beautiful in shimmering heat, looked exhausted.

Cyprus is a nation of dusty hills and olive groves, of terracotta amphora, of bitter oranges, and bitter history. It is a nation divided between north and south, between Greek and Turkish. A hard border snakes across the width of the island, running from coast to coast, bisecting the hardened landscape into *us* and *them*. And, as with any history, the causes and dates, the heroes and the villains of the story of Cyprus depend on who is telling the tale.

As Richard drove us closer to the capital, the stone fortifications of old Lefkosia came into view. The walls wrap around the ancient city, and within that ancient city, the border between north and south continues.

Our new home was, and remains, the last divided capital in the world.

In 2008 Cyprus was a country working toward reconciliation, trying to piece together a peace solution for a fifty-year-old conflict. A UN Peacekeeping mission had been there since 1964, working both to broker a resolution to the "Cyprus Problem" as well as to patrol the border. By the time our little family of four landed with a suitcase full of *Cars* paraphernalia, sunscreen, and a healthy dose of culture shock, the border between the Greek south and the Turkish-controlled north had loosened somewhat. Cypriots—Greek and Turkish—who had grown up with invasion stories over midnight shots of Zivania began to cross the border with more frequency. We would be there a year or so later as my friend Kallie crossed the border for the first time, watching as she and her husband took in the raw beauty of half an island stuck in time, untouched by tourism and development.

But in 2008, the island was in transition. They'd just introduced the euro. There was an influx in immigration. There were calls for reconciliation. There were calls for reparations. There were calls for revenge. Colleagues of Richard later described how much the city had grown and changed in the time they'd been there, maturing from a gangly teen into a fledgling adult, from an oversized village into city proper.

In short, Cyprus was a hot mess of an island trying to figure out exactly who it was in the new world order of things.

It turns out I wasn't the only one in the midst of an identity

crisis.

Richard stopped the car in front of a huge concrete block of a house on a quiet-ish cul-de-sac. The top half of the stucco facade was the pale pink of a faded tropical dream. Huge dark shutters on the windows and sliding glass doors were closed, presumably to keep the sun and heat at bay. There was a front garden, surprisingly lush. A tiled driveway closed off by an iron gate, once painted white and now peeling. The number on the whitewashed wall said 5.

In the space of a few weeks, I'd traded downtown for temple ruins and graffiti for mosaics. Pockmarked pillars stood in place of street lamps, and hot, dusty parking lots replaced subway tunnels.

Under an orange tree heavy with fruit, my husband killed the engine. The kids slept in the backseat. He turned to me.

"Ok, here we are."

Home.

We spent the first few days getting used to our new surroundings. There was a dusty lot at one end of the street and a dusty lot at the other, like unswept bookends. A secret alley teeming with snails offered a shortcut to what seemed like a more established neighborhood of huge houses and aqua-tinted pools. Elsewhere, everything was in flux. There were backhoes and flashing lights and traffic detours at every turn. For my truck-obsessed son, it was a dream, and we spent countless hours counting cement mixers, peering through chain-link fences, and watching buckets of earth move from one hole to another.

Along any road in or out of town, the landscape was dotted with the uniquely Mediterranean site of half-finished homes

and buildings, serrated rebar rods jutting out from unfinished top floors, like skeletal fingers, waiting for the future moment when someone came along to finish them.

At the time I found them ugly and strange. How could someone just leave something half-finished? What could have happened to cause them to abandon a home to the sun and heat, to be reclaimed by cacti and tumbleweeds?

Now when I think about those half-built structures I appreciate the beauty in their unfinished potential. They stood, waiting, waiting, waiting—like Miss Havisham in her tattered wedding dress.

They were blank slates, unwritten songs, someone else's dream.

I understand better now.

It can take a long time to finish a big project like a house. Or a self.

■ ■ ■ ■ ■ ■ ■ ■ ■ ■

My ideas of cities are, or at least were, dominated by the silhouette of metropolises. New York. London. Paris. Glass towers kissing the clouds and grand, wide avenues flanked by museums. From the squat, no-nonsense courthouses of Brooklyn to the serpentine buildings of Westminster, for me, *city* conjured a certain idea.

Like many European cities, Lefkosia is not just old, but ancient, dating from the seventh century BCE. It's been colonized, invaded, freed. It has, over the years, been under the control of Byzantines, the Lusignan Kings, the Venetians, Turks, and the British. It has reincarnated itself time and time again, expanding and contracting like a set of weary lungs.

Inside the fortified walls, the old city is beautiful, sepia-

toned, and nostalgic, like a Scorsese film. Old Nicosia is home to meandering allies and stray cats that dart in front of mopeds and trip you up as you walk. Walking down Ledra Street, the wrought iron balconies reminded me of the French Quarter in New Orleans. Colorful flowers spill over the side of pots and window boxes, while coffee drinkers spill out onto sidewalk cafes and sit under the curtain of draping leaves.

Outside of the thick stone walls, the modern city expanded outward into the hills. Despite all the construction, there was little in the way of public transport, and away from the shopping streets, sidewalks were rare.

This posed a not-so-small problem. What was I—New York walker and queen of the L train—supposed to do in a place with no public transport and no sidewalks?

For two decades I had counted in urban blocks. My sole sense of navigation hinged on whether the street number was going up or down. It was the abacus of Waze, the analog opposite of sat nav. Walking thirty or forty blocks because the M14 bus was too slow was my norm. If it was too far to walk I swiped my yellow Metrocard, sent a quick prayer to the MTA gods, and jumped on the train. I'd been using NYC public transport for so long, that I'm reasonably sure loose tokens were languishing in long-forgotten coat pockets. I had pushed my trusty city Maclaren endless miles over cracks in the pavement and Brooklyn curbs. Richard and I had walked from midtown down through the eerily silent streets of the East Village on 9/11, eventually joining the pilgrimage of Brooklynites walking home over the bridge. I knew my way around the streets of the Upper West Side, the Lower East Side, and the Williamsburg side of the East River. I had crisscrossed the city on just about every train but the JMZ, and

back then no one took the JMZ.

And here I was in a new city in a new country in a pink house with two kids, whole calendar days to fill, nothing to do, and no way to get there even if I did.

I did my best.

I pushed the baby swing in the small park around the corner until my shoulder ached. After the rain, we turned into the alley and counted the snails that clung to the stucco wall like crustaceous suction cups. We shooed away the feral cats that slunk around in the shrubbery. My older son rode his scooter up and down the tiled driveway, crashing into the peeling gate at the end.

Glide. Crash.

After a few weeks, we got a recommendation for a school for our oldest son. In the mornings Richard would drop the motley lot of us off before he headed to work. I would kiss them goodbye, perhaps a little too desperately, and then the baby and I would make our slow way home on foot. Without my daily playground routine or my Mama friends or the distraction of a part-time job, the days stretched eternal before me. Endless hours rolled by like the tumbleweeds we counted on our dusty trek. Anything that was going to kill some time was a welcome distraction. Of course, in killing an hour I almost killed us both countless times.

Determined, I pushed the stroller down sidewalk-less streets, diving into the oleander whenever a car appeared. I took long cuts through a monastery full of orange trees and stone archways. It didn't take me long to realize there are only so many orange groves you can push a stroller through, only so many tumbleweeds you can point out, and only so many times you can cheat death by squeezing into the bougainvillea before you admit defeat.

■ ■ ■ ■ ■ ■ ■ ■ ■ ■

Some people love to drive. The open road. Freedom and independence. Easy Rider, Thelma, and her pal Louise. As a teen growing up in the US, getting my driver's license was a rite of passage. It was a step over the threshold of adolescence into young adulthood.

Some people love to drive.

I am not one of those people.

I don't like highways or going fast or getting lost. I don't like people talking to me when I don't know where I am. I have to turn down the radio so I can see better. I don't like being too close to 18-wheelers or driving in the dark. Or in the park. Or in the rain or near the train. I do not like it, Sam I Am.

When I moved to NYC, I shed my car the same way I shed my high school insecurities. See ya later, small-town girl. Hello, city woman. When I say I was tripping down the cobblestones I'm not being cute or metaphorical. I really *was*. For two decades, I drove only sporadically, usually when I was visiting my parents in the town whose backroads I knew like the back of my hand. When we eventually got a car in Brooklyn, my driving was limited to moving the car from one side of the street to the other on alternate side of the street parking days. Even that made me break out in stress hives.

No, Sam I Am, I do not like to drive. But what's a modern city girl stuck in an ancient city with no sidewalks or subways supposed to do?

When Cyprus threw off the yoke of British colonization in the 1960s, one would have thought the island would jettison all things British as a way of starting fresh. Instead, there are remnants of the Land of Hope and Glory lurking behind the

Greco-Roman columns and hidden in the sand along long stretches of beach. Things like Marks and Spencer and little silver ketchup serving dishes that made my British husband giggle with nostalgia.

And, to my horror, driving on the left side of the road.

In case you are wondering how it feels for an independent, 38-year-old mother of two to contemplate the necessity of paying to relearn something she learned as a teen? The word you are looking for is *mortifying*.

I was mortified.

Panicos, contrary to his apt and awesome name, did not panic. He didn't mock me for freaking out, something I did more than twice. He didn't mutter under his breath about how Americans don't know proper roundabout etiquette. Like the tortoise of lore, he was slow and steady. As I psyched myself up to pull away from the curb under the orange tree, he promised that I'd be fine. As I made my painfully slow loops around the neighborhood, he repeated it. And, after three or four afternoon sessions with non-panicky Panicos, the patron saint of Hondas heard my plea and a small Cypriot miracle happened: I was driving.

I drove between our pink house and the sweet little Montessori where my older son was, by now, making friends and macaroni art. I had to pump myself up for every trip. I had to repeat the directions in my head—straight at the door handle store, left at the purple house. And every time I pulled into the dusty lot across from the little schoolhouse, I let out a sigh of relief.

But I could do it.

Slowly, I added routes one by one. To and from school. To

and from the Alpha Mega supermarket where I ogled the goat heads shrink-wrapped in plastic. To and from the toy store at the end of Strovolos. Each destination was a new charm on my driving bracelet.

Until all that remained was one final destination: The Mall.

The Mall of Cyprus was my white whale. I was Ahab in a souped-up Honda Accord with a bulldog motif, eyes on the prize. If I could get to the mall, I could go to Zara. There was an Ikea. Fast fashion and Swedish meatballs were within my grasp. I could practically taste the lingonberry sauce.

There was just one stretch of highway, several roundabouts, and a knot of stomach-churning fear standing in my way.

By my non-scientific yet completely accurate estimate, at any given time, roughly 50% of Cypriot drivers are following the rules of the road. The other half? It depends on the day. The fun is trying to figure out which type of driver you're behind. Driving in Cyprus was like playing a game of *Clue* while going around in circles.

Is that Professor Plum, in a Renault, running a red light? Or was it Ms. Peacock, exiting from the inside lane, with a Toyota? By the time I worked it out, repeatedly turning on the windshield wipers instead of the turn signal, I'd be on my way around again.

The first time I drove to the mall by myself, I pulled into the underground garage, tires squealing on the highly polished floor, and let out the breath I'd been holding since I'd pulled away from the curb in front of our house. I made my way to Gloria Jean's Coffee to find my new friend Jade already there, waiting. I ordered and we fell into easy conversation. Or rather,

her end of the conversation was easy. Mine was punctuated by bouts of hyperventilation whenever I thought about driving home. If I could indeed *make* it home. I'd memorized the turns and repeated the directions in my head before I had set out— right at the end of our road, past the big church, left onto Athalassa, past the M&S, right onto the highway—and had arrived relatively unscathed. Getting back to the pink house was a different story. An unfamiliar route with bigger stretches of highway, bigger roundabouts, and undoubtedly more Clue characters.

I talked to Jade, sipped my excellent coffee, and tried not to freak out. I was convinced I was going to get lost.

I got lost.

Waiting to see if Colonel Mustard in a Ford was going to signal, I took the wrong exit off one of the many roundabouts and ended up somewhere dusty and desolate. In actuality, I was only about three minutes away from where I needed to be, *but at the time, it felt desolate.* Eventually, I realized my mistake, turned around, and found my way home. I pulled up under the orange tree and turned off the ignition. I was bedraggled, shaky, and triumphant.

Because I had done it. I felt like Kate Winslet on the prow of the Titanic. I had caught my white whale. I had conquered *The Mall of Cyprus.*

After that, it was smooth driving.

Okay, fine. There was that one time I side-swiped an old Mercedes right around the corner from the pink house. As soon as I heard the unmistakable sound of metal on metal, I pulled over and called Richard.

"What do I do?" I whispered down the phone, peering over my shoulder to see if anyone was around.

"Come home immediately," he said.

Less than a minute later I pulled around the corner and onto the sidewalk under the orange tree. He met me at the gate and then went out in the dark to see what kind of damage I'd wrought with my reckless five-kilometer-per-hour driving. He was back a few minutes later.

"What did you do? Is the other car OK?" I asked.

"I pretended to be looking for a cat," he said.

I giggled.

"It's not funny," he said. "I was on my knees making kissing noises, saying *here, kitty, kitty* so that I had an excuse to look under the car." He glared at me. I laughed again. "The car is fine. That thing is built like a tank."

The Mercedes was fine, but my silver Honda ended up with a faint blue scar on the passenger side. For the next three years, I lived with a low-level fear that someone would run a paint splatter analysis and cite me for recklessly slow driving.

The patron saint of Hondas came through again. No one found out about the Mercedes and after that, it really was smooth driving.

I don't count the tree I clipped making a tight turn or the support beam I backed into at my husband's office because those things were all stationary.

Battle scars.

I drove every day until we left that dusty island and moved to a place where public transportation was not just available, it was efficient, on time, and encouraged. And sidewalks to boot.

■ ■ ■ ■ ■ ■ ■ ■ ■ ■

There are so many hard things about moving to another country. There are whole new skill sets that you need to learn, relearn, or learn to do differently. Skills like driving or biking or

knowing when to take your shoes off at the door or indeed what kind of shoes to wear. There are always going to be things that make you squirm. In Cyprus for me, it was driving. For someone else, it will be something completely different. It seems silly that getting behind the wheel of a car, something that millions of people do every day without a thought, threw me for such a loop. But we can't all be MVPs of all things, and even when we are, no one is giving us trophies for the little things we do that make us feel just a tiny bit triumphant.

What's that? You made a phone call you've been putting off? You definitely deserve a gold star, my friend.

In Cyprus, Panicos the driving instructor helped me relearn to drive and in doing so, gave me a kernel of resilience. But it was me, myself, and I who took that kernel and nurtured it until I caught my lingonberry whale.

Resilience has been a buzzy word for a while now, one of those things we are supposed to encourage and build, particularly in our children.

According to the American Psychological Association, resilience is *"The process and outcome of successfully adapting to difficult or challenging life experiences, especially through mental, emotional, and behavioral flexibility and adjustment to external and internal demands."*

Well, jeez APA, if that's not the very definition of expat life, I don't know what is.

There are certainly momentous events and difficult circumstances and big, hard things that build resilience. But we should recognize that we build resilience with small wins too.

As a semi-resident guest in someone else's homeland, I'm continually adapting to challenging life experiences, finding coping mechanisms, strategies, and shortcuts. Sure, white-

knuckling my way down Griva Digeni was not the prettiest coping mechanism for my driving-induced stress, nor was yelling *Jesus Christ!* whenever someone cut me off, especially when my toddler started repeating my Honda blasphemy, but for a time sweating and swearing were the only coping strategies I had. And you know what? They got me where I needed to be.

When we moved to Cyprus, I wasn't thinking about the things I was doing on a daily basis as building stores of resilience, but I probably should have been. Flexibility is not just a suggested qualification for this topsy-turvy lifestyle, it's a requirement.

It's the difference between getting yourself to and from Ikea or feeling sorry that you're missing out on all the meatballs.

Richard has a great story about the time I tried to learn to ski as a fully-fledged grown-up who should have known better. The story involves me hurling my pole, javelin style, at the ski instructor while my not-yet husband watched in bemusement from the chair lift above. Amazingly, he still married me a few years later, though admittedly, we don't ski together.

There's a reason "you can't teach an old dog new tricks" rings true. Learning new things or relearning old things as an adult is hard. Our minds are set like jelly left forgotten in the back of the fridge. You can eventually chip away at it, but it's going to take longer than it should, and more often than not, you end up throwing the whole thing away.

In Cyprus, getting comfortable driving meant more than just clocking in some alone time at Gloria Jean's or Zara, though.

Our first year abroad was brutal.

When we moved, I didn't simply trade in the keys to our two-bedroom apartment for the keys to the pink house. It wasn't a case of swapping out eggplant at the Italian deli on Driggs for baklava at Zorba's at the end of the dusty path. I also moved away from all the stuff which had, until then, defined me. Suddenly, I was a few oceans away and I had to unpack not only the cardboard boxes but my ideas about who I was. I had to peel the bubble wrap off of myself at the same time as the furniture.

I didn't know who I was supposed to be outside of New York. I didn't even know *how* to be me outside of New York—everything I thought I knew about myself I had learned on those mean streets. The city and my personality were so co-dependent that I had no idea where it ended and I began.

In every sense of the word, I was lost.

As a Brooklyn mom of two, I was comfortable. I was confident. I could sling a baby on my hip, fold a stroller, and run down the subway steps to catch the train. I knew where to get the best bagels, where to get the best slice of pizza at 1 a.m. But when we moved? I went from working mom to housewife. I went from knowing the ins and outs of the subway system to learning to drive again. I went from a circle of close friends to knowing absolutely no one except a yia-yia named Poppy.

It was not exciting.

It was not adventurous.

It was terrifying, depressing, and hard.

Everything I knew changed overnight. I was like Dorothy without the yellow brick road or the motley band of buddies. Just a lot of dust and debris.

In New York, I was my own person. I could go places and do things on my own. I earned my own money and made my own decisions and could get from here and there on my own steam. I knew my own people. And then suddenly I wasn't and I couldn't and I didn't.

The desire for some semblance of independence, even if it meant going to the mall or out for coffee at Gloria Jeans, was strong enough to get me back behind the wheel of a car, somewhere I had never been comfortable. Driving gave me back some element of control, but more than that, it eventually helped me understand that I'm far more resilient than I give myself credit for.

Maybe driving down Athalassa Avenue behind Ms. Scarlet wasn't the same kind of tough as chasing the guy who snatched my bag, but it was definitely a way of flexing those behavior muscles.

That small-town girl didn't think twice about leaving her one-stoplight town and moving to the big, bad city. She packed her bag full of dreams and set out to be queen of the hill.

Yet oddly that's not the memory I summon when I'm faced with hard things, when I need to remind myself that I'm stronger than I think. When that happens, I whisper that once upon a time I learned how to drive on the wrong side of the road. I used to leave the house, keys in hand, and go.

Slowly and with great care, but I went.

I keep that small triumph wrapped up in my pocket, nestled up next to my marriage resentment cards. Whenever I need to, I pull out that white whale-shaped win and hang it around my neck like a talisman.

I couldn't keep walking through those dusty lots, counting tumbleweeds and diving into the undergrowth.

We probably couldn't have stayed in that small two-bedroom Brooklyn apartment for much longer.

I definitely would have regretted not taking a risk and buying a plane ticket that long ago Christmas.

Only one question remained: Was I going to regret saying *yes* to moving all those Sundays ago?

WHIP IT

Take the frappe break

Someone once asked me why I talk about New York like an old flame. My answer is simple…it's the first time I fell in love.

As a young teen, I had plenty of crushes. I cried over boys, convinced I was ugly and unlovable. I stood in the corner of the school cafeteria hoping that some special Drakkar Noir-scented boy-person would come and ask me to dance. He rarely did. In a plot twist for the ages, I briefly dated the high school quarterback. There was a homecoming dance and some Whitney Houston and the flutter of butterflies in my stomach, but that's the stuff of *Sweet Valley High*, not lasting love.

Then there was my best friend Katie, with whom I was most of the way in love, in that intense way that teenage girls tend to be. But that's a different story with a different soundtrack.

It was Katie who staked the first claim to New York, who first set her sights on those bright city lights. They were Katie's dreams I half-attached myself to, altering them to fit my frame. I'm not sure if it was to stay close to her, to siphon some of her magnetism, or to give myself the courage to do something

big.

Would I have gone without her? It's impossible to tell.

But New York? I loved New York from the moment my feet hit the pavement.

Oh NYC, how did I love thee? Let me count the ways. I loved your boldness, your brashness. I loved that you could be anyone or anything you wanted and no one looked at you twice. I loved swimming in the ocean of languages I heard around me, I loved the energy, the 24-hour bodegas where you could buy cigarettes, a Hostess cherry pie, emergency nylons, and a pack of double A batteries. I loved the fast pace and the sharp edges. It fit me, New York, the same way it fits so many others—because it's roomy enough for anyone and everyone.

When the country turns its pockets inside out, New York City is where all of those lint-covered treasures often land.

When I was young, every December my sister and I sat in our pajamas in front of the television and watched *Rudolph the Red-Nosed Reindeer*. The animated interpretation of that holiday carol is nothing less than a hallucinogenic dreamscape. There was an elf named Hermey who longed to be a dentist, a rolling, talking snowman, a bearded prospector who befriends a snow monster, and a literal doe-eyed love interest. How we all survived the mass trauma unleashed upon us by mid-century claymation is a true Christmas miracle.

My favorite part of Rudolph's story arc was always his pilgrimage to the Isle of Misfit Toys, where a host of sad and misshapen toys live in self-conscious exile under the reign of a majestically maned lion.

To me, New York has always been the real-life, live-action embodiment of the Isle of Misfit Toys. It's the urban landing

pad of misfits, oddballs, and kids who color outside the lines. Back in the 80s, it was where queer kids moved to find a community. It's where the square pegs who felt hemmed in by or boxed out of small towns took those midnight trains. If Hermey the elf wanted to come out of his orthodontic closet, he would have headed to the Big Apple.

Why did I love New York so much? The city gave me the space to unfurl girl wings that had been itching to fly, wings I didn't realize I had.

I couldn't believe I was lucky enough to live there.

I even loved the haters. I loved that I was thriving in a place that many people found difficult and harsh. It made me feel strong, encased in stylish, urban armor. I loved the unspoken rules that you learn when you live in a big city. The way to walk. The right amount of space to give someone else. Who to steer clear of and how to avoid the tourists. Which bit of the platform to stand on to get the right train door and how to ride a rush hour train with a cup of scalding, shitty coffee.

Long before the arrival of the venti latte to go, before the term barista entered the hive lexicon, I drank bland, weak coffee from the corner diner or one of the ubiquitous coffee carts anchored outside thirty-story office buildings. Everyone I know drank their coffee black because we were *all in a hurry* and no one had time for milk and sugar. It ain't called the city that doesn't sleep for nuthin'. Back when I was regularly taking the A train, there were no syrups, no froths, no froufrou accouterment. There were definitely no straws.

You took your lousy coffee and you were grateful for it. Fuggadeaboutit.

For years, I spent most of my morning commute blowing

through a tiny hole in a plastic top, toggling the cup between my hands to avoid third-degree burns. We didn't even have those little cardboard cup sleeves that stopped you from searing your fingerprints. Carefully I'd sip, trying not to spill the whole thing down the front of my white work blouse from Express.

In Cyprus, locals skirted the temperature issue by skipping straight to a cold brew: the frappe. Made with instant coffee, sugar, milk, and ice, most Cypriots claim the frappe is a summer drink, meant to be enjoyed in the shade of an ancient tree while the sun scorches the sky and the bitter lemons fall on your head. They are lying to you. The frappe is a year-round drink, offered in every coffee shop, kiosk, and park cafe. And it's not just a coffee house bevvy. Everyone has a whizzy little milk frother at home, right next to the vegetable peeler and olive pitter.

"Frappe?" they ask as soon as you sit down.

Like life in many hot climates, Cyprus slows when the temperature climbs. Movements are languid and liquid, hammocks are strung in the shade of tree-lined parks. During the summer months the streets are quiet in the heat of the day, but open the door to any coffee house or cafe and it's a continuation of the island's history of coffee culture.

A Cyprus coffee, which is nearly indistinguishable from what many know as Turkish coffee, is probably the most recognized caffeinated jolt of Joe on the island, but for me, nothing sums up Cyprus like a frappe.

The frappe is more than just a quick sugar and caffeine hit, more than an icy refreshment sipped in the shady pines of the park. The frappe is merely the vessel. The conduit. The frappe is the hot weather cousin to the British cuppa. It's the

geographical neighbor of a puff on a shisha pipe. It is the Spanish siesta of coffee drinks. And while it is certainly tasty going down, the frappe is about the time-out as much as it is the caffeine jolt.

■ ■ ■ ■ ■ ■ ■ ■ ■ ■

There I was outside the pink house, sweeping the dust and dirt from the tiled patio. No matter how often I swept, the parade of stray cats that ruled the neighborhood like a feline *West Side Story* gang would come and dig in the shrubbery, jettisoning dirt and cat shit onto the tiles. My younger son was sitting in the little Cozy Coupe car we'd acquired second-hand. The older one was riding his scooter up and down the driveway, crashing into the gate.

Glide, crash. Glide, crash.

The woman across the street from us was doing something similar. I'd seen her a few times and each time she looked more tired than the last, her face pinched into something tiny. As her toddler twins ran wild, pulling up the flowers planted along the fence, I had a good idea why. Through my curtains, I had watched the comings and goings of the house across the street with curiosity. In addition to the woman, there was a man, presumably the husband and father, who got in his car every morning and drove off. There was a housemaid who washed the same car every morning before he got into it to drive off. There was a surly teenage son who stomped around. In the house. Out of the house. Doors slamming. And there were the twins; one girl, one boy.

I must have been staring at her because when she looked up from whatever it was she was doing, she gave me half a smile. I pretended not to see and looked away, busying myself with the broom.

Sweep, glide, crash.

When I looked up again she had opened her gate and was walking across the street toward me.

"Hello," she said. I think she was smiling, but truly, it was difficult to tell.

"Hello!" I answered brightly. Inwardly, I was cursing my son and his scooter and the feral cats who liked to shit in our dirt.

We stood, her on one side of the gate and me on the other. We traded mother talk—the ages of the children, the weather, tips for keeping the cat scat at bay, perhaps.

"Would you like to come for a coffee?" she asked me after a while.

I froze.

Did I want to come for a cup of coffee? I don't know. Did I? Did I not?

"Oh *ha ha ha ha*," I spluttered. "Oh, I ummm—I don't really—I ummm *ha ha ha* don't drink coffee!" *What was wrong with me? Sounds were coming out of my mouth but I was making no sense.*

I flailed in a feeble attempt to appear slightly less deranged. "What I mean is that I don't drink coffee after noon!" With each word, my voice rose in pitch, as if the syllables were filled with helium. I watched as each ridiculous word flew higher and higher into the air.

She stood and stared at me, a quasi-smile glued into place. It is entirely possible that behind her glasses, one of her eyes twitched. Around us, my children continued to glide and crash, blissfully unaware of the utter fool their mother was making of herself. Across the street, the maid was dragging a twin away from the flowers, glancing at us.

It's been nearly fifteen years and I still cringe when I think

about that interaction. I can still remember how awkward I felt standing there, desperate to come up with an excuse as to why I didn't want to sit in her house and have a cup of coffee.

Fifteen years later, I still don't have one. I don't know why I said no. I don't know why I didn't just go and have the cup of proffered coffee and deal with the lack of sleep later. I don't know why I was so freaked out and didn't see it for what it was —a little bit of island hospitality, a neighbor being neighborly.

When I think back over my long history of cultural faux pas, turning down a Cypriot offer of coffee is up there. This is, after all, a culture that shows its hospitality through the ritual roasting of coffee beans. I may as well have thrown my shoe at her.

"So, umm…maybe, yeah, maybe another time. In…you know, the morning, *ha ha ha.*"

Oh my God.

"Of course," she said, more gracious than she needed to be. She blinked once or twice and then mercifully, she turned and left. As soon as her back was turned, I abandoned the broom and the dustpan and the dirt, grabbed the kids, and hurried inside. Cat shit be damned.

In Cyprus, no one drinks coffee on the go. And certainly, no one drinks a frappe on the go. No one juggles a frappe while hanging onto the (non-existent) subway pole, bracing against sudden lurches, trying not to spill it down their overpriced white work blouse from Express. No one risks brain freeze by gulping down a frappe on their way to a meeting. When someone says, "Let's take a frappe break," what they are really saying is "Life moves too fast, let's slow down and play some backgammon."

What my neighbor probably wanted was a break from it all. I was just too dumb to realize it at the time.

It took me a long time to recognize that for most of my life, I have had a fundamental misunderstanding of the concept of a *coffee break*. Much like I misunderstood the concept of mince pies (note: you can't call two different things mince meat and then wonder why people get confused). Like other American breaks—lunch, vacation, maternity—an American coffee break is a timed affair, something you clock in and out of. You spend your break counting the minutes until your break is over. There's little relaxing or rejuvenating about it. It's not enjoyable, it's simply mandated by law.

Living on the other side of the world, the frappe break reminded me of the times my mother visited the neighbors, lit up a Pall Mall, and sipped a cup of instant coffee around someone's kitchen table. The housework was finished. The kids were—if not in sight, assumed alive—and dinner was still a few hours away.

For my mother and the millions of kerchiefed housewives of my youth, it wasn't about the coffee then either. It was a breather, a time-out. It was a few minutes to connect with another human being, or lacking that, at least the human in yourself.

In Cyprus, at any park, any beach, any shop, I invariably encountered people on a frappe break. It was an entire nation of 1970s suburban housewives taking a breather. I went to the post office to pick up a letter. Frappe break. I had to pick up the clothes from the dry cleaner. Frappe break. The mechanics, the bank, the office, they guys digging up the road down the block? Frappe break.

It's an iced, instant coffee-flavored breath. A literal chill out.

I have never been good at relaxing. Don't confuse that with ambition or drive or motivation, it's just that my brain is always on, making lists of things that need doing. When the Netflix and chill trend was happening, I laughed. I don't chill. I am not a chill person. My husband? He's a chill guy. My sons? Cool as the proverbial cucumbers. Not I, said the old woman who swallowed the to-do list. I go stiff as a board during the rare massages I've had, including the one Richard arranged for me not long after we'd arrived in Cyprus, when I spent an hour trying to relax under the enormous hands of a bald Bulgarian man who kept gruffly asking me "You have pain?". I once had a full-blown panic attack during a seaweed wrap in Las Vegas. I have endless lists, in every pocket, every bag. In every nook and cranny, there is a scrap of paper with things to do. If someday my children see fit to bury me with a marker, it would not surprise me if there was a to-do list on there.

Here is an incomplete list of other things I am no good at: cutting myself any slack, allowing room for mistakes, asking for help, or just generally going easy on myself. I am my own worst enemy. A Lex Luthor of my own design, my arch nemesis is…*me*.

Few of these traits are conducive to the lifestyle we'd just chosen, the one where I was supposed to be building resilience by continually adapting.

Richard once tried to give me directions like an actual adult, with geographical words like north and west and I hissed at him.

"Just tell me if I need to go right or left at the door handle store!" I yelled. "Is that so hard?"

Whenever I would panic about not knowing where to go or how to get home—which was all the time—he would say,

"Head toward the mountains." And in fairness, it was impossible to miss the Kyrenia mountain range that rose to the north of the pink house. For one, it was a literal mountain range. But even more, it was emblazoned with an enormous Turkish Cypriot flag on its rocky facade—so big, in fact, that you can see it from space. Rumor has it that Turkish Cypriots worked on the flag for months until it was complete, painting rocks by night and turning them over during the daylight hours. On the morning of Oxi Day, (literally the Day of No), Greek Cypriots woke up to a giant middle finger of a flag on their mountain range.

I don't know if the story is true, but it felt apropos.

We made this enormous decision that was supposed to be *good* for us and it felt like life kept giving me a giant middle finger. Everything was hard. I was depressed. Sure, we had a house, but I wanted my Williamsburg apartment back. Sure, I didn't have to push the stroller through the Lake Michigan of slush puddles to get across North 7th Street, but I longed for a sidewalk to actually cross.

I spent most of those early days pining for *home*, for before, for myself. I fantasized about going to the airport and getting on a plane back to the US. Had I been more comfortable driving in those first few months, I may well have. I didn't want to be in and among the olive groves and the lemon trees. I wanted to be back among the skyscrapers and the subway platforms. I wanted to be back at Grand Street playground with my Mama friends, complaining about nap schedules and fretting about pre-K. Ok, that's a lie, I was definitely happier not fretting about Pre-K. I wanted to hang out at CeeCee's house, making Thomas the Tank engine tracks with our boys. I wanted my stash of take-out menus. I wanted a pizza that didn't taste like cinnamon. I wanted to know what kind of

46

meat I was buying at the supermarket. I wanted to stop feeling like everything I did was wrong.

I wanted someone to talk to. I wanted friends.

But the things I wanted most of all were the things I couldn't have: someone to tell me that we'd made the right choice and, that in all the to-ing and fro-ing, in all the packing and unpacking, I hadn't packed myself up and forgotten to take her back out again.

My neighbor and I had a lot more in common than I realized. I too could have done with a break.

Richard was devastated by my despondency. He blamed himself—and most of the time, so did I. After all, it was his dumb job that caused this gargantuan upheaval in our lives and my psyche. He started coming home for lunch, ostensibly to keep us company, but I think it was also to check that I was getting out of bed and not simply hiding out under the covers.

"Are you here to make sure I'm not sticking my head in the oven?" I'd say as he walked into the kitchen through the back door, a sheepish look on his face.

"No, no, I just wanted to hang out with you guys and have lunch," he'd say.

"Great. More housewifery," said as I slapped some cheese and a piece of bread on a plate. "So happy that college degree is working out for me."

If I was feeling generous, he got an apple.

I was a mess. I was weepy, angry, and resentful. A month after we arrived Barack Obama was elected president. I cried that I wasn't there to celebrate on the streets of Brooklyn with my people. At six a.m. on New Year's Day, the television was on, and the iconic glitter ball was dropping in Times Square. Richard came down the stairs to find me silently weeping into a

pillow while Auld Lang Syne played in the background.

I was at a loss as to where to even begin setting up life in a new country. I felt like we were kids playing house, simply pretending to know what we were doing. The easiest path to normalcy was to simply try and recreate our Brooklyn lives but in the sunnier climes of Cyprus.

This was, and always will be, the wrong thing to do.

We did it anyway. We started with the local playgrounds. Life in our Brooklyn apartment with a toddler, an infant, and broomstick-happy neighbors meant I spent a great deal of time outside of those four walls and on the playground tarmac. If I was going to feel at home anywhere, feel like myself anywhere, surely it would be amongst the swings and the slides of Nicosia, right?

We drove toward the old city and found a place to park near the thick, stone walls. On the edges of the walls, there were groups of Filipino maids picnicking on the sparse grass, taking advantage of their day off. I wondered if the car-washing maid from across the street was there. I grimace-smiled at them all just in case. The kids were quiet as we walked, looking for anything resembling a playground.

We eventually found...something, though it looked more like a scene out of a Stephen King novel than a playground. Half-dead weeds were pushing up through buckled, broken concrete. There was a rusty see-saw I renamed the Tetanus-Totter. Lethargic birds lay about in cages along the edges of the park, occasionally omitting a half-hearted chirp. Let's be clear, NYC playgrounds are not beacons of safe, colorful cleanliness. One of the most disgusting places I have ever been in my life was the toilet at McCarren Park, but I was never worried about contracting bird flu while I was waiting at the bottom of the slide for my toddler to careen down.

The American in me worried about lawsuits and liability. The mother in me worried about whether or not the kids' vaccinations were up to date. The New Yorker in me wondered just what in the name of the Big Apple made us think leaving the city was a good idea.

■ ■ ■ ■ ■ ■ ■ ■ ■ ■

While Richard was at work, talking to grown-ups and doing other adult things like using the toilet by himself, I was stuck at home with two kids. I was not so slowly losing my mind. Our afternoon entertainment was walking through one of the dusty abandoned lots to buy stickers for my son to put in his *Cars* sticker book. I developed an unhealthy investment in those stickers, simply because it gave me something to look forward to.

"Do we have that one?" I'd ask breathlessly as we got home and spread our sticky booty on the floor. "Oh, another Mr. the King," I'd say sadly. "Oh for a Snot-Rod, eh? We'll try again tomorrow, buddy."

We were all bored. I was lonely and friendless, regularly second-guessing our decision to leave our old life behind. Worse, I blamed myself for not being able to find a way out of my hole of unhappiness. I'd slide into a funk, and chastise myself for sliding into the funk, all of which made the funk... well, *funkier*. I berated myself for not being strong enough, adventurous enough, not being enough.

You're supposed to be this tough chick, I'd remind myself. Why are you finding this so hard?

Even I got tired of hearing myself moan.

People sometimes ask if there are things I would have done differently.

I would have said yes to my coffee-offering neighbor.

I would have taken more damn frappe breaks.

I still struggle with the art of giving myself a break. And it *is* an art—learned, perfected, and practiced over time. Whether it's with an iced coffee drink, a glass of wine, a weekend away, or just recognizing that we don't have to go it alone, I still flail about when it comes to cutting myself any slack. I wish I could say I was getting better at it, but the reality is that I just forget to be as stressed as I used to be because I'm old.

■ ■ ■ ■ ■ ■ ■ ■ ■ ■

Years later, my friend Gemma told me a story.

Her young daughter came home from school one day with a small, empty bucket and a list of instructions. Each family member had to write nice things on slips of paper. The child's classmates and teachers would do the same until there were enough slips to fill the bucket. The result was that each child would end the assignment with a bucket brimming with *joy*.

Joy. What a concept, right?

Having a crappy day at school because your best friend is being mean? Go to your bucket and grab yourself some joy. Missing your friends and your life and pizza by the slice? Pick out a slip of joy. Not sure who the hell you are or how to get back to yourself? Go grab your bucket, lady. I've got joy for you, and you, and you.

Things I was doing: desperately trying to figure out how to navigate this brand new life we'd chosen for ourselves. Things I was not: regularly filling up our buckets with joy, let alone replenishing those buckets when they ran low.

I didn't understand the importance of taking the time to refuel or reset. I didn't take breaks or breathers or cut myself

any slack. I didn't ask for help. Instead, I berated myself for focusing on the negative. I thought it was me. I thought I was weak.

I didn't let anyone know how hard I was finding everything, other than to lash out.

A frappe break is a little bit like recess for adulthood. It's like hearing a favorite song on the radio and stopping what you're doing to sing along, forgetting that you're mad or pissed off or worried about something. For a few, frothy minutes you can belt out *Don't Stop Believing* and forget that you're never going to hit those high notes like Steve Perry.

It's giving yourself permission to take a few moments to sip your iced drink in the shade, preferably with a friend, or at least to reconnect with the human in yourself.

Cyprus has it right.

Those first six months, when the tag of our new life was still scratching against the skin of my neck, there wasn't a whole lot of joy. There were a lot of tears and a fair amount of yelling. There was plenty of stress and uncertainty. There was me, 7,000 miles away from home, trying to figure out who I was supposed to be in a place I never expected to be and was pretty sure I didn't want to be. I kept trying to cobble something together that looked vaguely like the me I was used to.

Who was this woman, this house Frau? Because honestly, I did not recognize her nor did I particularly like her. Where was the confident woman I'd spent twenty years perfecting in New York? I wanted to put my motorcycle boots on and stomp back into my old life.

I was beating myself up because I hadn't hit the ground running when in reality I didn't have the shoes, the stamina, or

the sidewalks to run even if I *could* have.

What I needed, had I only known, was the mother of all frappe breaks.

My favorite story from our early time in Cyprus is from the day we were walking through the olive groves of the local monastery. It was mid-December and the heat had finally eased, mellowing into pleasant. Life seemed a little less parched. Our family of four meandered through the orderly rows of trees. The twitch and tickle in my sinuses hinted at an allergy, but never mind, we were here. We were together.

We were going to make this dusty life work.

My husband, ever the optimist, ever the half-full guy, stopped under a random olive tree. There is something about olive trees, the way they've weathered the years and decades of relentless sun. Like generational sentinels. On that day the waxy leaves were still. The tree had fruited, and there were small hard olives right above his head. He reached up and plucked one straight from the branch. In an *Eat, Pray, Love* moment he rolled it between his fingers. I think he might have said something profound about the privilege of being in such a place, a place where olives were just ripe for the picking. How lucky we were!

And then, before I could advise him against it, he popped that raw, unbrined olive in his mouth.

Like half-finished houses and half-finished lives, olives need some time to ripen.

He spat it out.

You need to soak those suckers over time to take away the bitterness.

The worst thing about trying to figure out where I fit into my new life was that it was too easy to get caught in swirling

eddies of despair. I kept comparing before and after, then and now. And everything came up short. Prior versions of myself blew by like tumbleweeds. I was stuck in a vortex and once I was there, it was difficult to peek out at the good stuff.

It's almost as if I was so invested in the gloom that recognizing anything good felt like a betrayal.

If I started to like some things about this new life, was I cheating on my NYC self? If I leaned into this whole expat partner schtick, was I betraying the independent woman I loudly proclaimed myself to be? Was I turning my back on the life I kept saying I wanted to get back to if I recognized anything good?

Because there *were* good things.

As promised, Richard was home every night for dinner. Sometimes annoying early, but home nonetheless. Gone were the days when the L train got stuck in the tunnel between Manhattan and Brooklyn. His office, on a dusty old airfield, was a ten-minute drive away. Together we explored and found different, less deadly parks where we could sit under the shade of towering pine trees and watch the kids play. On the coast, there was a winding, twisted road that ended in a secret cove with gentle waves and a cafe under a canopy of purple bougainvillea. In the North, at the very tip of the island, was a hostel called Oasis, a row of basic rooms built among the ruins. There the kids played hide and seek behind fluted columns, their feet sliding on the mosaic tiles of a half-uncovered Roman floor. On the beach below, underneath a velvet sky filled with stars, the sea turtles made a yearly pilgrimage, crawling onto the beach to hatch turtle eggs on the golden sand.

There were good things.

Not too far from where we lived, there was another park, accessed through a gap in the trees which, in turn, led down a dirt path. At the bottom of a small hill, nestled among the giant, swaying pines, there was a clearing. In the summer months, it was a blessedly shady haven from the sun, part playground, part rewilding. The first time someone brought me there I felt like I was being initiated into a secret. There was a small kiosk called the Frog Cafe that sold water and Kit Kat bars and Oranginas and ice cream cones. And of course, frappes.

In our time in Cyprus, I spent a lot of time there, much of it drinking frappes at small tables with wobbly legs while the kids rode bikes and took turns on a rope swing. I will never be a *stop-and-smell-the-roses* kind of woman. I wasn't back in New York, and that aspect of my personality hasn't changed regardless of the places we've lived. But eventually, I did learn to appreciate the cool, frothy ritual of the frappe for what it was meant to be.

With each month I grew more used to our island home, and by the time we were nearing our goodbyes a few years later, I had even brought a few newcomers down that dirt path, initiating them into the secret Narnia park. Some were still tripping over themselves, trying to figure out where to place themselves among the bitter orange trees. We would sit together in the shade while our kids ran through the pine needles and I would listen to them, hearing myself reflected in their worries and complaints.

Often I would excuse myself for a moment to go to the cafe.

"You're not imagining it. It's really hard sometimes," I'd say when I got back, handing over the cold glass I was holding.

"Take a break. Have a frappe."

JUST LIKE HONEY

There's a substitute for (almost) everything

There's only a stretch of salty sea between Greek yia-yias and Italian Nanas. Step into the kitchen of either and you're likely to find the same things. A stovetop of dented pots coming to a boil, a casserole dish bubbling in the oven, and an aging woman slurping from a spoon and muttering under her breath.

In that way, Cyprus was as familiar as Sunday dinner at Nana's to me. Those late afternoons spent at my grandparent's house meant an array of food—plate after pie tin full of all things stuffed and breaded and braised. Pots of escarole and pasta e fagioli, cold meats, and macaroni with red gravy heavy with sausage. Loaves of bread so soft they melted on your tongue. And always, lime jello in cut glass dessert dishes with a dollop of Cool Whip on top.

In Cyprus, the grill was always hot. Chunky cubes of pork were skewered between onion wedges in neat souvlaki rows. Kleftiko slow-cooked in the oven, tender lamb and potato, and fragrant sprigs of rosemary. Roasted peppers and zucchini were drizzled with oil. Plates of grill-charred Halloumi sat near baskets of pita bread draped with a cloth napkin to keep them

from going stale.

"Are you hungry? Of course, you're hungry. Sit, eat something!"

Mangiare! Φάτε το φαγητό! Eat!

I missed that particular Mama memo, the one that gives you a step-by-step guide on how to reach into your heart and spoon-feed your family with love. Over the years, and especially as my children have gotten older and conversant beyond Minecraft creepers and Lego Ninjago, there's a sense of satisfaction in seeing my family well-fed and watered. However, that came later. In Cyprus, as well as in New York, I was at best, a reluctant cook. Cooking was a necessary evil, something that had to be done, like a pap smear, but multiple times every day.

Richard likes to scare the children with boogeyman stories of what he considers the rock bottom of that period of unenthusiastic meal prep.

"You don't know how lucky you are," he tells them as he digs into a bowl of spicy ginger pork stir fry. "You're too young to remember the brown rice and frozen veggie burger days."

Chefgirlardee I was not.

Maddeningly, I still had to routinely procure food for my family—and honestly, did they really need to eat *every* day? But that infuriating endless loop of food shopping, chopping, and consumption was the beginning of my love affair with Alpha Mega.

A mere two roundabouts from the pink house I could find almost all of my family's needs and plenty of things I didn't realize we might need until they were on sale. Beach towels, Christmas trees, souvlaki, vacuum cleaners and vacuum sealed

goat meat; booze, beans, toys, and magazines. Clothing, candles, shoes. Oh, and food!

There were bins of curly kale, the color of ocean depths and fat, orange yams. Spring green Bibb lettuce and just dug-up potatoes with the dirt still on them. There were vats of Kalamata olives glistening in oil and tubs of roasted peppers and pickled cauliflower.

As I pushed my trolley up and down the supermarket aisle on one particular day, however, I wasn't after a paper bag full of fresh green beans or a slab of crumbly Feta. There was a boy birthday coming up and I was on the hunt for a cake mix. A natural baker I was not, but Duncan Hines I could usually swing.

I scanned the shelves, looking for something familiar, something easy enough to follow without having to translate instructions. Ah, there! A Betty Crocker box mix. I could have cried with joy and relief. I plucked it off the shelf and then caught the price out of the corner of my eye. And then I *did* cry.

Eight euros!

Box in hand I did some quick math.

One euro times one and a half dollars times eight = outrage.

And then, in the baking aisle of a Cypriot hypermarket, among the brown sugar and the non-self-raising flour, the spirit of my frugal father rose in a swirling eddy before me. The lights flickered. I heard his voice boom in my head.

"I'm not paying eight euros for a cake mix!"

Only it wasn't my father's voice, it was mine.

I put the box back on the shelf and walked away feeling nothing but sorry for myself.

I just wanted to bake a cake for my son's birthday. Why did

everything need to be so hard?

In the beginning, it was easy, especially when I was feeling a little bit lost, to float away on the salty sea of *the way things used to be*. I wanted my life to be exactly the same, just in a different place. I wanted all my NYC know-how and city swagger but with a bit of sun and some hummus. I longed for things to be uncomplicated. Or, if they had to be complicated, to at least have a manual in a language I could read. I had two young kids, I was already dragging my feet. The added exhaustion of being a new expat was crushing me.

I never knew where I was going and felt like a child having to constantly ask for directions. *Which way at the door handle store?* I didn't know how the washing machine worked, or who to call if something went wrong and I spun when I should have rinsed. I didn't know how to find a doctor. The whole childhood vaccine schedule in a different country was a maze I couldn't hack my way out of. I couldn't figure out how much those little coins were worth or why people kept yelling all the time. I didn't know where anything was or how it worked or if I was accidentally putting drain cleaner in the kettle.

I was.

At one point I wondered if I was supposed to park diagonally across the straight white lines because so many other cars seemed to. I didn't know if the neighbor across the street would ever invite me for coffee again. I didn't know if I *wanted* her to invite me again. I didn't know where to get the things I needed, let alone wanted. I could never find the peanut butter. Everything took five times longer than it would have if we were back in New York.

I should have realized that once we left American air space, once that cargo ship set sail with our books and crockery,

things were never going to be the same. It was never going to be pizza with a side of baba ganoush. It wasn't going to be brash Brooklyn confidence on the sandy beach with motorcycle flip-flops.

My life was never going to be the same, just somewhere else.

That didn't stop me from wanting it or from being any less angry or upset about it.

When we told people we were moving to Cyprus, we were met with a range of reactions. Many of those conversations were heavy on misconceptions, namely that we would be swanning into a life of household help, and that I, in particular, would be living a tennis and bonbon existence. There are places in the world where household help is not only affordable, but encouraged, expected, and easy to find, just like there are international jobs that pay you a lot of money. Neither category applied to us.

Things I know: I'm no good at tennis. Things I don't: what a bonbon actually is.

When we moved I became, for all intents and purposes, a housewife. I was not bringing home the bacon, but I *was* frying it up in the pan—or at least something I thought was bacon. My days were spent cooking, cleaning, and caring for children. I may not have had the kerchief or Pall Malls of those 70s housewives from my neighborhood memories, but I was doing all the same things they'd done.

Except I didn't have any friends to sip an instant coffee with so that I could reconnect with an adult human, even if that adult human was myself.

I wasn't treading water, I was sinking. I wasn't floating away

on the sea of *the way things used to be*, I was drowning in it. And in order to keep my head above the water line I clung to anything familiar. My life preservers were the things I thought would make my life smell, taste, and shine like the things back home.

I just wanted *something* to be easy. I wanted the stupid cake mix in a box.

After channeling my dead father in the baking aisle, I got back into my car. It is possible that in the act of peeling out of the parking lot, I cut off Ms. Peacock in a Fiat. At home, I looked up a recipe for a basic vanilla cake. Then I looked up the translation of baking soda. Then I got back in the car, spun around the two roundabouts, and found myself back at Alpha Mega. I grabbed a bag of flour. I grabbed a bag of sugar. Eggs. And then I went home and in a pique of stubbornness that rivaled Scarlett O'Hara, I taught myself how to bake. As God as my witness, they'll not lick me.

Just the spoon.

My go-to vanilla cake calls for buttermilk: One tablespoon of vinegar or lemon juice to $7/8$ of a cup of milk. No molasses for the gingerbread: 1 cup brown sugar. My chocolate espresso cake needs self-raising flour: One cup of all-purpose flour, 1 teaspoon baking powder, $1/2$ teaspoon salt, and $1/4$ teaspoon baking soda. Lisa's Banana Bread uses margarine: 1 to 1 butter ratio.

You can substitute almost everything.

Sometimes you have to fiddle. Sometimes you have to fudge the measurements, eyeball the teaspoons, and add more salt to make up for the ingredients you're missing.

Sometimes you have to bake it from scratch rather than

from a box.

Sometimes you have to find a new dessert altogether.

■ ■ ■ ■ ■ ■ ■ ■ ■ ■

When my father died in 2005, we spent a lot of weekends driving between Brooklyn and my family home in Massachusetts. My son was only a year old at the time, and watching him tear around the house and the yard was a mood break for my mother. Babies are distracting. Not only their rapt interest in how the power cord works, but because they require endless attention and doing. There are meals and snacks and playing and naps to prepare for and baths and constant attention and making sure forks are not being forked into the outlet. For me, the grief of losing my Dad was buffered somewhat by the fact that I was a new mother. I didn't have the time to let myself think too much about what I had lost. Giving my mother that mental break, even for a weekend, was a gift I was happy to give. She got to lose herself, for just a little while, in the distraction of being a grandmother, something she had longed to be for years.

All of those miles logged, all the trips back and forth on the Merrit Parkway when I was tip-toeing around the reality of life without my father, I never thought anything would change. As my mother and sister and I flipped through the photo albums and turned the light off in my father's workshop, I watched their relationship with my son take root and grow. It didn't fill the hole my father left behind, but it helped pin the edges together so at least it didn't gape as much. A few years later our second son arrived, and we squeezed two car seats into our two-door Golf and made the same drive.

"New York is the perfect distance," I would say to my husband somewhere in Connecticut.

"How so?" he'd ask, merging onto the parkway.

"Close enough that we can go visit for a weekend, but far enough away that nobody is just showing up and ringing the bell."

Then we went and screwed up the whole thing by moving. With time zones, oceans, and half a world between us, it wasn't the grandparent/grandchild relationship any of us were expecting.

My kids were born into a grandparent deficit. With my father gone, they were already down a Papa, but the truth was no matter where we lived, someone was going to miss out on the Hallmark stuff. If we partied in the USA, the UK side lost out. If we hosted Sunday roast dinners in Britannia, then the US side would. In a twisted way, moving to a third country was one way of leveling the playing field. Everyone missed out, including us.

It was an equal opportunity missing.

There's no recipe for baking a successful long-distance relationship. Richard and I had spent hours on the phone and writing letters to one another while there was a sea between us, but that solution wasn't going to work with a four-year-old and a baby.

There was no box I could buy that was going to give me an easy, ready-made answer.

Much like cake mix I was too cheap to buy, I had to find a substitute.

The word substitute gets a bad rap. It's the second best, it's the B-team. It's the teacher the school kids take advantage of, the benched player going in when the captain can't play, or the understudy stepping into the spotlight when the star gets the flu. There's something phony or not real about the idea of a

substitute, as if it hasn't proven its bona fides.

The truth, of course, is that most of the time making a substitution isn't noticeable at all. Most of the time whatever it is you're making turns out just as good, whether it's a birthday cake or something else entirely.

Sometimes it turns out even better.

Had we stayed in Brooklyn we probably would have seen my mother a handful of times a year. A long weekend here. A holiday or special event there. And while it would have meant that yes, she could be there when someone made a wish and blew out the birthday candles, it also would have meant missing out on those long summers of concentrated family time.

When we were white-boarding the pros and cons of moving abroad, the promise that the kids and I would spend summers in the US was my deal-breaker. That July and August trip home was a non-negotiable clause in our personal contract, much like the way Richard made me pinky swear that I would call it football and not soccer when we had children.

Those extended summers meant that my mother and sister got to spend long chunks of undiluted time with my kids. It wasn't just a Sunday dinner they were required to sit through with lime jello for dessert. It was languid summer days spent at the beach, boogie boarding, and building sand castles. It was daily trips to the ice cream shop for dripping cones and paddle boarding on a nearby lake. It was adventures into Boston and touring battleships in between lazy days of hanging out at someone else's pool. And all of it helped to shore up the foundations of a relationship.

We found a way to make it work. We swapped out the Betty Crocker box mix—the way we had always done it--for a

different way, a new way that no one had thought of before then.

And really, who's to say the one we cooked up isn't tastier than the original?

■ ■ ■ ■ ■ ■ ■ ■ ■ ■

There's a lot of emotion tied up in the things we're used to. Whether it's Sunday roast, lime jello with Cool Whip, or the familiarity of the face looking back at you in the mirror, when they are suddenly missing, the loss can leave a giant, gaping hole.

An American I knew used to bemoan the lack of sugary breakfast cereals. Another one missed her furniture polish. I've known more than one Brit who regularly smuggles pork products in their luggage. Around Christmas, there was always a brisk trade in bacon-wrapped sausages.

When you're stuck in a hole longing for the familiar, it's easy to think that if you could only get your Lucky Charms, Lemon Pledge, or M&S chipolatas, then everything else would magically fall into place. As if hiding in there with the shamrock-shaped marshmallows is the answer to why things feel so desperately hard.

I wanted to open a box and shake my New York City self into a Cyprus life. I wasn't particularly interested in figuring out how to tweak it, change it, or do anything differently.

I didn't want to bake a new me from scratch. The very idea of having to do that made me weep with exhaustion.

Yet I was struggling, desperately trying to figure out who I was and where I fit in. If I was an expat wife in Cyprus, by default I was no longer a freelancing mother in Brooklyn. If I was more Nicosia housewife, then I was less Williamsburg badass. And the most difficult to reconcile? If I was financially

dependent on Richard's income, how could I still be the independent woman I had always been?

I had always earned my own money. Even when we decided I would stay home with our first son, I had enough money put away that I was contributing to our household expenses. In addition to our joint account, I still had the Citibank account that I'd opened as a wide-eyed, small-town girl. I was the one who dealt with our finances, wrote the checks, and paid the bills. If Richard was the dreamer in the relationship, I was the realist who was telling him those dreams were over budget.

"Just buy it if you want it," Richard said whenever I wistfully pointed out something that I liked.

I rarely did.

"It's your money," I'd say. "It feels weird to spend it."

"It's not my money, it's ours," he repeated countless times.

I wanted to believe him, and sometimes I did. Most of the time though, I bristled. The idea of buying myself a new pair of shoes or a dress, things that I liked but didn't need, with money that was maybe ours, but definitely his?

It made me feel icky and small. After all, I wasn't the one going to work every day and earning that money.

He was.

I was busy cleaning up cat shit and making vanilla cakes with buttermilk I'd made from scratch.

■ ■ ■ ■ ■ ■ ■ ■ ■ ■

When I was nursing our younger son, there was a pretty bra I fell in love with. It was lacy and frilly and more money than I wanted to spend on a nursing bra. And so I did what I usually do, which is talk incessantly about the item I coveted but rarely allowed myself to buy.

"Just buy the bra," Richard said to me, more than once. It is

possible he was fed up with hearing about a bra.

"It's too expensive," I said. "I can't justify it."

"Why not?" he asked incredulously.

"Pfft," I sputtered. "Would *you* spend seventy-five dollars on a pair of boxer shorts?"

He looked me straight in the eye and said: "D, if my nuts swelled to three times their normal size and I had to get them out several times a day in public to feed our kid? I'd buy three pairs."

He's a keeper, that man of mine. And the bra? Someone I knew had bought two and never worn them and sold them to me for half price. Everyone won.

The cake mix wasn't going to break our Laiki Bank account. I could have put it in the trolley, packed it in my reusable Alpha Mega tote, and no one would have known but me. I was still the one taking care of the finances, setting the budget, and paying the bills, with money that was maybe ours but definitely his.

The notion that I need to be deserving of or earn nice things is something I've wrestled with for most of my life, whether it's a cake mix, the fancy nursing bra, or psychotherapy to haul my depressed self out of a black hole.

"You always do that," Richard said when I talked to him about this memory. "It's almost like you want…"

"…to make my life…"

"…to make your life…"

"Harder than it needs to be," we said almost in unison.

My Beatty's chocolate cake is ten times better than any box cake I could buy. Flip-flops are ten times easier to walk on the beach with than motorcycle boots. Long, lazy summers are better than an occasional roast dinner, even if there is lime jello

for dessert.

Those are the no-brainers.

The challenge comes when you find yourself face to face with the tougher recognitions.

Like when you finally break through the sea of *the way things used to be* and realize that the life you're living might be just as good as the one you've been yearning to get back to.

Or that there may even be a few things that were better.

I missed my Brooklyn self and the security of knowing exactly who the woman looking back at me in the bathroom mirror was. I missed the city life we had left in the rear-view mirror. Yet a few thousand miles and some time away from the day-to-dayness of that life made it easier to see where the weak points were.

Urban living is hard and at times, urban living with young kids is nothing short of brutal. I used to love the idea of that toughened skin I put on like a suit of armor whenever I walked out the door and onto those Big Apple avenues. In fact, it's one of the things I missed the most about *before times me*. But in Cyprus, I was beginning to get a glimpse of how much that armor can weigh you down.

At number 5 Egnatias, we left the Honda unlocked under the orange tree. The only thing we worried about was the sound of overripe fruit bouncing off the hood at night. *Plink, plink, plonk*. I didn't freak out if I forgot to lock the back door when I ran to the grocery store. I didn't worry about the car window getting smashed and having to vacuum glass out of a car seat. In New York, someone had once stolen the license plates right off of our car and I'd lost count of how many times we had to replace the window, including two weeks before we had moved overseas.

There were Oscar-worthy histrionics in Cyprus, including my own—like the time Richard ran out of the house in a towel to find me standing in the middle of the road screaming like a banshee—but we'd yet to wake up to a drunk neighbor dressed like Wonder Woman trying to break into our home by drop-kicking the front door.

It was easier to buckle the kids in the car than it was to fold the stroller and clamber onto the bus. It was easier to leave the toddler sleeping in the car seat than it was to carry the stroller up the subway steps, hoping someone would offer to help. We had more space than we could ever need, and more bathrooms too. The kids could stomp around without worrying about downstairs neighbors. School anxiety was a thing of the past. We saw two and picked one. Every aspect of grocery shopping, that necessary evil, was more manageable, including not having to use my toddler as a counterweight to balance bags on the stroller.

When I wasn't elbow-deep in resentment or anger-baking birthday cakes, I could see how pieces of this new life weren't just taking root, but starting to bloom in ways I wasn't expecting.

I missed Brooklyn every day. What I didn't miss were the hard everyday bits—I just wasn't ready to admit there were a lot of everyday Cyprus bits to like.

I might not have recognized the floundering, flour-dusted woman who stared back at me from the mirror, and I certainly didn't see her blossoming in any way. Still, it was hard to deny that *that* woman, however unrecognizable, had a lot to do with the blooming and blossoming that was happening all around her.

FAITH

And I would move 7,000 miles

On Tuesday afternoons, our wonderful cleaner Marie used to come and do her best to dispense of the dust that seemed to follow us everywhere. She would sweep up the burst oranges that fell on the sidewalk and the bruised petals from the oleander in the driveway. And when she left, for a brief moment, we could walk barefoot along the tile floors without exfoliating the bottoms of our feet on the grit that infiltrated our lives. Sometimes she would stay for an extra hour to keep an eye on the boys so that Richard and I could spend some time together.

It was an hour my husband grew to dread.

On those afternoons I would jump into my car, drive down the Coca-Cola Road, and around the roundabout until I got to the old air base where Richard worked. I'd wind my way up the hill, past the sentry with his desert-colored fatigues, past the old brick huts the color of sand, past the commissary, past the pool. I'd pick him up and we'd head into the old part of the city, parking along the Green Line border and going the rest of the way by foot. Once we found a secret tea room where we

sat and drank pots of spicy tea flanked by colorful pillows. Sometimes the one who wasn't driving grabbed a beer. We sat, and we talked.

Or rather, I talked.

My husband referred to these little marital accords as "Free-fall Tuesdays". I would pop open the cork on the torrent of worries and complaints I'd been bottling up since we'd arrived. By that point we'd been in Cyprus for about eighteen months, and while life was smoother in general—thanks in no small part to Marie—it was becoming increasingly clear to both of us that the plans we had to get back to New York were not going to pan out. The loophole had closed. The promotion he needed was unlikely to happen in the current structure.

It was not going to be two years.

"Maybe three, tops?" I'd ask desperately. And my husband would break out in a sweat as he tried to find a diplomatic way to say, *doubtful.*

"Hard to tell."

In other words, we were stuck there.

I was not going to put my motorcycle boots back on anytime soon. I was not going to unpack the life or woman I'd put on ice when we left.

Infuriatingly, if we'd decided right then and there to call time on the whole adventure and head back to NYC, we were going to time loophole ourselves right back to where we started, like some perverse Christopher Nolan screenplay. *It's all been for nothing*, I wanted to scream. In actuality, it would have been worse because we'd likely go back without a job.

What were the options? Were there other jobs? Why had everything failed to materialize? Has it all been a big lie? I started to wonder if my husband had been gaslighting me all along. Had he just wanted out of New York and hatched a

dastardly plan? If I snuck up on him in our bathroom, would I find him waxing and twirling a villainous mustache? What was he doing about it?

It was a laundry list of questions I ran through in the same order every Tuesday.

I longed for answers.

And there were no answers.

I think it must have been during one of these free-fall outings when my husband told me I was infamous in his office. Newcomers to the island and the office could rank themselves on a scale that ranged from *excited* to *Dina*. Welcome to the land of never-ending summer! You've been stationed on an island in the Mediterranean. Everyone loves it here other than Richard's wife. Here's some souvlaki and a frappe, good luck!

In those early moments of trying to figure out where I fit in this new life of ours, ending up the office joke, good-natured or not, was not exactly what I had in mind.

Are there times I've resented my husband's job, his wild-west adventurousness, and his laid-back/take-it-as-it-comes attitude toward the idea of moving our family around the world? How could I not?

Are there times I've felt unseen, unappreciated, an afterthought, forgotten? Are there times I've raged against the machine that is his work, lamented like a Greek chorus at the unfairness of expecting people to move their kids in a crucial school year?

More times than I can count.

There are times I've felt like I traded in my life for my husband's. He got a life upgrade and I got…a toaster. He got a promotion and a raise and *still* had dinner on the table and I got cat shit in the garden.

I felt like I'd been bamboozled into relinquishing control of my own life.

Here's an expat truth: The expat partner, that is the one without the paying job, is often the one who does the majority of the groundwork for any successful move abroad. That's me. I'm the non-earning—yet plenty working—expat partner in this scenario.

I am the plumber laying the pipes. I am the electrician lighting the way. I am the reconnaissance woman forging the path. I am, I am. I am.

I am what though? An accompanying expat? A trailing spouse? If our life were a movie, would my name be tacked on to the end as an uncredited role? No paycheck, no perks. No one is booking me a business class seat to a conference in Paris to talk about the best way to secure school spots and set up a bank account.

At times, it's hard not to feel like I traded in my potential for his, what I could be for what he is.

It was like I stopped being a person with all my own accessories and became an accessory, like a belt or a pair of plastic Barbie shoes.

This was not the way things were supposed to be.

I was supposed to be something and I was a belt.

Of course I resented it.

I couldn't make sense of my role in my upside-down life or how it meshed with before me, the one who used to earn her own money and buy what she wanted—or at least know she *could* buy it. When I went walking through the streets of old Nicosia, tripping down and over a different kind of cobblestone, the border between here and there, between north and south, was always in sight. You could press your

nose up against a chain link fence, peer through the barbed wire, and get a glimpse of what used to be.

I got it, I felt the same way by myself.

New York City me knew who she was. She was, as a good friend put it, "a thing".

"How do you answer people when they ask you what you are? Charlie *is* something," my friend Alice said on a weekend away. "He's a *thing*. What am I? I want to be a thing too."

We used to be *things*, Alice and I, and the others who were on the trip with us, all either current or former expats.

That conversation hit hard, like a punch to the solar plexus, because I know exactly what she means. Like Alice, like so many other expats I know who have stopped working or given up their work to follow a partner's career around the world, it is difficult to reconcile not having an identity of your own, one that is not tangled up in knots with your spouse's.

Why are you here?
Oh, my husband's work.
Why did you move?
Oh, my wife's job.
How long will you be here?
Depends on my partner's job.

It's not gender specific, I know men who've moved for their wives' jobs, and same-sex couples who've done the same. It's a "my identity has been subsumed into yours," kind of thing—and when Alice and I were talking about the desire to be a *thing*, that's not exactly what we had in mind.

As an expat partner, my identity became tied to my husband's, but not in an equal way, like two shoelaces that belong to the same pair of shoes. More like a piece of string

that trails behind in the dirt and gets caught in doors and under feet. My very presence in a country depends on my husband and his job. My right to have a bank account. My right to be listed on a lease. My right to work. My right to have a credit card—all of that depends on him and *his job*.

None of that meshes at all with the picture of the Big Apple woman I carry around in my pocket, the one who worked three jobs and put herself through college, the one who used to earn more than her spouse, the one who was slowly building herself a little freelance niche that had enough room for everyone. That picture, by the way, is increasingly worn and creased. The colors are fading and the edges are ragged. I've had to tape it together more than once.

■ ■ ■ ■ ■ ■ ■ ■ ■ ■

When expats talk about the 'package', we're usually talking about whether or not school fees are included or the local tax rate deferral. Do we get a rental allowance? Is there a car? A trip home once a year? But just as important to the package is what—and by default *who*—you're bringing along for the ride.

As a spouse, I'm part of the package, slightly above the line for a household goods allowance. Not exactly what I dreamed of as a girl growing up when I thought I might be the first female pitcher for the Boston Red Sox.

When my fifth-grade teacher told me I should be an accountant because I was good at math, I didn't say "No, Mrs. Mohan, what I *really* want to be when I grow up is a name in the box marked *dependent*." When people said to me at one time I'd make a great teacher, I didn't think "Nah, I'll use those skills to teach myself what it's like to try to set up the electricity in a country that still uses faxes in 2023."

A long time ago I wanted to be a truck driver. Then a

hairdresser. A Rockette, a film star, a journalist. A screenwriter. Yet the thing that tied all those grade school dreams together, the common gold thread that wove through them all was that they were about *me*. Not me as part of a package. Nothing in tow. Just me and my ten-year-old self, ribbon barrettes, friendship pins and all.

Admittedly it's a lot easier to make plans and dreams when you don't have a spouse and kids to consider. Those primary-colored dreams didn't include trying to untangle my sense of self from my identity as an expat spouse.

Things I've been: ice cream slinger, telemarketer, retail clerk, cashier, accounts payable trainee, nanny, director of children's programming, summer art teacher, permanent substitute teacher, receptionist, office manager, billing, bookkeeper, freelancer, volunteer, blogger, author. Seems Mrs. Mohan was right about my accounting skills. Thanks, Mrs. M.

The thing is, when you meet new people you don't give them a resume. They're not interested in the things of the past.

"It's your money," I kept saying.
"It's not my money, it's our money," Richard kept insisting.
I'm not working, I wanted to shout at him. I'm not a *thing*!

Back when I was pitching tennis balls in the middle of our road thinking I would break some glass ceilings, my generation of girls was told we could have it all. Sally Ride was riding into space and Sandra Day O'Connor was tipping the scales on the Supreme Court. Girls like me were raised to storm the ramparts, shatter those ceilings, and make room in the history books.

No wonder the notion of being a thing got stuck like a needle in a record groove playing the same beat over and over.

Before we moved abroad I used to be a thing, and then 7,000 miles later, I was not. I was just part of the package, along for the ride. And now as each Free-fall Tuesday came and went, we were more and more *stuck there* and I was further and further from being anything at all.

At first, the thing-less-ness was easier to stomach. Finding out that a mother of young kids doesn't have a business card with her *thing* embossed in a 15-point serif is not shocking. There were a few women I knew who worked, or went back to work while we lived in Cyprus, but for the most part, I found myself socializing with other women like me, expatriates with young children.

As my kids got a little older and started needing me a little less, things started to shift. At first, that free time was like liquid gold. But after a while, even that coveted alone time started to get harder to fill with anything meaningful. There are only so many trips to the mall you can make. Only so many sale racks you can peruse. Only so many cakes you can bake. And then one day I caught sight of myself in a mirror and wondered what the hell happened to the ten-year-old girl and her dreams, and maybe it was too late to become the first female pitcher for the Red Sox, but hey, maybe not too late to become an accountant?

No matter how much I tried, I couldn't untangle the "who" from the "where" and "why". I was *that and there* and now I was *this and here*. And the longer we stayed away, the more of a stranglehold my identity as an expat partner had on the idea of my former self.

In Brooklyn, I'd been keeping books, and while the extra income was welcome, it wasn't just about the money. It was having hours in the day that weren't tied up with my family. It

was starting and finishing something that had nothing to do with peeling carrots or looking after someone's well-being. It was having something that was mine. It was possibility. It was potential. And it was gone.

■ ■ ■ ■ ■ ■ ■ ■ ■ ■

When we had landed in Larnaca two years earlier, I was exhausted. It had been months of planning and packing, of explaining and goodbye-ing. No one was sleeping and everyone was crying. After six weeks apart, Richard was excited to see us all. I was nervous, I was cranky, I was pretty sure we'd made a terrible mistake. I still didn't know why I'd even agreed to all of this in the first place.

Can we have a do-over? I wanted to yell. Is there one of those time windows when you can change your mind? A refund? How about a return policy?

I was caught up in the honeycomb maze of my own mess. And in that hive of buzzing worries and thoughts, I wasn't thinking that my husband's life had changed just as much as mine had. He'd taken a leap of faith too. He started a new job, found a house, borrowed a car, and bought "my first expat starter kit" from Ikea.

When I spluttered out into the heat of the arrival hall, did I plant a wet, sloppy kiss on that man's lips, sealing our reconciliation? Dear Reader, I did not.

Did I wax poetic about the olive groves lining the highway home? Not so much. Did I gush and fawn about all the work he'd done by himself while getting settled in?

Also, no.

What I *did* do was tell him he bought the wrong kind of high chair. And then I saw the sheets he bought. And truly, they were awful, a saffron Hari Krishna panhandler on the

corner color, but…my husband did not deserve my comments about the sheets. Not then anyway.

Years later I did the same thing. He'd started a new job, found an apartment, and lived without complaint for a month with nothing more than the mug, plate, fork, and towel I'd packed him. The first thing I said about the apartment he'd found was to make a crack about the size of the bathroom.

Both times I hurt his feelings. And while I wouldn't say it was a conscious on-purpose thing, it definitely wasn't *not* conscious or *not* on-purpose. I was floundering and I think I wanted to see him flounder a bit too, or at least squirm.

I was scared and confused. Instead of feeling a sense of belonging, I felt like *I was the belonging.* I didn't know who I was or where I fit in or what I was supposed to do. And he was one step ahead of me because he did.

He was, after all, a thing.

Standing in that echoing box of a house tucked back from the orange trees, crying over sheets the color of summer squash, it was easy to forget that we were there because of a decision we made together. *I* was there because of a decision we made together.

At that moment it felt like it was his stupid job. And by extension, that meant him. I was there because of him. *I was not what I used to be because of him.* In those moments, when you're caught upside down in the waves and don't recognize the sky from the ground, you are rarely at your level-headed best.

Little tests a relationship like a 7,000-mile move across time zones and oceans.

I'd love to say I learned from all of that. I did not. Our most recent move featured more of the same. Once again, it

was his dumb job that was making me give up my glorious, sun-filled apartment. It was his miserable job that was going to make me leave my friends to start over. It was his damn job…

It's grossly unfair of course. It's his job that keeps a roof over our heads and allows us to live this unbelievably privileged life. It's his job that has allowed us all to grow into who we are now.

It's his job that has given us the world.

Intellectually, I know that the resentment I feel when we move is not fair.

Emotionally, that doesn't make it any less real.

■ ■ ■ ■ ■ ■ ■ ■ ■ ■

Once, in a small town in Cyprus somewhere along the coast, we stepped into the coolness of a church to escape the intensity of the sun. Stacked vertically in a dim corner was a trove of gold-flecked icons painted on wood. The kids were skipping in and out of empty pews, playing hide and seek. Dust motes were floating in the rays of sun that pierced the stained glass windows.

I am not religious. I don't pray. But there's something about a church. Maybe it's the stillness or the way everyone talks in hushed voices without being told. Maybe it's the echo of your breath or simply the weight of other people's history. Even if it doesn't mean anything to me, countless knees have bent in prayer, thousands of hands clasped together looking for guidance, a sign.

Some sort of evidence that their faith will pay off in the end.

I don't have a church, or a liturgy, or a string of beads worn smooth under my thumb. The closest I have to a sermon are my lectures about the importance of kindness. But I have my

family.

This whole expat thing is nothing if not a giant exercise in faith. You have to have faith that things will work out one way or another and hopefully, your marriage will survive the challenge. You have to have faith that you're doing the right thing for your kids if you have them and that the distance from parents and grandparents and extended family isn't too much to bridge with other means.

Sometimes you have to have faith in your partner's dreams, even if they aren't the same as yours. You have to believe that in time you will figure out the things that need figuring out because really, what's the alternative?

A never-ending spiral of despair and a vortex of bleakness. I've spent enough time in that vacuum of depression. It's dark and it smells. Sort of like my teenage son's bedroom, but with less technology.

Around the same time as those Free-fall Tuesday conversations, something started to shift. While it's true that I stopped regularly hitting stationary things with the car and that the baby was no longer a baby and sleeping through the night, it was more than that. Maybe it was the dawning recognition that we weren't getting out of there anytime soon, or maybe it was simply the passage of time, but like butter left out on the counter, I found myself softening to our island home.

There were still a lot of hard things—the distance from my family, the island mentality, and hair-pulling hysterics. The relentless heat. I still pined for New York and for the endless list of things I missed, including my boots. I still felt roundly and soundly American. From time to time I still resented the dumb job, but there was, at last, a break in the clouds of Mordor which had been hanging black and heavy over my head

since we had landed.

The first time I returned to Cyprus from the US, I cried into my sleeve. As the plane taxied in and I was greeted by that landscape of parch and beige, I turned away from the window and swallowed my sadness. The longing for home and family and familiarity, and feeling that I had just left all of that behind, was too much. It caught in my throat like a sob.

I didn't feel like I was going home, I felt like I was going back somewhere I didn't want to be.

By that second summer, however, the tears had dried up and the idea of returning *home* to Nicosia was, if not appealing, at least not chained to cinder blocks of existential dread. That year as the plane landed in Larnaca, I was focused more on what was ahead than on what I had left behind. There were friends to catch up with and trade summer tales with. School would be starting and the days would fill up with coffee dates, toddler playdates, and family dinners under the oleander tree. There would be mezze and laughter at the Syrian Arab Friendship Club. October was my favorite month to lounge on the beach, when the sea was still hanging on to a bit of summer heat but the air was getting cooler. We'd drive home, sand between our toes, and fall into a sun-kissed sleep.

If I stood back and took stock, I had to admit that we were no longer just surviving. We were starting to thrive. Even me.

We were making the whole circus work. We had made a home.

There is an awful lot of worth in making a home, in creating a place where people feel safe and loved. There is tremendous value in growing and tending to a family in places where no one expected to be.

I was only beginning to understand that the work involved in all of that was a job, and that job was mine…and I was good

81

at it.

I was the ringmaster.

"It's not my money, it's ours," Richard would say as I eyed up a pair of boots.

And I finally started to believe him.

There are still times when I wallow in a shallow pool of pity. There are times when my family tip-toes around me. There are times when I say mean things that I shouldn't, especially to the people I love the most. Those times, however, are usually the exception rather than the rule.

We have had to learn to rely on one another, perhaps more than is strictly emotionally healthy at times. That doesn't mean it's always easy or that we never argue and fight or roll our eyes at one another. It doesn't mean that I don't spend time mad at everyone and everything or that I don't lay awake worrying about the choices we've made, the ones which have kept us abroad not for two years as *someone* promised, but closer to two decades.

I'm not religious, but I do have a certain kind of faith. I have faith in our partnership, in the decisions we make together, and in the life that we've created; one that I've had a big part in making successful.

We are the package. Not just the school fees or the shipping allowance or the trip home. Not just me.

The package is all of us.

IT'S RAINING MEN

There's no bad weather, just bad clothing

One early summer night, Richard and I were watching *So You Think You Can Dance* on an illegal VPN when I looked over and saw that the front of his shins were glistening with sweat. Until then I didn't know that shins *could* sweat.

When the thermometer starts to creep up and the air gets heavier, it gets harder to pull a breath into your lungs. The collective mood slides and melts into a puddle of permanent crankiness. Already questionable drivers tip into crazy. Once a man got out of his car to bang on my hood in frustration. He pointed at the red light, the one that I was duly stopped at. I shrugged and also pointed at the red light. His eyes were wide, his hair wild. I made sure the window was up and my door locked.

As the temperature climbed, the streets filled with the cacophonous rage orchestra that is the Cypriot car horn. Even I started using my horn more often.

"It's like a rocket launcher," Richard used to say from the passenger seat. He was jealous. My Honda had an excellent, satisfying blast of a horn that you could activate with either, or

83

both, thumbs. It was like driving a Star Wars X-Wing through the canyon of Nicosia side streets. His car's horn was pathetic, and despite the enthusiasm with which he pounded it, never emitted more than weak Road Runner chirps. Whenever I was annoyed with him I would follow him around crying *meep, meep*.

Like I said, the heat does crazy things to you.

We bought a shallow kiddie pool and risked our rationed water supply filling it up. By the next morning, it had morphed into some sort of ecosystem, a primordial soup that was too hot to stand in. It was beyond saving. Even the army of stray cats that slunk around and shit in our shrubbery stayed hidden until the sun went down. As the temperature dipped slightly we could hear their wailing mews over the whir of the air conditioning.

And then there was the tragedy of Lightning McQueen, the goldfish who lived in a tank on our kitchen counter.

It had never occurred to me that a goldfish could essentially boil. *Kachow*, Lightning, you were a good fish. Long may you swim around your plastic castle in the sky.

We found ways around it. We moved the fish tank for a start. We stayed out of the sun as much as possible. We spent a lot of time at the beach. I went for walks at 6 a.m., power walking up a hill to get a view of the sunrise. We went directly to the pool from school, did not pass go, and submerged ourselves until it was cool enough to think about eating dinner.

And, as soon as I could, I got the hell out of Dodge.

As promised, every summer I'd pack myself and the kids up and head out. I'd fill a bag with snacks and small presents and make a large monetary offering to the airline deities. Two flights, a brief pit stop with my gracious in-laws, and twenty-four hours later we'd land in Boston. I'd hand off some

parenting duties to my mom and sister, troll the aisles of Target, and eat my weight in cheeseburgers that tasted like ground beef and not cinnamon.

Those summer trips were a way for the kids to spend time with my family and cultivate their rapidly vanishing American-ness. And it was a chance for me to let out the breath I was always holding while we were in Cyprus, the one that held all the stress of life in a place where you're not sure you belong. I knew how my mother's washing machine worked. I knew the aisles of the supermarket and where to find things. When I looked into the mirror hanging in my mother's bathroom, the same one where teenage me had crimped her hair and lined her eyes with thick black liner, I knew who was looking back at me.

Standing in the shoe section of TJ Maxx, it was easy to wonder if Dorothy was right. Maybe there really was no place like home.

Usually, after a few weeks, Richard would fly to meet us and then we'd rent a car and drive a few hours south to New York. That first summer, when we approached the city over the bridge, skyscrapers shimmering on the Hudson horizon, I clapped with giddy glee.

Home.

I slipped into the skin of my former self, trying it on for size. I was still counting the months until we got back to Brooklyn, back to what I still considered our real lives. We haunted our favorite restaurants, eating dumplings at May's and burgers at Relish. We slurped Italian ice and ran through the sprinklers to cool down in McCarren Park. We ate pizza and drank chilled red wine at Brick Oven Gallery.

I used those early vacation days to make sure my city self still fit.

That first year, being back felt like slipping into a pair of

comfy old pajamas, something I didn't even need to think about. I could stretch and move without feeling constricted. Things felt normal and natural and familiar. By the next summer, though, my Brooklyn persona was starting to sag a little bit around the middle. We were still running around trying to see as many people as we could, but our list had dwindled from the year before. And while I was thrilled to be home, soaking up the sites and sounds of my heart, I noticed that for my kids, there wasn't much about New York that felt like home.

My babies, heirs to the coolest city in the world, were tourists in the city they were born.

By 2011, our last summer in Cyprus, my outsized New York persona was starting to puddle around my ankles. Three years of life outside the sharp edges of New York had rounded me. I was still unmistakably American—loud, brash, colorful—but with the beginnings of a softer, European glaze.

It was the slower pace of island living, yes, but it was more than that. By then we had a group of friends and a rota of babysitters. We had started to take advantage of the travel opportunities. My kids hadn't been to Disney World, but they'd stood in front of the Great Pyramid of Giza. They weren't playing Little League, but they played cricket on the beach at Dikhalia. The sandboxes of Brooklyn playgrounds were no match for the endless sandy beaches of Northern Cyprus.

Whenever we could, we drove to the north of the island, passing through checkpoints and borders, and watched the waves lap the shore while the kids surfed down the dunes. The furthest reaches of the island had just gotten electricity a year or two before, a few lone poles strung with one looping wire. At night, under a charcoal sky, eating slabs of grilled halloumi and drinking bottles of Efes with friends, sticking around

didn't seem unthinkable.

Life was slipping into something like easy.

■ ■ ■ ■ ■ ■ ■ ■ ■ ■

In 2011, not long after our flight out of Cyprus hit cruising altitude, the island's only power station blew up spectacularly. Two years before, a Cypriot-flagged ship full of ammunition was on its way somewhere naughty when it was stopped by the Americans. They, in turn, put pressure on Cyprus to confiscate the goods.

"Hey, President Christofias! We've got all these explosives, can you look after them for us for a sec? Kthxbye!"

The politics of who, when, and where got muddled, and meanwhile, the ammunition continued to roast in the sun. It was, quite literally, a tinderbox. A series of small fires erupted, eventually reaching the storage sheds where the ammunition was. The massive explosion was felt for miles. Thirteen people, including the Commander of the Cypriot Navy, were killed. The main power station was destroyed, and the supply to half of the island was decimated. To conserve what energy they could cobble together, including a deal with the Turkish-controlled north, the government instituted rolling blackouts.

I remember talking to Richard over Skype that year from the cool luxury of my mother's central air. He sat in our Nicosia living room in the dark, the rattling air conditioner unit set to 23° rather than 17°, just enough cool air to take the razor edge off the heat. We spoke quickly because at any moment the power might cut out.

I was sure if I looked close enough, I would see his shins sweating from where I was, 7,000 miles away.

Something electric was crackling in the air that summer,

more than just heat building up until it finally exploded.

Change was coming.

■ ■ ■ ■ ■ ■ ■ ■ ■ ■

Earlier that year, on that same sofa where Richard sat talking to me with his sweaty shins, he and I had binge-watched *Forbrydelsen* (The Killing). The Scandi crime thriller introduced us to Sophie Lund and her famous sweater, to Lars Mikkelsen, and to the dreary, rain-soaked backdrop of Copenhagen in November. Each night we'd tuck the kids into bed and watch two episodes, following sub-titled twists and turns through the downpours, straining to make out shapes in the dimly lit scenery. Who was the killer? What kind of name is Troels? Does it always rain that much? When the final credits rolled on the damp cobblestoned streets of the Danish capital, I turned to my husband and said, "Well, that has cured any desire I have to go to Copenhagen!"

The universe has a wicked sense of humor. Less than two weeks after we found out who had killed Nanna Birk-Laarsen, my husband came home with the news that he'd been invited to an interview for a job, "north and west" as he put it–just like I'd advised him to look for on many a Free-fall Tuesday. The place?

Copenhagen.

"What do you think?" he asked.

"Is it going to give us a better chance of getting back to New York?" I asked.

He nodded.

"Then I think that you'd better get this dumb job," I said.

And just like that, the moving parts clicked into gear again.

As he had before the move to Nicosia, Richard went ahead to start writing our Copenhagen chapter while I stayed behind to close up any Cypriot plot holes. The kids and I were temporarily housed on the old military base, high on a hill overlooking the quiet city below. At night I would tuck the boys into bed, sit on the back step, and like we did all those years ago when we were getting to know one another, we talked on the phone. We'd talk about our days, the kids, and his job, but what I longed to hear about was the place we were about to call home.

What was Copenhagen like? Did he like it so far? Was it rainy? I'd read that it rained 300 days a year! What were people wearing? Did I need a Sophie Lund sweater? Did I need rain boots? Yes, of course I would need rain boots, should they be yellow, red? Surely a pop of color would brighten up those 300 gray days, right?

"Actually," he said, his voice crackling over the distance, "everyone here wears a lot of black and gray."

Weird, I thought. The next day I bought a rain jacket emblazoned with bright pink flowers.

■ ■ ■ ■ ■ ■ ■ ■ ■ ■

We landed at Kastrup airport on December 17, four days before the longest night of the year. The Scandi capital of cool was smack dab in the cold of winter. That night we splurged on an expensive taxi to take us to yet another place like home. Copenhagen had on her Christmas best, twinkling fairy lights and merry red and white Julehjerte strung between lampposts. In front of the city hall, a giant huge Christmas fir towered, outsized metallic baubles dangling from its boughs.

On the street, folks were bundled up like Eskimos because everybody knows that coffee and some mistletoe might sound

good in a song, but they don't do much to keep you warm. And from the back seat, wedged between two boys and a pile of bags, I watched the city flash by.

The cobblestoned streets of *The Killing* were dry.

But while it might not have been raining, it was *cold*.

Northern Europeans love to tell you that *there's no bad weather, just bad clothing.*

My son's new school gleefully exhorted this sentiment while they handed over a list of the 72 different items of winter clothing he would need. There were boots for the cold and boots for the wet, boots for the mud, and boots for the snow. There were rain pants, snow pants, under-layers, over-layers, extra layers.

The clothing wasn't bad, but it was expensive. After three years of beach living, having to gear ourselves up for winter cost an eye-watering sum. In addition to the boots, we all needed winter coats, scarves, hats, and long underwear. Then hats that fit under bike helmets. Mittens. Gloves to use on our bikes. Tights that fit under jeans and snow pants, for me and thee. At one point there were enough tights in our house to stage a Shakespearean production. I bought leg warmers and wore them un-ironically as I *Flash Danced* my way through the grocery aisles looking for the peanut butter.

There's a reason the Danes like twinkling lights and the soft glow of a taper candle. In the depths of the Danish winter the sun sets at 3:35 pm and, if you're lucky, it rises in June. The nights are long and the darkness winds around you like a woolen scarf. The city is surrounded by canals and the Øresund Sound, and the wind doesn't whistle in from the coast but comes walloping in, like the blast of a foghorn.

There are only so many days you can sit by the window like

the children in *The Cat in the Hat* lamenting the weather before you realize that annoying phrase is true. At some point, you have to pull your rain/snow/mud pants/boots on and get out there.

And so we be-hatted. We be-scarfed and rebooted. I have pictures of Richard channeling Ernest Shackleton as we prepared for a polar expedition to the zoo. There were bright bluebird days with gorgeous azure skies. We stood gawking at the edge of the frozen Øresund where slush fields stretched out toward Sweden nestled on the other side of the water. We walked along the canals, giraffe skin ice patterns crackling the water's surface. Along The Lakes, five former reservoirs that run along the east-west axis of the city, the deep freeze brought out skaters and dog-walkers, spinning and panting their way across the ice. My kids slipped and slid along frozen puddles in the park and built snow figures in the courtyard, chomping on the carrots I gave them for noses. At times it was breathtaking. At times it was gloomy. And always, it was cold.

There's a story about Denmark's favorite son, Hans Christian Andersen, and his fan-boy crush on Charles Dickens. Somehow Andersen finagled an invitation to stay with Dickens while he was visiting London on a promotional tour. Dickens figured he would stay for a night or two, they could share some port, a few literary quips, and then HC would be on his way. Five moody weeks later Andersen finally left, and Dickens's critique of his overlong house guest was biting.

In the guest room where Andersen stayed, Dickens wrote on a mirror: "Hans Andersen slept in this room for five weeks —which seemed to the family AGES!"

Danish winters, like their native son, almost always overstay their welcome.

I'd experienced colder winters in New York and snowier winters in Massachusetts, but those first few Danish winters were relentless. The season hunkered down and made itself at home, refusing to budge. If Andersen's five weeks were interminable, winter's five months and counting wore thin very quickly. We waited for signs of spring. Shoots sprouted and we switched to a slightly less bulky glove, only to have to switch back again. The cherry blossoms blossomed and we ventured out without hats. We'd set out on a sunny morning and come home batting hailstones from our bike seats like Major League sluggers. The light changed and the clocks moved forward and still the cold remained. At one point I felt about my winter coat the way I had felt about my maternity clothes by the end of my pregnancies, ready to burn it and never set eyes on it again. Easter came and went and the days lengthened and the nights shortened and winter kept snoring away in the guest room.

If, during those long winter months we waited for nice weather, we would have starved–literally and metaphorically.

I'm not a Goddess of the weather. I'm not Zeus, chief of lightning or Isis and her rays, or even a lowly muse responsible for an ode to the wind. I can't even influence my family to eat spinach, let alone influence the weather. There is nothing I can do about the wind or the rain or the endless gray sky or the length of a winter that overstays its welcome. The only thing I *can* do is prepare for it. I can control how I react to it all.

I can make sure I have the right clothing.

There's no bad weather, just bad clothing.

I don't know whether or not the sun is going to shine or it's going to be one of those days when the rain does not stay mainly on the plain in Spain. The weather goddesses are not surveying me to see if I would like a low-humidity day so my

hair looks nice.

If only it worked like that.

Of course, that annoying nursery rhyme of a phrase applied to so much more than the weather.

■ ■ ■ ■ ■ ■ ■ ■ ■ ■

Back in my real life, the one on ice in New York, the decision to earn money was mine. There were opportunities I could take advantage of, or not. There were clients I could take on, or not. And earning money meant, for better or worse, the semblance of independence. Financial, yes, but psychological as well.

Abroad, I was sometimes seen by others, and almost always by myself, as *just* a mother, *just* a housewife, *just* a trailing partner—and it rankled. Not only was the working Brooklyn mom gone, the poet was gone, and the independent young woman who could do whatever she wanted was gone. The girl with the glass-ceiling dreams was gone too. What would Mrs. Mohan have thought?

I was waiting for sunny days and blue skies. I was waiting for the conditions to be perfect. I was putting everything on hold until we got back to life, back to reality, where, I thought, I could just pick up where I had left off.

There's no bad weather, just bad clothing.

I was only just beginning to understand that waiting until the meteorological conditions were exactly right wasn't doing me any favors, especially when I was basing my forecast on a version of myself from the past.

The conditions of life are never going to be 100%, it doesn't matter if you're checking the clouds for the barbecue you're hosting or making a master plan for moving back home.

It's always cloudy with a chance of curveballs. There's never going to be a perfect time to move. Or get married. Or have a baby, or buy a house. There's never going to be the exact right time to take that dream vacation or have another baby or move back or switch jobs or fall in love or any number of the thousand things that make up the beautiful complexity of life.

Unless I picked up and left my family behind, there wasn't much I could do to control the fact that we were living in a way and place that I hadn't forecast or foreseen. No more than I could control the rain clouds that seemed to blow in daily from the sea.

What I *could* control was how I reacted to it all.

I didn't do that of course, at least not right away.

There's a Facebook group run by my friend Nora that brilliantly encapsulates the flora and fauna of expat life. The group itself is an offshoot of a podcast about life abroad, and is a hive of knowledge, buzzing with experiences and information and advice. If you need to know about schools in Shanghai? Head over to the *Two Fat Expats*. If you need to know if you should move when the kids are 2, 4, 6, 8 when do we repatriate? Make that your first port of call. With over 40,000 members there's almost always someone who has the answer you are seeking.

As long as you are asking answerable questions.

Every now and then someone asks a deeper expat-existential question. The type of question that has no right or wrong answer because the answer can only come from a place deep within each of us. We can share our experiences, our thoughts, our advice, but those deep questions? Those answers are bound in our hearts. We only find them when we flip through the pages of our own books.

That original decision we made to move to Cyprus from New York? Though it took me a long time to realize, it ended up being the right decision for us, but it would have been the wrong one for someone else. Just as the decision to move to Copenhagen might have been different if it had come six months earlier or six months later.

There is no move—abroad or home, forward or backward — that's going to be the magic, perfect solution. Even if there were, it isn't one-size-fits-all.

Sometimes you can control it.

Most of the time you just have to make sure you have the right boots.

A day or two after we landed in Denmark, I bundled up in a winter coat so new it still smelled like plastic packaging and went outside for a walk. It could have been the air, fresh and cold, or the feeling of coming unstuck from the unexpectedly gluey job situation in Nicosia, but real or imagined, I felt like I could breathe better. Walking down the city's narrow sidewalks, Copenhagen already felt like home. We'd touched down in a place that seemed familiar, a bit like when you wake and remember the edges of a dream. I turned left and walked along a street full of shops, each festooned with garlands of greenery. As the daylight faded, the white lights which were nestled in boughs of evergreen blinked on. I turned left again and passed shoppers walking along, heads down against the wind. I looped left one more time, and headed back to the apartment, smiling.

Maybe it was just a city thing.

Of course, that's the easy answer. The more complicated answer is that my life was changing, regardless of where we were living. The boys were getting older, soon they would both

be in school full time and my day-to-day life would change yet again, prompting even more questions about who I was and who I wanted to be and if ever the two would meet. I was another step removed from reclaiming the life I'd left on hold in NYC, more degrees of latitude and separation. With the move to Denmark, it was harder to say that that first decision, the one that brought us to Cyprus, was a one-off adventure with an expiration date.

Every day we stayed away was a day further away from the idea of going back to what in my heart was still *home*. Back to New York, back to the life we had known, back to the idea of myself I was still holding on to, even though it felt like those things were slipping through my fingers.

What kind of clothing do you buy for an identity crisis anyway? Would a chunky Lund sweater have helped me figure it all out any quicker? And how would that pair with a pair of too-tight leather pants and some well-worn motorcycle boots?

BICYCLE RACE
You can ding my bell

If my first impression of Cyprus was muted tones of olive and sand, Copenhagen was an artist's palette.

Our new home had a skyscape of domes like bishop's hats, oxidized blue from the maritime air. The tapered spire of the old stock exchange was adorned with three twisted dragon tails while the Church of Our Saviour's outdoor staircase wrapped around its steeple like gilded ivy. Along the iconic canal at Nyhavn, once a bustling port where drunken sailors walked the pier, houses stand like crayons: bright yellow, burnt orange, periwinkle blue. If you walk north toward the ochre buildings of Kastelet, you'll pass Amalienborg Palace, Queen Margarethe's city residence. Rumor has it that from time to time the monarch steps out onto the balcony to enjoy a cheeky cigarette.

Royal guards in navy fur hats and bright blue trousers stand in red, wooden boxes. As the bell tolls at 11:30, they march from Rosenborg Palace to Amalienborg for the changing of the guard. When the Queen is in town, the King's Guard marches with them down the pedestrian shopping street of

Strøget, their brass instruments catching the sun, like an army of nutcrackers come to life.

Wonderful, wonderful Copenhagen, that friendly old girl of a town. The Danny Kaye song is true.

Copenhagen is a fairy tale perched on the side of the sea.

Since it emerged as a maritime power in the 8th century, the Kingdom of Denmark has stood relatively, and somewhat remarkably, unscathed. Over the centuries the island nation of Noma and Vikings has grown and shrunk, usually returning to the general map size and shape it retains today. In 965, Harald Bluetooth, son of Gorm and Thyra, unified and Christianized the country. Denmark briefly controlled England after attacking the country in retaliation for the St. Brice Massacre of 1002, when King Æthelred the Unready overreacted and went on a Dane-slaughter spree. There was the usual string of spats, land grabs, peasant revolts, and uprisings which are the bread and butter of Continental history. From the 14th to the 16th century, Denmark was part of the Kalmar Union, happily sharing their Lego blocks with the neighboring Nordics until 1523 when Gustav of Sweden said, "nej tak". A few centuries of frenemy relations with the country across the bridge followed.

Just north of the city, along the coast road is Charlottenlund Fort, where you can picnic in the shadow of the cannons that protected the Danes from marauding Swedes during a stretch of Northern Wars. After one of those, Norway was ceded to Sweden as booty. There were battles with Prussia and Austria, and a back and forth of Schleswig and Holstein. In the early 19th century, the British attacked the city and then six years later they came back and did it again. The country bucked the revolution trend that swept through

Europe and became a constitutional monarchy. Iceland took itself back. And during WWII Europe's worst neighbor, Germany, rolled in and occupied the country.

European land history is nuts, y'all.

A little over six million people call themselves Danes. A million of those live in København, half of whom are leggy and blonde and can effortlessly ride a bike in heels while drinking a Carlsberg and texting. Much (and better) has been written about Copenhagen's biking culture and infrastructure, but let's go with this: there are a lot of bikes. Almost 90% of those who live in the capital own a bike. On any given day in any given bike lane, kamikaze toddlers are wobbling alongside their parents and lithe Danish teens with top-knotted hair are pedaling gracefully along. Families use cargo bikes to cart kids, groceries, two-by-fours, golf clubs, Christmas trees, gas grills, and grandmothers with dodgy knees. Watch the Danes cycle and you'll see they even have a graceful move where they step off a still-moving bike as it slows to a stop, like walking away from a slow dance as the last musical notes fade into the air.

Bike magic.

Like many small-town Gen X kids, I grew up on a ten-speed. I cycled through the woods, wheeling over the mint leaves and the mushrooms, ditching my wheels to make out with Johnny D. in an abandoned fort. I spun around the neighborhood, sneaking cigarettes and traveling to friends' houses. I biked to the ice cream restaurant down the road, buying overstuffed cones of butter pecan. I'd pedal off in the early summer sun and come home with the fireflies and porch lights.

None of that prepared me for cycling in a Danish bike lane.

Much to my disappointment, there were no leopard print bikes to be found in all the land. Still, I was pretty happy with the sturdy pink upright shopper I eventually chose. At least until I started riding it. I huffed, my giant pre-schooler balanced precariously on a seat bolted to the back and a bag of overpriced groceries in a basket in the front. My hair whipped behind *and* in front, sticking to my lips, which were plied with Vaseline to ease the chapping from the wicked wind. As I plodded along, old Danish women sped past like a fleet of Scandinavian witches. They would ring their bells and shout words I did not understand, as if casting spells.

Double, double bike and bubble…the American looks like she might be in trouble.

In the autobahn of the Danish bike lane, cycling is not for enjoyment. "There's no fun in the cycle lane!" I screamed at my children as they messed about, zig-zagging and trying to race one another. Cycling in the network of bike lanes is about getting from point A to point B, preferably in one piece and without being on the receiving end of a torrent of Danish admonishment. Cycling is serious business.

It's bike hard or be killed.

Things I've experienced in the bike lane: Being lectured for idling in the turning lane when I was not turning, spat at for briefly cycling on the wrong side of the street, nearly run over in a crosswalk because I did not get off and walk my bike, tutted at, snarled at, huffed at, sighed at, and **Pas På-ed!!** (Watch Out!) more times than I can count.

Still, though my early cycling transgressions were plentiful, I was never guilty of the most heinous of all Danish bike crimes, that capital offense of biking: failing to signal in the bike lane.

Back in the mid 20Teens, when internet listicles were all the rage, someone shared one with me called *How to Piss off a Dane*. The humor in those salty little pieces works because it takes an existing truth and cranks it up into caricature.

Number three on the list of how to piss off a Dane? Failing to signal in the bike lane.

"Fail to signal and you will trigger a chain reaction of last-minute breaking and a string of surprisingly violent hisses from passing bikers. They work 37-hour weeks for free healthcare and childcare. Minimum wage is over $20 and the government pays for their college education. Your failure to signal is probably the worst thing that's happened to them in years."

It's funny. Because it's true.

Covens of bell-ringing bike witches aside, it didn't take us long to become cycling converts. Once again I was more than happy to ditch my car. Once again I had to ditch my footwear to accommodate a different climate and mode of transportation. But I was back, baby! Back in the city saddle *and* the bike saddle. I was a few thousand miles and one public transit system closer to the woman I'd left behind, the one I packed away a few years before.

As long as I didn't forget to put my hand up like Diana Ross on a Raleigh, I was confident that if I could stay upright, I might just be able to pedal my way back to her.

■ ■ ■ ■ ■ ■ ■ ■ ■ ■ ■

In Faelledparken, one of the many green parks throughout the city, there is a playground where you can take your kids and their two-wheelers to learn about bike safety. Without worrying

about cars or grown men in lycra onesies who treat the bike lanes like their own Tour de France, kids can practice stopping and turning and following road symbols. It's a clever idea, really: Teach your youngest riders the rules of safety from an early age and they'll become responsible bikers.

And responsible citizens.

When you're taught to put your arm out to let Mads know you're turning left, you're not just preventing him from ripping his Samsøe & Samsøe trousers. You're taking accountability for your actions and acknowledging that you play a part in the fabric of the whole.

Hey lady speeding up behind me on your bike! I'm gonna make sure I hold my hand up to tell you that I'm going to stop over here to get some play money out of the ATM so you don't barrel into the back of me and take us both out.

Mette's going left, I'm going right, Henrik is coming to a complete stop. When we take the time to signal our intentions to other people, it shows them that we are considering their well-being as much as our own. It says *Hey, tall Danish man with the ironic mustache and the white tee-shirt from COS, I see you. I'm looking out for you because you and me, man? We're part of the whole.*

In the end, we are all but mere cogs in the great Danish bike lane of life.

■ ■ ■ ■ ■ ■ ■ ■ ■ ■

By the time we were starting to settle into our new lives in Copenhagen, Denmark was already blossoming on the world's radar. It was hip. It was happening. There was a thriving foodie scene and Nordic cuisine was having a very expensive moment in a carefully curated sun. People were waiting a year for a table at Noma to eat ants and forage for their own appetizers. The New York Times was op-ed-ing about what made such a small

country work so well. Hipsters were growing handlebar mustaches and artisanal beards. And until Finland started regularly whooping their asses in the happiness sweepstakes, the little Nordic-that-could was consistently voted the happiest place on earth. Put that in your black licorice pipe and smoke it, Walt Disney.

So what makes Denmark work? Is it magic and pocketfuls of HC Andersen fairy tale dust? Maybe a bit. But I always argue that much of what makes Denmark work is its people's collective understanding of what it means to be part of the whole, part of the great Danish bike lane we call life.

Every culture has a special sauce that simmers in the national psyche. It is what salts the zeitgeist. As an American, I grew up marinating in a barbecue sauce flavored with Budweiser, exceptionalism, pumpkin-spiced rebellion, and the smoky scent of July 4th backyard fireworks. My husband the Brit swam around in a stew of Earl Gray, pomp, clotted cream, colonialism, and tikka masala.

The Danish special sauce is heavy on the remoulade and the social principle of Janteloven, a set of guidelines which loosely translates into '*sit down, Lars, you're no better than anyone else*'.

Growing up, my Americanness encouraged me to stand up and be heard, to tap dance across the world's stage as loudly as I could. Meanwhile, the Danes were busy making sure everyone was safely tucked in the middle because no one deserves more than anyone else. Even poor Queen Margarethe can't smoke her daily cigarette in peace. While the Danish royals technically own the palace, in the national psyche, it belongs to everyone—and your average Ida doesn't want the smell of smoke lingering in the drapes.

I came from a place where the national pastime was moving up and down the class and social ladder, stepping on people accordingly. Now I was living in a country that based its social principles on the idea that we all start and end on the same rung, somewhere in the middle.

It is a powerful ethos to buoy up a culture and country, right?*

I was hooked.

The trick was going to be figuring out how to reconcile my cultural DNA with my new surroundings. From my Made in the USA cradle straight on through the years, I was rocked to sleep by a lullaby sung to the tune of *America, the Beautiful*. If I worked hard I would succeed and conversely, if I didn't succeed it was simply because I wasn't working hard enough. Obstacles were there to overcome. Bootstraps were used to yank yourself up. Ceilings were meant to shatter in the rocket's red glare. Add in a healthy dose of New York brashness, some Broadway jazz hands, and a pair of too-small leather pants that had traveled the world, and you ended up with something in the vague shape of me.

Living in Denmark was a bit like living in the Upside Down from *Stranger Things*…if the Upside Down was the nicer bit. It wasn't just the bike lane, either. It was the whole mythology that shored up the foundation of the Danish psyche.

I recognized parts of the rugged individualism that peppers the American Dream in the stories of the Vikings, but the history of Sigrid and Ragnar is old and musty. The Danish stories that seasoned the more recent past were stories of 'we' rather than 'me'.

The story of King Christian X wearing a yellow star in solidarity with the nation's Jewish population during the

Second World War and the accounts of farmers ferrying Danish Jews to Sweden and safety. There is the story of rank-and-file Copenhageners rescuing the national treasures from a fire at Christiansborg Palace. The stories are just that; they're not necessarily true (the King Christian X one is definitely false), and if there is a truth to them, it's certainly embellished. But stories and myths are a powerful tool. They are how we connect, how we make sense of the world, each other, and ourselves.

Why does Denmark work? I don't know if it's Janteloven or the cold weather or Viking ancestry. Maybe it's Lego or a well-regulated market economy with a strong welfare net.

I like to think it's growing up with stories that say *we look out for one another, we take care of one another.*

In other words, maybe it really is as simple as signaling in the bike lane.

Back in Cyprus, I didn't have a bike lane to practice good citizenship, but for the first year or two I was there, I was part of a Mom and Toddler group. I was nearing the end of my toddler era, but there were plenty who were just starting out, or continuing. One American woman in the group was heavily pregnant with her sixth child. It was perpetual toddlerdom in their home.

When she came home from the hospital with Baby Six, the group pulled together a two-week meal train in a matter of minutes. I was astonished. When another friend's son was hospitalized, those same Mamas came to the rescue again and organized a rota of friends to drop meals by their door. I used to sometimes bemoan the idea of Nicosia as an overgrown village. But you know what? Sometimes it takes a village.

Those meals were one less thing for busy or stressed

families to worry about, but they were also a reminder that life works better when we're all in it together. It was the meal train equivalent of throwing your arm out to make a right turn.

Maybe those things were happening around me when I had my babies back in NYC, but they weren't happening *to me*. I had my kids in a country that doesn't even have a mandatory paid maternity policy. Women were not only going back to work straight from their C-sections, some high-powered women were subtly encouraged to take a perverse sense of pride in it.

Maternity leave? Pfft. I don't need your stinking maternity leave. I'll just pump some breast milk and take out my own stitches while I run this report with the year-end figures.

It took moving outside of my own country to witness how people could come together. It took living in a few different places to understand that accepting help wasn't a sign of weakness or a dent in my individualism, but a gift.

I see you, Mama of six, and holy cannoli, here's a lasagna so you don't need to worry about dinner tonight. Hell, here's a salad too.

When we moved out of the US, I got caught up in a show of my own making, starring myself. I got sidetracked, lost track, and went off the track. I kept focusing inward, fighting —mostly with myself—to forge some sort of identity, to hang on to some piece of myself because honestly, that's all I knew how to do. I only knew the 'me' that had been encouraged to loudly tap dance in motorcycle boots because she, at least, was her own person.

I didn't want to be Richard's wife, Dina, who didn't like Cyprus, or even *just* Mom. I didn't want to be the unpaid ringmaster of a traveling circus whose name was in the box

marked dependent.

I just wanted to be some recognizable version of *me*.

■ ■ ■ ■ ■ ■ ■ ■ ■ ■

In between the daily grocery shop and racing old ladies in the bike lane, there were still hours to fill. By then, both children were in school and the days stretched before me. I didn't even know how to begin to fill them. So I did what every woman in the mid-2010s did when she found herself with time on her hands.

I took up knitting.

"What is this?" Richard asked, picking up a banana that had a small knit square tied around its yellow peel.

"That is a banana cape," I said proudly.

Everyone got a scarf for Christmas that year.

The knitting didn't last long. Nor did the homemade stationery, the jewelry making, or the photography project. Years later we would be packing to move and I would unearth archaeological evidence of my failed hobbies, including a box of felt balls that I have no recollection of buying nor what use I had planned for them.

Instead, I seemed to spend most of my time thinking and talking and talking and thinking.

What more do you want, you crazy American?

I wanted to be all the things that I couldn't be, but most of all, I wanted to be the ten-year-old girl who didn't yet realize she'd been bamboozled by the world into thinking she could be all the things at once.

Perhaps it took a year in the Danish bike lanes to get me to start looking outward a little bit more. After all, you have to pay attention to those bike witches or they'll come for you.

Maybe taking the time and care to signal my intentions to others helped me start to understand those intentions a little more myself. For the first time, a picture of who I could be started to emerge. Not the motorcycle boot wearing me, but something else.

And when I least expected it, a part of me that had been dormant for a long time poked her head above the parapet and started to look around.

"Mother's hands are rarely idle. Hands that spend hours cleaning, sorting, folding, tidying, shopping, making appointments, making play dates, wiping spills, cooking, organizing, driving to and fro, and baking strange-shaped cakes are rarely idle. Hands that soothe a scrape, wipe away a tear, tease out a tangle, turn the pages of a favorite bedtime book simply don't have time to be idle. Hands that cradle newborns and pinch cheeks and ruffle hair and catch vomit and wipe dirty faces and dirty bums....well. Well, indeed.

"But there is a space in there, somewhere between the mundane of the everyday, and the blinkered intensity of the creative moment, where even busy hands start to fidget. Start to tap a tattoo on the tabletop, start to drum a little rebellion, start to crave a little bit more than a fantastic meal, a tidy house, a vaccinated kid. A space where busy hands actually become idle hands.

And thus another blog is born."

Slowly or maybe suddenly, I started writing again. It was a part of me that pre-dated our moves, but it also pre-dated my children, my husband, and even to some extent, my New York bildungsroman.

I was writing about my trying to fill my free time, about writing, about the difficulty of putting yourself out in the world, especially a world that wasn't yours. I was writing about parenting, about marriage and relationships, and how all of those things were affected by living in someone else's country. I wrote about motherhood and womanhood and the messy intersections where all of those things collide, which is exactly where I found myself, picking the glass out of my hair.

I was writing to find my own value and worth.

"I have spent the better part of the last decade trying to perfect the art of housewifery. Because that's what women of my generation do. We try to be the perfect..(fill in the blank). Often we have to sell a slice of our soul to do so, not realizing how big that slice actually is until much farther down the road. And so I can bake a cake in the shape of a Lego brick, stitch a Halloween costume, and make a tasty vegetarian meal. I can do 2 loads of laundry, get dinner started, feed the kids, make lunches, and vacuum the floors by 9 a.m. on a Saturday. I have unspoiled food in the fridge, clean clothes in the dresser, and kids at various activities throughout the week that I actually remember to pick up.

"And yet, my hands are idle. Not from lack of work. Not from lack of 'things to do'. There are always things to do. But those things seem to always be for someone else. A moment of selfishness? It sure sounds like it, doesn't it? But for a long time, that spark of something, that urge to create, has been hyper-focused on someone else. And so, I have decided to be just a little selfish for a bit. To make use of these idle hands to create something, not for anyone else, but maybe

just for me."
(*Idle Hands*, September 2012)

I hit publish and then hid behind my idle hands. For better or for worse, I'd put myself back out into the world.

■ ■ ■ ■ ■ ■ ■ ■ ■ ■

Eventually, I passed my first granny in the bike lane. *Pas På that, MorMor.* I didn't recite cycling spells, but sometimes when I was zipping along in a pedaling rhythm I hummed the theme tune to the Wicked Witch of the West. I always signaled, even if I risked losing all the eggs in my basket.

I was still trying to figure out how to fit my very loud, very American self into a society that prides itself on squishing everyone into the middle. Amongst the Gattaca-like backdrop of Copenhagen streets, where everyone wore the same Ilse Jacobsen rain gear, I stood out like a sore thumb in my pink flowery rain jacket. But the Danish way of looking out for one another made a poetic sense to me. Maybe not worrying so much about someone crashing into the back of my bike freed up the brain space to do something I had always loved, something I thought I'd lost.

We are all safer if we see each other. If we look out for one another.

What if I started to look out for myself as well?

*It's easy to hold Denmark up as an example of equality, and while the country certainly scores higher in some metrics of equity and diversity, that doesn't mean it is free of racism, sexism, or xenophobia. Despite the social concept that everyone is equal, in practice, discrimination, anti-immigrant sentiment, and extremism are just as prevalent in the Nordics as they are anywhere else.

SOMEBODY'S WATCHING ME

Yes, you're doing it wrong

As soon as I saw the sign indicating the S Tog carriage was a designated Quiet Zone, I stood up and gestured for my chattering kids to grab their backpacks and follow me. Then, just for good measure, I hushed them. Gently enough not to get told off—it had happened—but loud enough to make sure it was clear I knew I had transgressed. Forgive me, S Tog lady, for I have sinned.

It still wasn't quick enough to stop the old crank pot from loudly shushing us. My cheeks flushed as I bumbled my way out of the carriage. A grizzly old man lifted the *sleep mask* from his eyes to glare at us before he pointed at the sign denoting the carriage a quiet zone. I'm MOVING, I mimed to him. The glass doors quietly closed behind us.

We were in that carriage for fifteen seconds, tops. Our butts hardly had time to sink into the seats. The quiet zone, for what it's worth, is meant to be a space free of loud conversation. It's not a place to catch an hour of uninterrupted beauty sleep on your way to Helsingør.

Let those who have never sat in the quiet carriage by

accident hiss the first shush, I wanted to scream.

From Tivoli Gardens, where the red metal skeleton of the Demon roller coaster rises like a sea serpent, to the Little Mermaid sitting guard on her harbor rocks to the bronze statue of Christian V astride his horse in the square at Kongens Nytorv, Copenhagen is full of stunning places to see. For some Danes however, the sights are not nearly as interesting as the foreigners doing their country the wrong way.

At times, living in someone else's country was a lot like living across the street from a nosy neighbor. No matter what I did, I couldn't shake the feeling that a pair of local eyes were watching, just waiting for me to screw up.

Which of course I did, over and over and over.

There were a hundred times I did something wrong in the bike lane, including passing a male while female. There were times I didn't move my groceries fast enough for the shopper behind me who was parked firmly up my backside. There was even a time long ago when I didn't know I was supposed to put the little divider down on the conveyor belt so the checkout clerk knew whose rugbrød belonged to whom. Not mine, Netto clerk, that stuff's like eating a doorstop.

There was a time I didn't move fast enough when someone rang their bike bell at me while I was *on the sidewalk*. How was I to know why you weren't using the perfectly good bike lane right next to you, grumpy young Dane? That one led to a bit of an altercation on the normally quiet streets of Hellerup. I may have shouted.

There was the time my kid had the tip of a sneaker too close to a seat on the train. Or the many times they were too loud. There was a time when someone sneezed on the bus, prompting several craned necks and dirty looks. In my meaner

moments, I fantasized about telling people that if their country produced people that could do the dumb job my husband was hired to do, then we wouldn't be here and I'd be snacking on bagels and complaining about the L train, so suck on that, Emil. There was the time our downstairs neighbor came stomping upstairs to tell us she was having dinner and would we *please keep it down.*

"I am having people to dinner," she said, "and you are very loud."

RIP downstairs neighbor with resting Dane face. I hope you know we made an effort not to rollerblade or play basketball in the apartment that night so you could enjoy your dinner party.

And of course, there were the countless times we just weren't *Danish.*

There are people in every country in the world who welcome immigrants, who welcome guests, tourists, and others. Folks who enjoy meeting other people and learning about them, who get a kick out of those quirks and foibles that set us apart from one another. And in every country in the world, there are those who…don't do that. They get mad if you don't speak the language, even if you've been there for a week. They're grumpy if you don't do it the way they do. My friend Mischa was yelled at for buying too many groceries at one time, even though Mischa has five children and one day's worth of groceries is a week's shopping for someone else. Joanie's husband was told he wasn't allowed to mow his lawn on a Sunday. Someone else's kids were told off for playing too loudly in their own backyard. Actually, I'm fairly sure that was Joanie as well.

Sneezing in the quiet compartment of the S Tog to

Ballerup is hardly a high crime or even a misdemeanor. Yet sometimes I would walk home from these encounters, my head low, feeling like I committed a cultural crime.

I'd go over and over it again in the shower, slapping the wall in soapy frustration when I thought of a witty, biting comeback that I would never have been able to deliver because I don't speak the language.

■ ■ ■ ■ ■ ■ ■ ■ ■ ■

After the Great Cyprus Coffee Refusal, I eventually did visit my pinch-faced neighbor for a coffee, sitting in her kitchen while her housekeeper feather-dusted around us. It was just as awkward as it sounds.

"Would you like to come for a coffee?"

"Why yes, Antigoni, that sounds lovely, efharisto. What can I bring other than my anxieties and insecurities?"

I think it was clear to both of us that we were never going to be best friends and I'm sure I tossed and turned in an over-caffeinated effort to get to sleep that night, but I tried. I made the effort to do what the locals expected me to do, which in that case, was to be hyper-caffeinated at all times.

Though I never got used to doing it, I parked my Honda with two wheels on the sidewalk because that's what everyone else did. I didn't hose down my dusty driveway because there was a water shortage—even though the neighbors did. Or rather, the maid did. And though it went against my better judgment, I didn't pay our cleaner Marie more than the going rate.

"That's hardly a living wage," I said to Richard when he told me what Marie's hourly rate was. "I'm not going to pay her that."

"You have to," he said.

"Why?" I whined. "She's working for us, I can pay her whatever I want."

Then he told me the story about Ahmed.

Back in the early part of the century, my husband spent some time in Afghanistan. He lived in a compound of houses and each house was looked after by a helper. Their helper was named Ahmed. Ahmed, like most of the helpers who cooked, cleaned, and fetched for the foreign white people, was paid the local rate. A paltry sum. One night, after many fetched beers, the group realized just how much they relied on Ahmed. They took a vote and decided to double Ahmed's salary. Ahmed was, unsurprisingly, overjoyed and fell over himself thanking the foreign white people for finally paying him a quarter of what he was worth.

Ahmed was also conspicuously missing the next day.

Someone called for him, but Ahmed was nowhere to be found. Instead, Faheed was there, ready to cook, clean, and fetch.

"What happened to Ahmed?" I asked.

"We were paying him so much more than the going rate that he hired Faheed at his old salary and Ahmed was sitting on his ass in the garden reading a magazine."

I laughed. "Well, fair play to Ahmed!"

"I know. But there were rumblings up and down the street. House helpers were demanding that their salaries double too. We were on the cusp of setting off a local revolt amongst the house help. So we had to fire Ahmed, who in turn fired Faheed, and then we rehired Ahmed back at his original salary."

"So you're saying I could be responsible for causing a tear in the local economic continuum?"

He nodded.

"That I could be fermenting a labor movement among the maids of Cyprus if I pay Marie a few euros extra?" I had seen the neighbor's maid out there washing the car at 6 a.m. every day. The idea appealed to me, on many levels.

"I'm saying don't mess with the local economy."

So I didn't pay Marie what she deserved…on the record. I just made up for it in other ways. The point is, I tried to play nice. I tried my best to follow the local rules.

But no matter how hard I try, I can't be from somewhere I'm not.

When I moved abroad and staked my half-flag in someone else's country, I was worried about culture shock and doing the wrong thing, but I didn't give much thought to how the local population would view me. Naive? Moi?

Oui.

There are nuanced discussions about the intersection of immigrants, migrants, and expats that deserve to be had, but at the time, I didn't see myself in any of those terms. Our plans to live elsewhere weren't permanent. Sure, by the time we were pedaling around Copenhagen, we'd doubled our initial estimate of two to three years, but someday we were definitely going home.

It's just that *home* was becoming an increasingly difficult word to define. I didn't know how to define what we were. It was almost as if we were on a very long vacation from real life, but one of those vacations where you still have to do the housework and admin and pay the bills.

Is there a word for that?

Is it *expat*?

In Cyprus, I once came out of a store to find that someone had pulled my windshield wipers up so that they were pointing at the sky like extended middle fingers. I didn't understand until a friend explained that it's what the locals do when they're frustrated with the way you've parked. It is the horse head in the bed of Cypriot parking—a warning. Clearly, I'd committed enough of a parking faux pas for someone to leave me an automotive anti-love note. Perhaps I only had one and a half wheels on the sidewalk instead of two.

In Denmark, I spent years trying to figure out who had the right of way in the game of Copenhagen sidewalk chicken.

"Is there a rule?" I asked my friend Dorthea in frustration. Dorthea was my resident font of all Danish things.

"What do you mean?" she asked me.

"When I am walking down the sidewalk and someone else is walking down the sidewalk from the opposite direction, is one person supposed to move? Does the person furthest from the curb move in?"

I'd been slammed into on the sidewalk more times than I could count. It was infuriating. And painful. If I didn't move and the person clipped me, they glared at me, as if that too was my fault. It had been bugging me for years.

"Nope. No rule." Dorthea said with Danish authority.

"Ugh," I said. It's good to have a rule so you're prepared.

There was the time a neighbor in our apartment block told us that the piece of *rare* steak we were grilling on our balcony was interfering with his enjoyment of his balcony. In the time it took for him to come down the stairs and cross the courtyard, the steak was done.

Whose enjoyment trumps whose, I wondered? Is this something that Danes just *know*? Is there a book we can buy on

Amazon that spells it all out?

There was the time a woman threatened to call the police because something accidentally fell from my balcony and nearly hit her. I didn't point out that she was only in danger of being hit because she was riding her bike on the sidewalk, itself a no-no. Had I done that, no doubt it would have triggered a different avalanche of Danish telling off.

As she spluttered and yelled at me, I looked next door, where my blonde, Danish neighbor stood on her balcony, watching the entire thing unfold. She could see I was struggling with what to do, yet said nothing. Thanks a lot, Blondie. What's that? You need me to look out for that package for you when you're away? Sure thing.

There was the time our good friends across the courtyard got a letter pushed through their mailbox. They had to run the whole thing through Google translate just to find out that the downstairs Dane didn't agree with their parenting because they let their daughter shout hello to passersby from the balcony.

Wonderful, wonderful Copenhagen, where there is no shortage of people willing to tell you that you're doing it wrong.

This crazy life we lead has given me many things, including many a sore shoulder from sidewalk chicken and an intense dislike of my blonde former neighbor. Another is a new level of appreciation for those who pick up and move for a better life, who work hard and learn the language and try to assimilate. Who, no matter what they do, are never going to be accepted in the place they are living by some because they are never going to tick all the boxes.

Technically we had picked up and moved for a better life,

but we were definitely going back.

Probably.

Before I called someone else's country home, I'd never had to imagine being an outsider. I grew up white in a mostly white state in a mostly white country. I was the default setting. And when you're the factory setting and most of the people in the spaces you occupy look like you, you usually don't spend a lot of time noticing those who don't. Suddenly though, I was boxed out of things. I was cut off from the language, from the nuances of the culture, the little unspoken rules that tell you who is supposed to move on the sidewalk, sure, but also the fonts of tacit understanding. I didn't have a say because most of the time, my voice wasn't wanted, needed, or understood.

It took me a while to realize that sometimes being an outsider can be a gift.

■ ■ ■ ■ ■ ■ ■ ■ ■ ■ ■

Here's a story that predates our move, but with a moral I only recognized after I'd lived in places where I didn't talk or act like everyone else.

When we were living in Brooklyn, I got sucked into the vortex of school anxiety. My kid was three. He was gluing lentils down and singing about aardvarks. But I bought into the whole schtick and made appointments to tour the local schools trying to find the best fit for my three-year-old because that's what everyone else around me was doing and we were all whipping up each other's anxieties.

Will there be yoga? Do you have Mandarin immersion classes? Are there vegan lunch options?

Ah, Brooklyn parents. Never change.

There was a public school two blocks away from our

apartment, which was in a diverse neighborhood, heavily Hispanic. It was somewhat institutional-looking, but it had small classes. They'd had a grant from the New York Public Library to build a brand new library. And if my son attended there was a good chance he would have been the only white student in his class.

And in a series of racist, mental gymnastics I am mortified by, I crossed it off my list. I crossed off a school that was two blocks away—in the neighborhood *we lived in*—because I was worried he would be an "outsider".

If I could go back in time, I would sign him up for that school because now I understand how much better off he would have been for knowing what life is like when you're not the default. He would have had a depth and a breadth of understanding that swimming in a sea of sameness is never going to give you.

I had to be an outsider myself to see that. I had to move abroad. I had to be somewhere where I felt the discomfort of constantly wondering if people thought I was doing it wrong because I wasn't like them.

I didn't have that clarity in Brooklyn.

■ ■ ■ ■ ■ ■ ■ ■ ■ ■

I still screw up. I still piss people off, sometimes just by being in their homeland. They don't know who I am or what I'm like, but I'm not one of them. I'm an *other*.

Living in someone else's country is messy. It's an intricate bit of choreography no one has taught me the steps to and while the locals are waltzing through the supermarket, I look like I'm doing the chicken dance.

If I feel like there are often eyes on me, it's because many times there are. My "Americanness" almost always gives me

away. And lest you think I'm out here in flag-draped paraphernalia, screaming "USA!" like a rabid sports fan, it's a lot more subtle than that. It is my propensity for small talk in the store, or holding the door open for the person behind me. It's automatically saying, "Hi, how are you?" or sending food that isn't cooked back to the kitchen—politely, of course.

They are all small clues that I'm not from 'round these parts. If the citizens of the country I live in are playing Inspector Clouseau, those are all the hints they need to know a stranger is in their midst. If I'm lucky, I meet people who find the insertion of some diversity in their circle interesting. As an American, I try to be a freelance ambassador for my passport land. It's not always easy, especially since 2016, but I do my best to answer questions people have—and you'd be amazed at some of them. Especially since 2016.

Some people find my answers interesting.

Some people just wish I would go home.

How boring the world would be if we were all the same? One type of food. One way of doing things. One brand of soap. One language, one climate, one season. Change is tough, but sometimes change is the only thing that makes life livable.

Wait…who said that?

The same woman who still semi-regularly pined for a pizza from Kenny's Brick Oven Gallery? Who still proudly announced her New York roots? Who still kept the leather pants in the back of the closet just in case? *That* woman is waxing lyrical about change?

What is happening?

■ ■ ■ ■ ■ ■ ■ ■ ■ ■

There I was, cycling down Bernstorffsvej, the wind in my hair—which I'd learned to pin up when I was on my bike. The

late summer sun was shining, the sky cerulean and bright. My skirt was loosely knotted to avoid getting caught in my bike chain. I passed someone I recognized and waved a cheery hello. I had a loaf of fresh bread and a bottle of chilled Prosecco in my bike basket, the green glass just starting to bead up with sweat. When I reached Juliet's house, I turned into the gravel driveway. Closer to the door I stopped pedaling and let the wheels glide, stepping off gracefully as the bike came to a stop. I clicked my wheel lock, untied my skirt and shook it out, and walked up the steps to Juliet's annual welcome-back brunch.

I heard the voices and raucous laughter even before I walked into the foyer.

"How was your summer?" someone was asking as they chased a crawling baby across the hardwood floor.

"So busy!" someone else said, "We had to visit so many family members we hardly slept in the same bed for more than a night!"

I made my way to the kitchen. "Hello!" I said to everyone I passed.

Juliet's apartment was glorious, made for get-togethers like this, from the gilt trim of the window frames to the large, sunlit living room. She and her husband had hosted countless parties, but her back-to-school brunches were special.

In the kitchen I found a breadboard and sliced up the loaf, finding room for it on the table.

"Hey, you!" someone said, giving me a hug around the shoulders. I hugged her back, keeping the knife above my head.

It was loud and deliciously giddy, the way it sometimes is among a group of women whose kids just went back to school and there are open bottles of Prosecco. Most of the people in

the kitchen and spilling outside into the garden sunshine were expats returning from holidays and trips home. Everyone was busy sharing their summer triumphs and tragedies. The table was piled high with cakes and pastries, with cold meats and cheese, crackers, and olives. Someone brought a quiche. Women were piling food onto their plates and filling cups with bubbles or coffee. Outside, more people sat, tipping their faces to the August sun.

I grabbed a plate, piled it with food, and joined in the conversation.

No, I wasn't tripping down Madison Avenue in my boots, but I was gracefully gliding into a brunch on my bike into a roomful of friends and who's to say that's not just as good?

Life was pretty good.

A few years into our perpetually extended stay in Copenhagen, I hit my stride. Unlike Stella, I didn't quite get my groove back, but I got out of my rut. Or rather, I got out of my own way. It's what I now call our Golden Era. We had a large social circle, with a smaller inner ring of close friends. We were regularly going out, kicking up our heels, singing songs from Grease, stumbling home, and forgetting how much we had to pay the sitter. The kids were in a sweet spot. I was writing again, sometimes love songs to New York and the woman I used to be, but other things too. In 2014, I wrote a blog post called *Nine Expats You'll Meet Abroad* that went viral, and suddenly not only was I writing, but people were reading what I wrote.

I wasn't fattening my bank account, but I was feeding an under-nourished sense of self-worth. There was a sense of purpose, of doing something worthwhile. Ironically, it took finding the value in something that wasn't earning any money

—my writing—to start to see the value in that *other* big job I did that wasn't earning any money.

The one where I looked after my family.

And it took being an outsider to see it all. It took the good, the bad, and the ugly, trading stories about the things that went wrong, but also looking around and seeing the things that were right—inside and out.

Would I have found my groove had we stayed in Cyprus or had we ended up somewhere other than Copenhagen? There's no way of knowing for sure, but I like to think so. As the calendar pages flipped and the kids grew and I sat writing at my desk in the sun, the idea of moving back to New York started to fade into the background. For the first time, I began to imagine a life and a future without NYC at the center of it. For the first time, I didn't feel that I was defined by the woman who once upon a time had lived in New York.

I invited the expat piece of myself in. I gave her a seat at the table. I bought her some cowboy boots. I gave her a say. And it turns out, she was kind of fun. And it was getting harder to deny she was going to be around for a while.

I've screwed up plenty of times. I have no doubt I'll continue. Sometimes, just the fact that I was or am in a country that isn't mine rubs someone the wrong way. I'm not aware of the arcane set of rules that gets passed down in secret code from generation to generation.

Sometimes I apologize. Often I bristle.

"Ok, Troels, feel free to go and do the dumb job yourself!" I scream, if only in my head.

When I'm feeling generous, I try to remember that there are an awful lot of people who fear change. Or that love where they come from so much, that they think they're protecting it

by keeping it the same, stuck in some nostalgic whimsy that only exists in a fantasy of the mind.

I come from a country that used to tout itself as the great melting pot and New York is the meltiest of it all, the fondue pot of the land. That great big mixed bag of nuts is one of the things I loved most about the city. I loved the breadth of languages squeezed into a city block and the lucky dip of culture, food, and music. In Brooklyn the samba beat from the bodega used to float up to our open window, while next door pizza place would be firing up the brick oven and playing *That's Amore*. I loved being able to peruse the takeout menus and order Thai or sushi or burgers or cheese quesadillas with rice and beans on the side. That's the upside of diversity and immigration. But there are lots of people in the world who think that the seasoning that comes with immigration and diversity is only spoiling their national dish.

At times, living in a place where I don't fully understand the rules or the nuances, a place that doesn't fully feel like mine, has been like standing in a corner with a giant hat that screams *Dunce*.

We don't do that here. That's not how we say it. That's not how we do it in this country. We don't speak that language, speak our language.

Nothing makes you feel less a part of the 'we' than being scolded by an old lady for not doing something the "right" way. Whether it is the language you said good morning in or accidentally sitting in the quiet car of the S Tog.

Yet it's those exact experiences that have given me a deeper sense of empathy, a depth of understanding that I might not have possessed had we stayed put, buffered in the bubble-wrapped warmth of our comfort zone.

It's also allowed me to look at myself differently, to imagine new ways of doing things or new ways of being. Once you've spent time on the outside looking in, the view forever changes.

I might regularly bemoan my lack of bank assets, but the empathy I've developed as an outsider is a worthwhile asset to have as well. It's what I call on when I need to do better or be better; whether it's trying to understand a cultural quirk that frustrates me or getting used to something new, like a friend's child's new pronouns or identity.

If all the world is really a stage, then my time as an outsider has given me a backstage pass. And friends? Life's rich pageant is a pretty amazing technicolor musical, one that we can all enjoy even if we don't know the words or the steps.

Is the access to that experience, the vantage point I get by being here and there, worth the tutting and the scolding, the feeling that I'm always and forever doing something wrong?

Yes.

And if I'm wrong about that? I have no doubt someone will be right there to tell me.

SWEET CHILD O'MINE

The kids are all right

I never thought my kids would be anything other than New Yorkers with a heaping side of Brit. When they were born and I snuggled their hot little bodies to my chest I didn't look them in the eyes and whisper about the benefits of growing up as a third culture kid. I didn't even know what a third culture kid *was* until we moved to Copenhagen and I started hearing the phrase from other parents. Though each year our New York life faded a little bit more and our global roots burrowed a little deeper, I was still clinging—just—to the idea that we'd be going back to New York—someday. Yes, it was longer than we thought we would be gone, but surely eventually my boys would be able to reclaim their city bona fides. They'd have some quaint turns of speech from their time abroad and it would all make for an interesting dinner conversation one day.

And then two things happened.

The first? I fell in love again.

Copenhagen is…nothing like New York. For starters it's clean and it smells good. Things work. You can actually hear what the announcer on the Metro is saying. There's a lot of

green space and the city is surrounded by water. By the Lakes, we would go for cold walks and watch the ducks skate along the ice. A mama swan stood guard over her eggs in the reeds that lined the water's edge, hissing at anyone who got too close. Unless there is a sale at Magasin department store, a beach day at Bellevue, or, God forbid, the ticket machine at Lagkagehuset breaks down and you have to enter the bakery scrum for the last loaf of rye bread, the city never feels overwhelming. It is, as I constantly refer to it, a Goldilocks city: not too big, not too small, but just right.

After eighteen months of living in the shadow of Tivoli, in our apartment with the impractical wooden countertops and chalkboard wall, we'd said goodbye to the Mama swan and her goslings and moved slightly north. Our new digs were flanked by a park with a small, meandering stream and towering rhododendron bushes. Two blocks east was a sea wall that we would sometimes clamber over on a hot evening to dip in the sea. A ten-minute cycle up the coast and you could picnic at Charlottenlund Fort. When my husband and I first walked through the apartment we whispered to each other that it was probably the nicest place we would ever live.

It was, and likely will remain, true.

One day my older son came home and showed me a picture he'd found on Google Earth, and there I was, zipping along confidentially on my pink bike, just in front of our building.

Home.

For a family with young kids, Copenhagen is a dream. There are designer playgrounds throughout the city, including one with a child-sized replica of the city's most famous towers and another that resembles the Bermuda Triangle, with a half-destroyed plane and a half-buried ship. There are canal

swimming baths. There are two amusement parks within cycling distance. Tivoli with its rickety mountain roller coaster is the world's second oldest park. The first, Bakken, is only a few miles up the road nestled in the royal forest where if you stand very still during the month of October, you will see deer scampering past. There are beaches and castles and gardens and parks and museums that all have special rooms for children. There was Lego everywhere, including all over my rugs.

But most of all, Copenhagen was safe.

Because the second thing that happened was Newtown.

In December of 2012, I watched the news reports coming out of the US about yet another school shooting, this time in a sleepy town in Connecticut. The unimaginable tragedy at Sandy Hook haunted me for weeks. It still haunts me. My oldest was only a little older than the six and seven-year-old innocents who were gunned down in their classroom that December morning. Newtown was the kind of place that NYC transplants head to when they want to leave the city and root themselves somewhere safe. It was the kind of place that people I knew moved to. It was the kind of town that we might have moved to had we not moved abroad.

I tried to make sense of something that was never going to make sense. If a first-grade classroom isn't safe, if kids can't go to school and just be kids, spinning and learning, swinging on the monkey bars, then where do you even start to fix what's wrong? I thought surely *this* is the bridge too far, *this* is the straw, *this* is the big, bad thing that is so big and so bad, that people will take notice, demand change. Because what country in the world does nothing when six and seven-year-olds are dying in a hailstorm of bullets instead of practicing phonics?

Mine.

I cried. I watched the President cry. And deep inside me something broke and I didn't know if it could fixed.

When Richard said to me a few days later "I don't want to go back to that. I don't think I could bear it. How do we go back to that?" I understood exactly what he meant.

I didn't want to go back to that either, especially because it kept happening.

When people ask why we stayed in Denmark as long as we did, the answer I usually give is that our kids had the kind of childhood that Richard and I had. They had freedom of movement. They had easy public transport and bike lanes. Kids as young as those from Sandy Hook were regularly going to and from school on their own steam. No one was shouting about boogeymen lurking behind the bushes and kidnappers waiting in vans. I felt like we, and therefore they, could just breathe.

As the boys grew, so did their independence. They rode the rides at Tivoli with their friends and came home with the fireflies. They set out with a football to the sandy beach up the road and kicked it around. They went swimming in the canal baths. They had time to be kids and to make mistakes and figure things out in an environment that wasn't going to chew them up and spit them out.

They had, quite literally, space and room to grow.

But there was more to it than that.

I worried that they'd fall off their bikes or that some distracted driver would clip them or that they wouldn't wear their helmets, but I never worried about getting a phone call to identify their bodies because someone shot up their school.

I worried they'd be lonely or anxious. I worried they might give in to peer pressure to do dumb things. I worried they'd

slip through the classroom cracks. I didn't worry about them hiding in a corner of that classroom while someone with an assault rifle roamed the hallway. I never had to look their teachers in the eye and try and figure out if they would take a bullet for my children. I didn't worry about them going to other people's homes where there may be unsecured, loaded weapons.

By the time of the Parkland shooting in 2018, what I worried about the most was going back to New York, back to the US. And that? Well, that broke my heart.

When people ask why we stayed?

My kids got to grow up—literally.

■ ■ ■ ■ ■ ■ ■ ■ ■ ■

My deepening crush on our newly adopted city aside, even all the ticks in the pro column didn't stop me from spiraling into the pit of expat despair from time to time, that black hole of doubt, the one that screams *have we made the right choices*?

It was bad enough that I couldn't figure out exactly who I was or where I fit in, but at least I was an adult who (mostly) understood what I was signing up for.

In my happier moments, I thought of our kids as cultural guinea pigs, the forerunners of a new and better global citizen. In my less cheery moments, I worried that our decisions and moves had stripped them of a culture, of an identity, of a shared history and life-long friends and a home to go back to.

That Sunday decision, the one that set this whole circus shebang into motion, was ours. The kids had no say in it. Nor did they have any say when we plucked them out of their relative Cypriot comfort zone and flew straight into the colder climes of Copenhagen. As they got older we shared the process with them a little more and took their needs into

consideration of course, but still, the final decisions about where home is going to be are ours, not theirs. Even though it's their home we're moving around the globe.

How do you know if you're doing the right thing?

How do you know if taking your kids out of the cultural soup they would have been floating in back from whence they came is a benefit…or a detriment?

Cultural soup: Bring two cups of norms and expectations to a boil; add a heaping tablespoon of unspoken rules, one stock cube of attitudes; a teaspoon essence of nation, and national pastimes diced into bite-size chunks. Season with a dash of nationalism. Stir while singing the anthem. For a dash of color, serve with strips of your flag. No substitutions.

I only know what it is like to grow up in one place. My husband only knows what it is like to grow up in one place. Both of us have a family home where our parent/s still live and schoolyard friends we can call when we visit. My friend Deanna grew up, moved away, got married, moved back, and bought the house she grew up in. She still has the same phone number she had when we were kids. When I visit, I can dial it without a second thought. My first kiss was under the porch of a boy down the street while we slow danced to REO Speedwagon. I was pals with the kids on the corner, not from a country across the globe. My son once asked me where my friend Katie was from.

"Down the street," I said.

"No, but which country?" he insisted, not understanding.

"Down the street," I said again. His own experience was so vastly different from mine that he couldn't wrap his brain around it. His friends were like him, born and raised in one, two, three countries.

Richard and I know the words to our respective national

anthems and we root for our national teams during the Olympics. Admittedly, in our mixed American/British household, the Fourth of July can sometimes be awkward, but our cultural identities were forged when we were young. More than that, because we were static, they were constantly reinforced by the people and things around us.

There's a lot tied up in culture. Everything from ideas about yourself (Brooklyn badass) to the volume you speak (eleven) to whether or not ten minutes late is considered on time or just rude (rude). The way we make decisions, our food traditions, our holiday norms. The way we do—or don't—form a queue, look out for others, personal space, eye contact. The way we take care of ourselves and one another. The myths and stories of who we are, who our people are, if we even *have* people.

What happens when you pull the plug on the cultural fluid you're floating in? What happens to your matrix when you're a third culture kid? What happens if my kids don't have people?

It's enough to send a worried mama into a tailspin.

■ ■ ■ ■ ■ ■ ■ ■ ■ ■

I lay in bed one night, staring at the ceiling. I tossed. I turned. I rolled over and peeked at Richard to see if he was awake. I sighed, loud enough that if he had been on the verge of sleeping he wasn't anymore.

"What now?" he asked.

"I was thinking about the kids' passports," I said.

Outside the night was quiet, save for the employees at the sushi restaurant across the street who were closing up. A cart clattered on the sidewalk. Laughter floated up.

"*Why?*"

"Well, right now they don't have any citizenship to pass down," I said. This realization had only recently come to my

attention and had manifested in a giant elastic band ball of anxiety that was currently sitting on my chest, making it hard for me to breathe.

"They haven't lived in the US long enough. They've never lived in the UK. They don't have any rights to citizenship here. What would happen if one of them got someone else in the same situation pregnant?" I whispered to the ceiling.

"I don't think we have to worry about them knocking anyone up right now," he said.

"But hypothetically?"

"Are we doing hypotheticals at eleven-thirty?"

"Humor me," I said.

Normally my worries centered on school. Were they learning the same things that their counterparts in the NYC school system were learning? What about history? They had no idea who Paul Revere or Sybil Luddington were. Or Guy Fawkes and Florence Nightingale for that matter. When—or increasingly if—we moved back, would they be behind?

The great passport anxiety, though, was focused on a hypothetical possibility that was far in the future.

None of that made it untrue, or less worrisome.

I had watched their little faces wrinkle up in concentration when people asked them where they were from. On International Days, there was at least some consolation that both home countries count red, white, and blue as their national colors. Thank goodness I didn't marry a Colombian. But even still, all these decisions have consequences.

What did I think? My husband had asked me all those mornings before.

What did I think? Right then I thought that no one better have unprotected sex with another third culture kid without a

clear path to citizenship.

"Let's talk about it in the morning," Richard said and rolled over. He was gently snoring within minutes.

I, on the other hand, lost count of the number of sheep I tallied before I eventually fell asleep. The question of citizenship got jammed into the overstuffed filing cabinet in my head, the one labeled "things that keep me up at night," where it has been unresolved ever since.

When someone asks me where I am from, I usually say New York. Sometimes I'll say Boston or just a generalized "East Coast". My husband usually says London. Often those map cues are enough for the asker to form a generalized idea about us, how we speak, how we vote, what we eat, how or where we were educated. All that from a vague geographical clue.

By the time we finish this great expatriation experiment, I will likely have lived outside the US for as long or longer than I lived in New York. Richard has now lived outside of the UK longer than he lived inside of it. Yet neither of us refers to ourselves as European or third culture. Neither of us knows the words to the anthems of the countries we've lived in. Neither of us considers ourselves global citizens. We still very much identify with the country that is stamped on the front of our respective passports in gold lettering.

Perhaps it was too late for us, the mold of our cultural identities was already set. I guess you soak up a lot of slop during those formative years.

My kids though…they are plugged into something else altogether. A true melting pot made up of ingredients from our respective cultures, (lots of British banter and a mega dose of American rebelliousness) *plus* the ones they have and do live

in, *plus* the stuff they pick up from living in an international community.

I once asked my children if they could sing the Star Spangled Banner and they looked at me like I was nuts.

"How about God Save the Queen?" I asked.

Blank stares.

Honestly, I didn't even know the name, words, or tune of the Danish anthem to ask about.

They are teetering on the border of a no-citizen's-land, picking and choosing what they like from each culture and getting rid of the rest.

It took me a long time wallowing around in the pit of expat despair and worrying about birthright citizenship to realize that's not such a bad thing.

When they needed to, the kids channeled their Americana as easily as tuning a radio. As soon as the passports were stamped back into the US, they'd code switch and dial into their stateside frequency. They'd glitch a little at first, an over-annunciated word here, an accent or unfamiliar phrase there, but they'd morph and flow until they found a comfortable wavelength to inhabit. They do the same when we spend time in the UK. They were too young in Cyprus to really need a wavelength, but they found a comfortable frequency to inhabit in Denmark, one that was sort of between and among the others.

We all reinvent ourselves a little bit when we move, that's expat Darwinism–you evolve and mutate a bit to fit where you are. My problem had always been that I kept trying to shove my square NYC shape into the round hole of wherever else I was. It never worked. I just ended up with bruises purpling my skin.

Despite my crush on Denmark and my interest in the collective norms, despite having lived there for many years by that point, I still didn't know quite *how* to be my very American self in another place. I kept getting snagged on the idea that it had to be a drastic change, from an NYC square to a Nicosia Octagon or a Copenhagen Hexagram. In truth, all I needed to do was round my edges a little.

My kids figured that out way before I did.

■ ■ ■ ■ ■ ■ ■ ■ ■ ■

In expat circles, there's a well-known article by Naomi Hattaway about living outside your culture, and the unique shape of a life where you don't quite fit where you came from, but not where you live either. Her *I Am A Triangle* article resonated with a lot of people, especially parents of third culture kids. For a while everything I saw referenced all the triangles we were raising.

I've watched my kids live this life for most of theirs and I don't think they're triangles. A triangle is too rigid. It's too geometric and solid.

I think these kids are more like a wave. They're not boxed in, but fluid and dynamic.

My cultural borders are fixed. I am squarely a square. I like to think that after nearly fifteen years abroad the sides of my square are slightly more bendy than they used to be, perhaps at times I can turn at an angle and become a diamond? For my kids though, culture is a spectrum rather than a fixed shape. It's not solid, but sinuous. It's a wavelength they exist upon, cresting and troughing to fit their needs.

For a long time, I had missed stomping around in my boots. Then, after a year and a half in Cyprus, I started wearing heels again, something I hadn't done since before the boys were

born. Driving everywhere meant I didn't need to worry about a heel cap getting caught in a crack or calculating the number of blocks I could walk before my arches started aching. I could wear fancy shoes and strappy sandals. And though I could eventually ride my bike in a slight wedge, for the most part, in Copenhagen I traded in my summertime heels for fur-lined winter boots. They did have hot pink laces though.

In other words, my footwear was better at adapting than I was.

■ ■ ■ ■ ■ ■ ■ ■ ■ ■

During our first endless winter in Copenhagen, while we were still getting used to those fur-lined boots, we came across a little eatery around the corner called The Bagel Co.

Oh bagels, you sphere of doughy deliciousness, how I'd missed you, I thought the first time we went in. My mouth was watering just thinking about an Everything bagel with butter.

A side note to New Yorkers, if you come to Europe expecting to get a New York bagel, you are going to leave disappointed and broke. I am a bagel minimalist. A bagel purist. Butter or cream cheese, and for a special occasion smoked salmon, if that's your jam. For some reason I have yet to decipher, Europeans take a perfectly good bagel and use it as a very expensive sandwich base, filling it with things that should never be on a bagel.

Bagel fouls aside, the next surprise was how quickly and seamlessly the young woman behind the counter switched to English when she heard us come in. It reminded me of the way the kids turned on their Americanness or their Britishness as needed. As she made our bagel sandwiches, asking if we wanted cream cheese with the mustard—an emphatic *no* from me—we asked her about her English proficiency.

"Oh, we all learn English as kids," she said. "And a lot of the university classes are taught in English here, so you need to be fluent. Plus, there are only 5 million of us." She slapped some cheese and lettuce on my now increasingly sad and overburdened bagel.

Huh, I thought. About both the bagel and Danes and English.

The four of us are native English speakers. I sometimes joke that I'm bi-lingual and can speak both American English and British English, but really we're a monolingual household. Having English as a native tongue is the proverbial blessing and curse. Globally, it's widely spoken, often the language of instruction in an international school, and is the second or even third language of many. It's pretty easy to get by wherever you are. Unless you're in France, where they just keep talking French at you with increasing volume until you walk away, which I think may be the point. But it also means it's easy to get complacent. If there's no real need or reason to learn the local lingua Franca or Danca or Greeka, the desire and motivation have to come from within.

Danes are the second-best speakers of English as a second language, pipped at the post by the Dutch. There are plenty of reasons why, but at the end of the day, we live in an increasingly global society and a language spoken by only 6 million people isn't going to get you much past Malmo on the other side of the bridge.

I briefly toyed with and then quickly abandoned the idea of learning Danish. It was too much of a time commitment, too much play money in the form of Danish Krone, and there was no real need. As soon as I opened my mouth I gave myself away and, like the young bagelrista, most folks switched to English without missing a beat. Perhaps my stubborn refusal to

learn a new and difficult language was an unconscious way of holding onto my former self. Perhaps it was a way to keep a tight grip on that Big Apple gal.

You can bastardize my bagels, Copenhagen, but you can't have all of me.

Or, more likely, I was both lazy and cheap.

Language is a funny old thing. My friend Emily bent over backward to learn Danish, hoping to feel more integrated in her community, and confessed to me that she ended up lonelier than ever. My own Danish was limited to asking for a large sparkling water and I felt about as *at home* as you can feel when you're living in another country with no real idea of how long you'll be there.

Language allows you a deeper insight into a culture, but it can also cut you off, because sometimes as soon as you open your mouth, you're pegged as an outsider.

■ ■ ■ ■ ■ ■ ■ ■ ■ ■

In Copenhagen as in Cyprus, I wasn't brave enough to put my kids into local public schools. It would be easy for me to say it was because we were transient or that we wanted a common language wherever we landed, or that it was mostly paid for so why not? And while all of those reasons are somewhat true, the biggest reason is that I was worried about them fitting in.

In between the moving and the settling and finding where the peanut butter was hiding, the idea of uprooting my kids and plonking them in a classroom where they didn't speak the language was just too much for me. My imagination was limited to my own adult insecurities. How would I feel if I had to go to a new job in a new place, not knowing what the stapler was called in the language I was expected to pick up? How

would I feel if everyone around me was speaking a language I didn't understand and yet I was still expected to be productive?

I projected my own imagined loneliness and discomfort onto my kids.

Yet every year at the school my boys' attended there would be a handful of primary students who spoke little to no English. Those Kinder classrooms were like a mini UN. And every year their teachers said the same thing–give them until the winter break and they'll be chattering away in English. And they were right. By the time the clocks wound back and the darkness descended, most of those kids were conversationally functional. First graders aren't talking about the use of metaphor or the political ramifications of Brexit, but they are talking about big things; feelings, friendships, lunch. Those things require nuance, negotiation, and delicacy.

Give a kid five to six months and not only are they holding their own in the deep end, they're surfing the waves.

My kids would have been fine.

I should have spent less time worrying about how my kids were going to fit in and more on myself.

Some estimates have the global number of third culture kids upward of 200 million (this includes children of multinational marriages, like my own). Oh, those little global masters we are raising! They absorb new people, places, and things into their orbits like third culture sponges. They are adept at adapting and making friends because *they're doing it constantly*.

Kids are almost always much better at this stuff than adults. They throw themselves into new situations with an energy that is beautiful to watch. There are difficult things, big things, that children face when moving from country to country. Those

feelings are real and deserve time and space to navigate. But overall? They just go with it. They are, in the immortal words of Buffy the Vampire Slayer, cookie dough. They are still soft and pliable enough to take on the shape they need or want.

I, on the other hand, had long passed the cookie dough stage and was well on the way to stale and crumbly.

Even though I adored tripping down the Copenhagen cobblestones, navigating the picture-postcard streets of the city center, and even though I was happily scribbling away at my desk in the sun, there was still a part of me that felt like I was treading water. Like I'd hit the pause button on my life.

I wanted to be all the good parts of the NYC me, but in Denmark. I wanted to be the pre-kids me, but with my boys. I wanted to be the pre-marriage me, but with Richard. What I really wanted to be was something I hadn't been in a very long time: the independent woman who'd grown wings on those Manhattan sidewalks decades before.

I wanted to be the version of myself who had, and chased, her own dreams.

I could have embraced the change and used it as an opportunity to reinvent myself. I could have thrown myself into our expatriated lives with abandon. I could have plugged into a new wavelength and learned to surf.

Instead, I remained stuck on my a.m. dial.

I could have done a lot of things.

You can read a hundred books about what it takes to succeed as an expat...or you can go and watch a kindergarten class and follow their lead.

■ ■ ■ ■ ■ ■ ■ ■ ■ ■

Before we even got to the application part of the university program with my son, we spent an inordinate amount of time trying to figure out what country to focus on. Where would he best fit in? Which country had the best options? Where would he feel the least out of place?

If it sounds like I'd learned nothing in twelve years, it was because clearly, I hadn't.

My son is a great kid. That said, he doesn't play the piccolo or do ice dancing or build orphanages in Bolivia. When it came to standing out to a university admissions department, I worried.

Until I reminded myself that his cultural fluidity is the best thing he's got going for him.

His life on this cultural spectrum should be seen for what it is: an asset. This wave shape, far from setting him adrift, is what should make him desirable-–to college admissions offices and future employers. Growing up with fewer cultural expectations enables him to be flexible. He's adaptable. He's a cultural shape-shifter. He can change his expectations like he changes his footwear…

Oh.

Usually, I hate when my kids are right, but in this case, not only are the kids right, they're all right. In fact, they're pretty great. I'm not sure if they're ahead of the curve or if they *are* the curve.

Back in 2014, I sat in a hard plastic chair with an atlas and a palette of face paint in front of me. All around me, kids were stuffing their faces with chocolate chip cookies and scones. There were perogies, paella, and slices of pizza. Someone was making dreidels out of pretzels and marshmallows. Someone else was running an experiment that had something to do with

oxidizing pennies and the Statue of Liberty.

"Can I have a flag?" a small boy asked me.

"Sure thing," I said. "Which flag would you like?"

"Hmmm," he said. "I'm not sure."

"Ok," I said. "Well, where do you come from?"

He thought. "Well,…I was born in Qatar, but my Dad is from the US and my mom is from Brazil and now we live in Denmark…"

It didn't take me long to stop asking that question to the kids who were lining up for a face flag.

To these children, children like mine, asking where do you come from isn't a straightforward question.

"So can I have all of those flags?" the boy was asking me.

I frantically flipped through my atlas. "Of course."

I wish I had spent a little bit less time worrying about my kids and more time observing them, taking notes, and following their lead.

I was so worried they wouldn't have roots that I didn't realize we'd given them wings.

DON'T WORRY, BE HAPPY

Hygge is a mindset

I was idling on my bike at the lights on Strandvejen. A leggy blonde pulled into the little square. A guy carrying a set of golf clubs on his back pedaled through the light. The line outside the ice cream shop was out the door and around the block, chubby child fingers clutching cones. In the little courtyard that housed the supermarket and florist was the English-language bookstore owned by my friend, Signe. It was a place to meet and greet and hold book club meetings. Later it's where I launched my book, with a cozy reading in the dimly lit back room. As I waited for the light to turn green I was struck by something.

Things were good.

Against the odds, that girl from New York who never wanted to leave was doing okay outside of it. No, not just okay. More than okay.

There were times I still felt like I was in a clandestine urban affair, an adulterous relationship with another city, but by then we were far enough removed from our former lives that New York felt like that first heady love. Those dense, dripping

feelings were real and always would be, but the colors weren't as vibrant. Instead, when I thought about our New York lives it was with a nostalgia that tugged at my heart, twanged it like a country love song for a beat or two, and then softly faded.

I'd been in Copenhagen long enough that new people asked for my opinions and advice. I was the old timer who knew where to go to get a haircut that wasn't going to set you back a week's salary, who could explain the MYP program to parents who were freaking out. I was running a few small writing workshops and mentoring kids who loved to write. At school, everyone knew my name, and more often than not, were glad I came.

Without being able to pinpoint exactly when or where it happened, I'd stopped feeling like a belonging, a dependent that was simply attached to my husband's job. Instead, I felt like I belonged to something bigger than me.

People knew and read my work. When my husband was introduced to someone new, he was more often than not referred to as *Dina's husband*. For the first time since Brooklyn, I felt like we were a set of shoelaces belonging to the same pair of shoes.

The longer we stayed, the more women I met, and the more women I met, the more women I spoke to. Some were women like me who were or had been struggling to figure out where and how they fit in. They were women both with degrees and without, women who left careers behind and those who hadn't. Some earned money outside, some didn't. Some found all the fulfillment they needed in raising a family, others were looking for something more.

Almost all were doing this woman's work of tending a life in an unexpected place.

My husband understands he couldn't do the job he does, where he does it, at the level he does it, without me doing the job I do. And he is vocal about it, singing my praises to whoever will listen. But while I appreciate the appreciation, while "you're my everything" looks lovely on a note, the nasty truth is that the way my husband views me and what I do is not the way everyone else views me. There was one woman I met who, in a tone that was equal parts smug and derisive, told a group of gathered women that anyone who didn't work was a parasite on the system. And in case it's not clear, by work she didn't mean shepherding the kids on a field trip to the art museum, running the PTA, or volunteering with a refugee center; by work, she meant someone who pays taxes. She wasn't interested in my theories about unpaid labor or the way institutions rely on the volunteer work of women to stay relevant and afloat or adding unpaid labor to the GDP.

Those types of comments sting—no matter how thick your skin is.

And they sting because you go to sleep at night wondering if there is a kernel of truth in them.

It took me a while to figure out that the smug and derisive woman? She was too linear, too narrow, and most importantly, flat-out wrong.

I had succeeded in creating a home and family and security and friendships outside of everything I knew. Twice. Because while it was my husband's job that filled the bank coffers, I was the one who created and maintained our lives.

I was just as instrumental in making our lives abroad a success as he was.

We were partners.

It had always been easier for me to see that in others, to

remind the people I met of the value in what they were doing, not just at home, but at school, in clubs, and at volunteer centers. I just needed to hold up a mirror and see it in myself.

So, reminiscent of my NYC blossoming, Copenhagen became the place where my middle-aging expat self grew wings. Or perhaps she just got her regular, old wings out of long-term storage and dusted them off. I wouldn't say she climbed onto the Malmo Bridge and soared into the clouds, but maybe she jumped off the curb and didn't break an ankle.

Our little expatriate family had a comfortable rhythm, we were dancing to the beat of our own Danish drum, and I was holding one of the drumsticks. Pa rum pum pum pum.

The light changed and I pedaled off, the sun glinting off the glass fronts of shops. I passed the slow-moving white-haired ladies and the wobbly toddlers.

I was in the second happiest place on the planet and wait… was I happy? Is that what I was feeling?

■ ■ ■ ■ ■ ■ ■ ■ ■ ■

We were already snuggling down with our faux fur when the concept of hygge exploded onto the global scene like a K-pop band. Today, unless you've been living under the Little Mermaid's rocks, it's hard not to know about all things hygge. Famously, the word doesn't translate well, but it loosely means *I like to get cozy under my fleece blanket and light my candles while I get drunk with friends.*

The word is emblazoned on everything from mugs to t-shirts to the aforementioned cozy throws. There are hygge-scented candles and hygge how-to books. I'm reasonably sure it is part of the Danish tourism marketing plan. Come to Denmark! Buy cozy things!

Like Big Oil, Big Hygge is big business. If someone told

me there was a cabal of Vikings named Gunhild and Knut monopolizing the market of scented candles and mulled wine, I wouldn't blink twice.

But while it's easy enough to style an Ikea catalog around the idea of what hygge might look like, at its heart, hygge is not about fur throws and candles. It's not about sitting around the fire or which aromatics you chuck into your stew. You can't buy it, sell it, or curate it because more than soft lighting and fuzzy socks, hygge is about relationship building, with yourself and your family and others. It's coziness, yes, but for me, hygge is a lot more like contentment. That fat sigh when you sit down at the end of the day, when everything is tucked away and in its place?

That's hygge.

■ ■ ■ ■ ■ ■ ■ ■ ■ ■

The World Happiness Report swears that happiness is something quantifiable. And while I certainly think there are reasons why the Nordics rank so high on the happiness scale—trust in their institutions, strong social policies, and mutually supportive communities—I'm not sure I believe that something as fragile as happiness is measurable.

Everything I know about happiness is that it's all relative.

If I scour my personal history for happy stories, they are always specific moments or days rather than long stretches of sustained joy. There are the expected moments, the first time Richard and I shyly poked around at those feelings that were swirling in the air, the day I witnessed the ultrasound heartbeats of my long-fought-for babies, graduation days, and finishing big writing projects. But there are smaller moments as well, singing karaoke in a friend's basement, laughing around the dinner table, playing cards on vacation, or a Sunday board

game. The feeling of sand between my toes on that first hot day. The first night back in your own bed after an awesome vacation. I might not be able to tell you the day and month or even the year that those things happened, but I remember the way I felt in those moments.

It's the feeling that at that moment something is right with the world. But more, actively recognizing and accepting it.

■ ■ ■ ■ ■ ■ ■ ■ ■ ■

"The grill is almost hot!" Tamara shouted as she wrestled with the canisters and valves of the portable gas grill she had cycled in her ladybug bike.

I was sitting on a picnic blanket where the sand met the grass. The younger kids, coated in thick layers of sunscreen, waded into the water, running back out with buckets full of water, most of which spilled on the sand. More families came, dumping their bikes on the grass and throwing blankets down until there was a patchwork of quilts on the ground. Someone popped opened up a bottle of something fizzy. And then another. When the grill got hot enough, the pølser went on, fat sizzling and popping. The older kids were kicking footballs and throwing frisbees, blue lips quivering from being in the water too long.

We ate, reaching into communal bags of chips and crunching on carrot sticks as the day grew long, and then even longer until finally, the sun began to sink into the water, impressionist colors brushing Sweden across the sound.

It was 10:30 p.m.

The mayor made a speech and then moved to set the towering pyre of the Sankt Hans bonfire alight. On midsommar, the longest day of the year, Danes—and expats— crowd the beaches and the lakes and the waterways to watch

the bonfire flames lick the night. They say the ritual fire repels the stray witches and other evil spirits lurking about, and there is something peaty and Pagan about the whole night. Sometimes it felt like the crowds were waiting for the old gods to rise up from the kindling.

I was still waiting for an official invitation to the local bike coven, but I was half afraid of being caught by a stray ember and going up in those witchy flames. I stayed clear. But around me, kids and adults celebrated and drank and whooped into the endless light. People were talking and laughing, content to ward off all the bad things for another year and invite in the good.

Hygge, contrary to what some might think, is a year-round thing.

During the Danish summer, the sun digs out her disco hat and puts it on. The sky stays light as the watch hands turn until it is long past my bedtime. Those long, languid days are almost universally adored, especially when they arrive after a long, cold winter. It's hard not to be entranced by the idea of endless sun when days bleed into one another. And there is something magical and ethereal about those nights, like Mother Nature is casting a spell.

If you need further proof that there are magical forces at play, during those long summer nights you can sometimes spot a smiling Dane in the wild. Danes only smile in the summer. I believe it is a parliamentary rule.

But while I enjoyed the feel of the evening sun on my skin, I also found those lengthy days disorienting. I'd look at my watch, wondering why I was so hungry or the why children were wild, only to realize that it was 10 p.m. On summer mornings I'd wake, the sun bright in our bedroom despite our blackout curtains, and check my phone to see what time it was.

4:12 am.

To my surprise, I grew to love the long winter nights even more than those long summer days. We strung fairy lights along the window panes and left them up from October to March, blinking in the velvety dark. There was something delicious about having everyone inside while the wind howled through the naked trees. They were all in my sight and dinner was in the oven and we would all squidge up on the couch to watch *Survivor* or *Stranger Things*.

Happiness. Contentment. Hygge.

It's easy to think that happiness means joy or even optimism. Yet in my experience, Scandinavia is not the land of endless Ted Lassoes. Perhaps coming from New York, where the unspoken rule is *do not speak even if spoken to*, I didn't find my daily Danish interactions that off-putting. When my neighbor saw me on the street, I wasn't offended if he didn't stop, smile, and ask me how my day was going. He assumed I had somewhere to be and didn't want to get sidetracked by meaningless small talk. Or large talk.

No one is skipping down the street in Denmark. No small animated birds are tweeting and singing. No one is breaking out into spontaneous dance numbers in the square in front of Radhuspladsen.

If you're looking for it, it's hard to spot the surplus of happiness that keeps the nation afloat.

In Brooklyn, like most New Yorkers, I ignored everyone. There were 8 million of us all vying for the same subway seat in a performative dance of feigned apathy. Confrontation was internalized. I very much wanted to bludgeon people who did *not* stand clear of the closing doors with my umbrella. But I kept that shit to myself. It stayed in the realm of fantasy.

In Cyprus, those confrontational moments were often a reality more than a fantasy. Once, a young man got out of his car and stood, moaning and throwing his arms up into the air as if to demand the gods answer for this traffic jam he found himself in. When I rolled down my window and said that I didn't speak Greek, he switched to flawless English to explain to me why he was so upset. I think it was because there was a line of cars in front of me and I wasn't doing some *Mission Impossible-like* maneuvers to get around them.

Outside of the pink house we regularly witnessed Cypriot standoffs on the street. Two cars. One road. No movement, other than copious rude hand gestures.

We'd watch through the curtains, sometimes taking bets on who was going to cave first.

For the three and a bit years we called Nicosia home, the thing that always threw me for the biggest loop was the speed between those screaming confrontations and an invitation for a frappe. By the end of our time in Nicosia, I had logged a few screaming fits of my own to the island's tally, but those episodes always left me drained and exhausted. I went home from any such encounter reeling from the adrenaline and intensity. The idea of sitting down with the person on the other end of those interactions with a plate of souvlaki was unimaginable.

I never truly got used to those fiery Mediterranean mood swings while we were there. It was like the whole country was in the throes of menopause. Then of course I went through menopause myself and understood a bit more.

The Cypriot man with hanks of hair in his fists definitely didn't seem happy. The same way straphangers on the L train, all looking for the perfect moment to sip their crappy coffee and ignore the pregnant woman looking for a seat don't seem

happy. Perhaps it comes as no surprise then that neither Americans nor Cypriots have managed to crack the top ten in the Great Happiness Quiz.

But if you *are* going to measure something like happiness, what metric do you use?

I've settled on something that combines contentment and safety and togetherness.

The longer we stayed in Copenhagen, the more content I was. Some of the stress that I used to feel in Brooklyn had fallen away. Yes, I had to go to the supermarket more often, but I wasn't lugging it up to the 3rd floor, faced with whether to carry the stroller up first and leave the groceries unattended or vice-versa. Sure, our downstairs neighbor with resting Dane face was grumpy, but after that one time she came up she left us alone. Once, in summer, she even sort of smiled at us, though it might have been a facial tic.

We had parks and beaches. I still worried about school, but it was more about "Are they learning their times tables" and not about the lasting trauma of lockdown and active shooter drills. When we visited friends in New York or London, by the time we left I was exhausted. Their lives were just *more*.

Sometimes I was jealous of that extra-ness. Like when there was a musical I wanted to see or an opportunity out of my reach. I was forever and always worried the kids were missing out on some chance or experience they would have had back in the US. Sometimes I felt I had gotten too soft, and there were definitely times I wondered what I would be doing work-wise if we had stayed in New York and what that would have meant both financially *and* psychologically. Sometimes I missed the urgency of the big city, the edge of it. The feeling that you were living life hard–in every sense of the word.

But the missing usually had no punch, no thrust. Whereas before it was a constant now it flared and quickly faded. Suns rose and set and the kids grew. With each new inch of height came new independence. Biking to school alone. Riding the train alone. Going out with friends at night. Seasons came and went and Richard and I were suddenly mellowing into middle age. We didn't need a babysitter anymore. We could afford better cheese. We switched from white wine to red.

Life was uncomplicated.

"You know what?" I said one day while we were lounging in bed having coffee.

"What's that?"

"I feel like we're in calm waters. Like I just want to make sure nothing rocks the boat, you know?"

It was as if the decision we had made all those Sundays before finally seemed to be paying off.

It was pretty freaking hyggelig.

You can trek to Ikea and buy all the scented candles you want and still not be happy. You can wrap up cozy and warm in one of those coats that look like a wearable duvet and still not be happy. Jaime Oliver's beef stew, while yummy, may bring you momentary happiness, but it's nothing lasting.

Happiness is something I've had to fight for in my life from time to time. I watched my father struggle with depression and anxiety, sometimes beating it, but not always. I have had bouts of deep-dive depression when the walls close in and the very idea of joy is so removed it is galaxies away. With help and time and often medication, I clawed my way out, sometimes fingernail by fingernail. Perhaps because I've fought so hard to recognize what happiness looks like, when it appears like an unexpected gift, I carefully unwrap it and hold it close.

For many years, including our time in Cyprus and even the first few years in Copenhagen, I would have put that gift of happiness on a high shelf, wrapped in a box, and done my best to keep it safe and unbroken.

I was well into my forties when it dawned on me that happiness on a high shelf is happiness you can't see.

A windless day on my bike. The perfect pint of strawberries. A night on the beach with sizzling hot dogs. A visit from my family. An article picked up for publication.

Things I've learned: There's no point hoarding happiness for a later date or a rainy day. Happiness is fleeting. It needs to be used right away. And there's no high shelf or box or hiding place that's going to keep it from disappearing when you least expect it to.

Writing is a form of happiness for me. I know this because from time to time I worry that I'm going to run out of words and the thought fills me with a kind of existential dread. Words have built the steps that have supported my climb out of bad times—as well as bringing me to heights I hadn't imagined.

Reclaiming that part of myself, which I had put on a high shelf along with the other things I wanted to keep safe, has been the most unexpected part of this dance around the world.

Had we stayed in Brooklyn, I would have continued working. That would have brought me a different kind of satisfaction and a fatter bank account, but would I have picked up my pen again after so long away from it? I don't know.

Much of that early foray back into writing blossomed from observations of the world around me—the expatriate world that I was now firmly a part of—but also from conversations with people like and unlike me, people from different countries and different cultures. It was born of the frustration of being

seen as 'just' a mother or 'just' a woman or 'just' a partner.

I wrote to validate the world I was living in, and by extension, myself.

I still do.

On one trip to the UK, the flight attendant handed me a landing form, the one that demanded to know where I was staying and why I was there, and had I had any recent contact with a mad cow? On the form, there is a tiny line to list your occupation. For a long time, I'd filled that line in with N/A.

Not applicable.

I had lost access to that part of myself, the one that was not just a *thing*, but a recognizable thing with value.

Not long before that particular trip, I had been paid for an article I'd written. It was a tiny amount, enough for a sandwich and a cup of coffee. The amount wasn't important, though. It was the validation of having achieved something that belonged to me. Not me, expat spouse, or me, Mom, but just me. As the plane descended I let my pen hover over the form. And then, before I could change my mind, I scribbled the word *writer*.

And just like that I was a thing.

I have learned a lot on this long, strange trip. Some things I wasn't ready to learn before, some I definitely wasn't open to. Some I was too stubborn to see even when they were staring me right in the face. One of the most powerful lessons, however, is that I am the only one who gets to define who I am.

No landing form, no smug, derisive woman, or LinkedIn entry. Me.

Within that nebulous, ever-changing definition includes defining my own happiness.

And none of it has anything to do with chestnuts roasting by the open fire, fur blankets, or candles.

At the end of the day, I think the Danes score so well on the happiness scale because they have a relatively low bar. Are my basic needs being met? Is the person in front of me signaling in the bike lane? Is Lurpak butter on sale? Will at least one week in July be summerhaus weather?

Jeez, you crazy American, what more do you need to be happy?

I'd been chasing my own tail since I took that flight out of Boston Logan with two young kids, a diaper bag, and a prayer. I'd been keeping my NYC self on a shelf waiting for a time to take her back out. And the only one missing out was me.

It turns out I had what I needed to be content all along. My family, my friends, Friday night pizza and wine. Don't get me wrong, I still have plenty of fur throws. I have a drawer full of candles that I don't light because they're too pretty. But those things don't make me happy.

I don't chase happiness like I used to, mostly because I'm too old and slow to run after it. I try to let it come to me. Sometimes I can summon it up with an aromatic beef stew from Jaime Oliver, a family movie night, and a cozy blanket. Sometimes it blindsides me, a bright blue sky, a really good burger, a message from a stranger who has read something I've written. Those things have nothing to do with the book definition of hygge, but they wrap you up in something warm and fuzzy all the same. They're just harder to put on a T-shirt.

I still have stretches where I sink into a hole, where my toes edge the abyss for a few days or weeks. Sometimes I take out a notebook and do some old-school journaling. There is

something about writing with a pen on paper that is different from writing on a keyboard. Different synapses, different connections. Sometimes I'm able to see a way out. Or write a way out.

Once, on my eventual way out of a particularly deep funk, I reminded myself that those moments of happiness are just that—moments. Most of my days are spent folding laundry or calling the electric company, figuring out what to have for dinner or spending an hour moving a comma from one clause to another. That is not being actively happy.

"What if," I said to Richard when he dragged me out for a walk one day, "it's not about being happy as much as it's about being *not unhappy*?"

There is something in the rhythm of walking that lets you articulate your epiphanies. We stepped over cracks in the pavement and made our way toward the park where the trees hung heavy and green.

"That's a good way of thinking about it," he said, looking at me out of the corner of his eye.

"I think so too," I said, taking his hand.

JUST CAN'T GET ENOUGH

Most of the time, less is more

In the mid-1990s I joined the hordes moving over the bridge looking for a better life, or, at the very least, a bathtub outside of the kitchen. The road to Brooklyn was well-trodden by then. I was at the tail end of a parade of urbanites who had been trekking across the river seeking a little more square footage for almost two centuries.

Williamsburg, nee Williamsburgh, started as a one-horse ferry town in 1792 when a real estate speculator named Woodhull bought up a swath of land across the East River. In addition to the horse ferry, he built a tavern and then set out to entice urban sprawlers on the Manhattan side to move to the 'burbs.

Give me your tired, your poor, your huddled masses seeking another bedroom and an open-plan kitchen.

Woodhull's business ventures failed—I guess Brooklyn was tainted as bridge and tunnel even before there were bridges or tunnels—but within the next few decades, roads were built and then the area grew. In 1827, Williamsburgh was incorporated as a village, and by 1852, it was awarded a city charter. A mere

three years later, she was consolidated into the larger city of Brooklyn, and like brides the world over, changed her name and dropped the 'h'.

Today, along the river's edge, you can still see the remnants of the industries and factories that dominated the waterfront in the 19th century: Pfizer, Domino Sugar, Standard Oil, and Schlitz Brewery. The old mills and factories and foundries stand along the shoreline like a gap-toothed smile.

Once the Williamsburg Bridge was completed in 1903, thousands of Lower East Side residents left their rat-infested tenements behind in search of something slightly less ratty and less infested. Between 1900 and 1920, the population of the neighborhood exploded, more than doubling. A steady stream of European immigrants from Poland, Italy, and Russia flowed into the Northside and Greenpoint neighborhoods, establishing overlapping communities of their own. In the 1930s, an influx of Eastern European Jewish immigrants fleeing the Nazis established a Hasidic enclave south of Division Street. Later, in the 1960s, the siren call of factory work lured thousands of Puerto Ricans, then later Dominican and other Latin American immigrants to the area.

Williamsburg has always been one spicy melting pot.

By 1996, when my friend Hannah and I rented an apartment on the Northside, the neighborhood had been working-class Italian and Latino for decades. Our little stretch, in the shadow of the Brooklyn Queens Expressway, was dominated by small turn-of-the-century apartment buildings and vinyl-side townhouses in dire need of a power wash. Our Lady of Mt. Carmel Catholic Church, a squat 60s-era church was on the far corner, a Latin bodega on the other. For two weeks in July, the street between the two geared up for the

famous Dancing of the Giglio. Under giant tinsel flowers strung from street lamp to street lamp, the neighborhood men would gather. And then, in the fierce heat of the day, step by laborious step, they carried a wooden platform, upon which stood a towering religious icon and a small brass band.

If it sounds insane, that's because it is.

Hannah and I would buy a bag of zeppoles and sit on our stoop, watching in fascination, powdered sugar clinging to our lips.

Two blocks west of our building was Joe's Busy Corner Deli, home of a killer eggplant rotini. When Hannah and I lugged a used air conditioner home, it was one of the guys from Joe's who came and installed it for us. It was that kind of OG neighborhood. When you're there, you're family.

Yet apart from excellent Italian subs at Joe's, there wasn't much going on.

There was Planet Thai, a hole-in-the-wall with a good reputation. There were a few pizza places, a dive bar called The Turkey's Nest, and a pub called Teddy's. There were lots of dimly lit corners where you could buy drugs. I spent most of that first Brooklyn year walking the three blocks and taking the L train back into Manhattan, continuing my Lower East Side life.

A few years later, by the time Hannah had moved out and Richard and his giant green duffel had moved in, the neighborhood was almost unrecognizable. First came Black Betty, a Middle Eastern restaurant and bar. Then a few more restaurants and niche boutiques. We blinked and the streets between Kent and the BQE, between Metropolitan and McCarren Park, were suddenly mustachioed and trendy. By the time I had my first son, eight years after I'd joined the Bridge

and Tunnel crowd, Williamsburg had been crowned hipster capital of the world. Handlebar mustaches and lumberjack core were a thing, and there were organized kickball leagues in the park.

As I pushed my son in his stroller, I was endlessly amused by teams in their de facto uniforms of long socks and shiny, nylon shorts.

It was like watching myself in fifth-grade gym class.

Mrs. Mohan would have loved it.

The restaurants came, so many restaurants. BBQ and Italian, French. Peruvian. Mexican and more Thai. Two diners in old, silver railroad cars. A fancy wine shop and next a fancy cheese shop and then boutique clothing shops with eye-watering price tags. A mini-mall. A cupcake bakery.

When King's Pharmacy finally opened on Bedford Avenue, the last piece of my everyday needs puzzle fell into place. Do you want crappy Chinese food? Tacos? Burgers? Ecuadorian? Brick-oven Pizza, New York Style Pizza, Pizza by the Slice? No problem. Benadryl, envelopes, echinacea tablets, and expensive cheddar from the rolling hills of Lancashire?

Everything was within a ten-block radius of our apartment. I almost never took the train into Manhattan, everything was on my doorstep.

Since I've been gone the pharmacy has been replaced by an Apple store. I don't know where my former neighbors are getting their prescriptions filled and stocking up on Arnica gel, but I guess they can get their iPhones serviced easily enough.

Living in Brooklyn, I was spoiled by convenience and choice and so convenience and choice were my norm. What kind of take-out are we having? Which train do you want to take to get there, or should we just jump in a cab? Where shall we eat tonight? Which playground do you want to go to?

Which supermarket? And while no one would ever call New York City cheap, back in 2008 when we moved to the newly euro-ed up island of Cyprus, relatively speaking, it was.

Part one of the expat consumer cycle is figuring out where to get your goods. In Europe, unlike in some US states, we can buy our booze in the same place as we get our bananas. Boon. But whenever I need some ibuprofen? I'm usually out of luck and have to go to the pharmacy. Part two? Absorbing the sticker shock. Remember the eight-euro Betty Crocker cake mix? Part three is my favorite daily game of supermarket swapsies. We can't afford the fancy cheddar but Halloumi is dirt cheap. Chicken is costly but pork is a bargain. It's all about finding good substitutes or even better, deciding that Mac n Cheese, even Annie's Organic, is no good for you anyway. And the final part of the expat consumer cycle? Sucking it up and buying it anyway. Into the reusable tote goes the fancy cheddar *and* the cake mix.

Those first few summers we traveled back to the US with nearly empty suitcases. We'd touch down in Boston early in the afternoon and the kids would dump their bags, dig their swimsuits out, and slam the screen door in search of a pool. To stay awake, I'd head for Marshalls. I would run my fingers over the racks of clothing, letting it fall away in a colorful rayon array. I didn't buy anything, I just liked knowing it was there.

On the flight back we were all slightly heavier, from the Peanut Buster Parfaits as well as the six pairs of shoes distributed evenly among the bags. That sort of binge consumer-ing, while enjoyable, is not sustainable. Especially not the eating parts. One year one of the kids went through a growth spurt and I couldn't wait until the next summer to buy him a new pair of sneakers. In Cyprus, I discovered the sale

rack at Debenhams. Outside of Copenhagen, we had the Big Mall in Herlev. I swapped out as needed. You don't like Mozzarella? Too bad, it's cheap. I deployed psychological tricks to justify the cost. In Copenhagen, which actually *did* make New York look cheap, anything less than 100 Danish Krone— about fifteen to eighteen USD—was *coffee and cinnamon bun money*.

I normalized.

Over time, my brain tired of doing all that currency math. We were far enough removed from the shores of the United States of Cheap Consumer Goods that I stopped fantasizing about take-out options and outlet malls and Target aisles. I wore a well-trodden path through the aisles of Alpha Mega and then Rema Tuksind and then Netto looking for substitutions and always, peanut butter. You buy less of one thing and more of another.

You find the local cheese and eat a lot of it.

Slowly, year by year, a sort of consumer erosion took place. Having four brands of shampoo to choose from became my new normal.

I was walking up and down the aisles of Walmart when I saw, on a high shelf, a scissor mouse on sale for 99 cents.

I still don't know what a scissor mouse is and I'm reasonably certain that means I don't need it in my life, though I suppose I may have been missing out all these years. Nevertheless, on that day I was mildly obsessed with the idea of something, anything, being under a dollar that I called my husband, who was an ocean and six time zones away, and asked him if he thought we had any need for a scissor mouse.

"Is this a joke?" he asked me.

"No," I said, "It's on sale for like a dollar. Should I get it,

you think?"

"D, I'm at work. If you want the scissor mouse, buy it. I have no opinion."

"All right. I'm going to think about it. I'll let you know what I decide."

"No need," he said, hanging up.

I wandered, rapt, up and down the giant, warehouse size aisles. Kitchenware, household goods, pillows, bedding, pet food, human food, bath goods, and electronics. Air filters for your car, an entire aisle of hair dyes. Yarn. Notebooks, half an aisle of different glue sticks. Bikes, toys, outdoor furniture.

It was all too much.

I had been gone long enough, had become so used to limited choice that when presented with thirty different iterations of Pantene I was a little freaked out.

There are times now when I get claustrophobic under the weight of so much choice. There are only so many colors of cotton poplin blouses you can look at before they all start to merge into one.

Why are there 100 brands of vanilla yogurt? It's nice to have more than two, but 100? It hurts my brain to have to make those kinds of decisions. What's going to happen if I choose wrong? Which brand of crackers should I buy? How much time do I need to go through two full aisles of birthday cards? The kids need school supplies but there are 50 different kinds of Papermate pens.

Less choice makes my life a little more simple. Here is a rack with five birthday cards. Pick one, fork over your 100 Kroner, and be on your way.

It's not just shampoo or yogurt. On that weekend trip, the one where Alice and I lamented our thing-less-ness, the

planning was all done by someone else. Decisions were made, hotels were found, reservations were secured and a tour booked. I just had to *show up*. The only decisions I had to make for three glorious days were what to order for dinner and whether or not I needed a light jacket. It was fantastic. I almost cried from the freedom of decision-making.

Decision fatigue is real.

What to have for dinner. When to see the family. Where to go for the holidays. What to do on the weekend. What to buy for a birthday. How to get to sports practice. How to parent. How to relationship. How to friendship.

When to stay put. When to go.

Some international careers, like embassy rotations, have contracts with a built-in expiration date. You go, you live, you leave—expat Caesars. The time frame of other jobs can sometimes be dictated by tax or residency regulations. We have always fallen in between the cracks, sort of one foot in, one out.

When the decision about whether to stay or whether to go is left up to you, it gives you a little bit more control, but it can also be paralyzing. Sometimes it can feel claustrophobic under the weight of choice.

Most of the time it's much easier to choose between two or three shampoos.

■ ■ ■ ■ ■ ■ ■ ■ ■ ■

In early 2016, Richard and I were sitting up in bed, having coffee. The kids were entertaining themselves in another part of the apartment, rifling through bins of Lego. There was probably food shopping to be done or a football match to schlep to, but the morning was relaxed. And then my husband,

the man I loved with all my heart, turned around and told me about a job. But not just any job.

As much as we adored our adopted home, we knew we couldn't stay there forever. And if I thought of our Copenhagen lives like a warm, knit blanket we could snuggle into, the one thread that kept coming loose, the one seam we kept picking at, was figuring out just how long we were going to stay.

The dumb job was always mumbling about changing the rules for international staff, but so far hadn't made anything official or binding. If it did come to pass though, we were much better off having control of our own ship, setting sail for a port of our choice rather than one we might be forced into. And then there was New York. Though those early pangs of longing had faded to an occasional twinge, the city still held a fair amount of sway for me.

It was still home.

"How about Bangkok?" Richard would say.

"Rome?" said with an eyebrow raised.

"What do we think about Cairo?" he would ask.

"How about New York?" I'd answer every time.

We made the decision to stay in Copenhagen on an annual basis. Is this the year we'll move? Are we staying? Red or black, stay or go, step right up, and take your chances on moving roulette.

"We got the forms to renew the kids in school," I'd shout from my desk. "Should I fill them out?"

"I guess so?"

"Yeah, you need to be sure because if your job decides to do something stupid, we're out of pocket a lot of money." Every year I would wait until the last possible minute before sending in the renewal contracts and the hefty deposit that

went with it. Then I would cross my fingers and pray. *Dear Saint Joseph, the patron saint of workers, please don't post a dream job right after we've paid the school fees.*

We loved our lives. We loved Copenhagen and our apartment with the beautiful crown moldings and ten-foot ceilings. We loved the school the boys attended and we loved our friends.

I was writing, having some success. I felt grounded. Things were hyggelig. I was content.

We were content.

Still, there was always one eye looking out for the next job, the next stepping stone, the one that was going to eventually get us *back*.

"How about New York?" I'd say.

Decision fatigue. Are we doing the right thing? Should we move now while the kids are still young enough that the scars won't be so deep, running like a river through their little psyches? And if we do go, where do we go? Do we draw a line under this great experiment and go home, maybe without a job? Do we go somewhere else and if we do, what does that mean: for them, for us, for the future? If we go one more place then do we go home? How long are we doing this for?

And the secret question that had started to whisper to me at night when I couldn't sleep, the one I'd yet to voice out loud…do I want to go home?

"So there's this job," he said.

"New York?" I asked, turning to look at him. For the first time since we'd left, I wasn't sure what I wanted the answer to be.

"Not New York. Montreal."

Huh. That was a new one.

Montreal ticked a lot of boxes. It was an easy drive to my mother's house, we could ease our way back to long weekends and in-person birthday parties. Being far from my family was something I constantly struggled with, like an expat ass under a heavy canvas burden of guilt. I'd had a country crush on Canada for a long time. The land of maple syrup and hockey had a lot of the things I missed about the US without it actually *being* the US, and let's face it, it was 2016, things were getting weird over there. And, because it was Montreal, there was a European flavor that was appealing. There was the whole French thing, but I was willing to overlook that. After all, no place is perfect.

The grating sound of a car's worth of Lego being dumped on the carpet reached our bedroom followed by the softer sounds of our Hellerup neighborhood. We refilled our coffee mugs and talked about moving, not just the logistical bits, but the emotional bits. Six months before we had said goodbye to Tamara and Carl, our closest neighbor friends, the ones who always had a bottle of bubbly in the fridge for impromptu celebrations, who'd asked us to be secular godparents to their youngest daughter. Mischa and Joanie and their families were getting ready to move that summer. Alice and Charlie would follow soon after.

The sun was getting ready to set on our Golden Era.

The Montreal job wasn't perfect, but it was a step up, and a step closer to home. It was a solid if unexciting job opportunity. And besides, I could write from wherever we were.

Whoa.

That realization came in like a wrecking ball; not the fact that I could physically move my desk and transport my binders, but the idea that I was factoring in a facet of my life that

belonged *just to me*. It was a consideration that went beyond how the kids would cope or the trauma of packing up a life, of leaving friends. It was not about the real pain of adjusting to life in a new country or what moving meant for us as a family or for the future. It was a far cry from the woman who'd packed up her Brooklyn life eight years before, who got off the plane not knowing who or where she was, who just wanted to go stomping back to New York.

On the street below someone shouted goodbye in singsong Danish. *Hej hej.* A car door closed.

Sometimes in this life of here, there, and everywhere, it's better to go big or go home. Dithering just prolongs the agony. You're in, or you're out.

We were in. I started emailing schools in Montreal the next day.

Another Sunday morning in bed, another momentous decision.

When Richard made the shortlist for the Montreal job, we told the kids. We had taken them out for dinner as a treat after a school performance. As the Wagamama waiter put plates of noodles and dumplings in front of us, we filled them in.

My older son put down his chopsticks. He looked at us across the table. He finished chewing his dumpling and swallowed hard.

"If we move, I'll be really sad to leave my friends."

And my heart broke. Not in two, but in a million tiny pieces. Unlike my poor younger son, who lost his best buddies every year, my older son had won the lottery of international school friendships—his friends, like us, had been around for a while.

We were heartless ogres. How could we do this to them,

this picking up and moving? It was cruel. It was unusual. It should be against the Geneva Convention. I reached out to comfort him and then in the next moment he inhaled deeply and said with a wisdom beyond his eleven years, "But I guess if we had never moved here, I never would have met them in the first place."

And just like that I knew that all the decisions we had made leading up to that moment were the right ones.

For me, the most torturous part of those limbo moments, when I'm waiting to hear if we're about to uproot our lives and attempt to replant them somewhere else, is keeping my mouth shut. We would decide to throw the dumb job hat into the ring and Richard would ask me not to say anything to anyone. And I understood that, of course, from a job perspective. At the same time, it's impossible to contemplate something as momentous as moving to another country and not want or need to talk about it with other people who have been there and done that.

"It's not fair that you expect me not to talk about this with anyone," I said to him one day, while we were waiting to hear if he'd got the job. "I need to sort through all my feelings about it and not necessarily with you."

I didn't mean that in a belittling or detrimental way. Moving affects us all, of course, but it affects us all differently.

"When we move," I told him once, "you need to get used to a new office layout and new printer instructions. Maybe the stapler is in a different place. Your life doesn't really change all that much. But for me? Everything changes," I said.

And that's the truth. Every part of my day-to-day life changes, the how and why and where of it. For Richard, wherever we live, he will go to work, and he will come home,

where all the things that were done in Copenhagen, or Cyprus, and to an extent, New York, will still be done in the same way. The food is cooked, the fridge is full, and the whites are whitish. The kids are vaccinated, the birthday parties are responded to and Christmas presents bought. Family relationships are maintained and friendships are cultivated. All by me. In a new place. Where I have to figure out how to do all those things with no support network, no friends, and in the beginning at least, no help.

"What kind of emotionally detached person wouldn't want to talk about all of that?" I asked him.

"Ok, just don't tell too many people," he said.

"Define too many."

He didn't get the Montreal job. He came close, but in the end, it didn't go our way. But the whole process, from sunny Sunday morning decision to the consolation prize email, was a turning point for us. We would have been happy enough if the offer had come through. It would have been sad to leave a life and city we loved, but we would have packed up our home and lives and shipped them to North America. I would have found the local cheese and figured out the footwear needs.

Yet when we parsed through it all, we realized we were just as happy to stay put.

While we were stuck in that limbo, waiting to hear if I'd be shipping my motorcycle boots to yet another country, we took stock of our lives, and in doing so, made another momentous decision: it was the Montreal job or nothing. And by nothing, we decided that we were going to stop looking for the next step, the next thing, the way back. There was always a half-unspoken agreement that if the dream, slightly less dumb job came up in New York we'd reconsider, but otherwise, we

decided to stop trying to figure out when and where and how. We decided to stay put and live.

The next spring when the renewal contracts for school landed in my inbox, I didn't shout at Richard from across the room. I don't think I even mentioned it. I simply filled them in and sent them off, along with that hefty deposit.

We stopped looking for thirty different options and realized the one we already had was more than fine.

Go big or stay home.

We were staying home.

RELAX

You'll probably be fine

I stood at the kitchen sink, looking out over the park that was across the street from our building. It was autumn and I was marveling at the fact that the trees were still heavy with leaves, crimson and gold.

"It's amazing," I said to whoever was in the kitchen. "It's the middle of October and the trees still have leaves!"

I said this every October. And every October, without fail, Wind Storm Gustav or Henrik would blow through, and with a massive huff, puff, and blow the leaves down, the next morning the trees would be bare. A single, browning leaf would remain, vying for the title of last leaf standing, until it too would fall to the grass below.

I would stare out at the trees, now bold and naked sentries among the grass. With no filter of leaves, I had a clear view of the park, where small children often played near the stream that wove through the grass. The little ones liked to poke at the surface of the water with long sticks, sending ducks and pigeons flapping. They would hover at the edge, squatting and peering into the reflective surface, before they turned and ran yelping back.

Sometimes you don't realize how much is hidden by a canopy of leaves until they are gone and one day you wake up and you can see clear through to the other side.

Once we'd made up our minds to stay put, for the first time since I'd left New York, I felt like my feet were firmly planted. Sure, they were wearing cowboy boots and not motorcycle boots and the soil was Danish, not American, but when the famous Danish wind blew in off the water, shaking the cars along the Øresund Bridge, I felt grounded. Like the trees outside of our kitchen window.

But if we were planted, it was in new topsoil. We were living in Denmark, but our life was thoroughly international. We dipped into the local community here and there, we supported one of the local football teams, but weren't wading in or splashing around like our good friends Rob and Cassie, who had decided to seek permanent residency in Vikingland. Our friend circle was made up of Brits and Canadians and Australians and Swedes and Dutch and Irish and Indians, with the occasional American thrown in. They had lived in Hong Kong and Singapore and Thailand and China and the Middle East. The Danes we knew or socialized with were Danes who had themselves lived abroad, or who had married foreigners. The commonality, the thread that bound us all together, was the experience of life outside your own borders. Nothing creates a bond like a shared status as an outsider.

To my astonishment, we had become the old guard. We'd said hello to new friends and then goodbye to the same ones a few years later. Seasoned expats, we cycled through the expat seasons. I had hardened myself somewhat to the inevitable goodbyes, instead putting an arm around those who were experiencing those first few exquisitely painful partings.

Expats make friends hard and fast. Friends are your lifeline in this world and sometimes when they're gone, the absence feels a lot like grief. We'd been around long enough to know that the friends who were meant to stay in our lives would always be there, but the losses were real. And they hurt.

The bios I wrote for publications listed me as an American expat in Denmark. My social media profiles listed me as an American abroad. By that point, expat was a label I accepted without question. It no longer seemed odd or awkward to identify myself as such. After all, what was I if not an expat? Where else did I fit in?

I was not a belonging or a belt or a pair of plastic Barbie shoes, I was just a woman living outside her own country, taking notes.

Every May I would stand at the same kitchen window, peeling carrots or chopping onions, looking out at the bare boughs of the trees in the park.

"When are the trees going to bud?" I would ask a quiet kitchen.

And overnight, just like that, new life. Green shoots and blossoms cloaked the boughs, the goings on across the park screened from view for another six months.

The leaves fall off, the leaves grow back.

And so it went.

It turns out that when you're not constantly worrying about if, when, or where you're going to move, it alleviates a whole lot of stress. It turns out that when you're not holding yourself back waiting to return to a castle that only exists in your mind, you can start to build castles on the ground where you are.

If you're not stopping to smell the roses or sipping a

frappe, then at least you can watch the trees through your kitchen window, right?

■ ■ ■ ■ ■ ■ ■ ■ ■ ■

In 2017, the boys' school moved to a new location. We said goodbye to the giant sandbox where my youngest had headed up the digging club and the benches where I had sat for countless hours talking and laughing and kvetching. Goodbye to the atrium where we'd had parent events and quiz nights and where a group of tremendous women had stood on a stage and performed with me. Goodbye to the gym where we said *sikre rejser* to friends at year end assemblies, our paper flags waving high.

The new school building was stunning, an architectural citadel on the canal. The facade was layered with solar panels that reflected the light. In the misty winter mornings, they mimicked the gray of the water. In the sunlight, they glowed emerald, like dragon scales. From the huge classroom windows, it was easy to lose yourself in fantasies of pirates and tales of the high seas as cargo ships docked and waited to be unloaded.

In the lead-up to the physical move, I dutifully sat through countless meetings and town halls about how it was going to all happen with as little disruption as possible. We'll pack a few boxes, plug in some whiteboards, and boom, we're in.

Anyone with any sense could see it was a logistical nightmare waiting to happen. But we all sat and smiled and got ready to push up our shirtsleeves and do what we needed to do, right?

Of course not.

The school was physically moving, but it was also expanding and merging two campuses into one. Soon, everyone from the smallest Vikings-in-training to high

schoolers who looked old enough to have retirement plans would be coming and going through the same front doors.

That was issue number one.

The dragon-scaled building perched on the water was problem number two.

The rooftop playground? Number three.

I lost track after that.

If you ever want to know how cultures truly differ, go to a school town hall and see what the burning issues are. Americans are always hyper-concerned about safety. And lawsuits. And the convergence of both.

"Are you building a fence?" someone demanded.

"How are you going to keep the kids from falling in the water?" someone else asked.

"What are you going to do about this?" someone else wanted to know.

By then my kids were (mostly) past accidentally falling in the canal age, but I understood the concerns of those with pre-school age kids. I remember thinking the same thing when we visited the park of death in Nicosia. Things in the cramped auditorium were starting to get heated, people were fanning themselves with leaflets. The school's director stood at the front of the room in her pantsuit, trying to maintain a sense of calm.

And then a Danish parent took the floor, rising like Vibeke from the half-shell.

"Stop," she said. "We do not need to build a fence to stop children from falling into the water. This is Denmark. We do not do that here. Here we teach the children not to walk near the water because it is dangerous. A fence will not teach them to avoid danger. You can't avoid what you don't know, you

have to teach them."

I thought about the small children in the park across from our apartment, how they liked to poke at ducks or stare at their shimmery reflections in the water. They never tumbled in. A shout from a nearby adult or their understanding of their boundaries was enough to get them to turn around and run away. I thought about how when my boys were small I would follow them around like that Mama swan, pulling them away from edges, never letting them get close enough to see the danger for themselves.

Not long after, in the same endless meeting, the topic turned to transportation. It was a private, international school in a newly developed area. The transportation options weren't fully functional yet and so the bus company had puzzle-pieced together a new route which would service the school in the mornings and afternoons.

"What if there are too many riders?" someone asked.

"What if they need more buses?" someone else inquired.

"What if the buses don't run late enough?" A third parent wanted to know.

Eventually, the beleaguered head of school, who was noticeably flagging after an hour and a half of playing whack-a-mole with parental questions, handed the mike over to the bus company representative. That man gave the group of gathered parents the biggest side eye imaginable. I heard his sigh in my bones.

"If it turns out we need more buses, we'll add them. If it becomes an issue, we'll address it. Until then, why waste time talking about a problem that has not happened?"

I thought about the Great Passport Conundrum. I thought about all the nights I couldn't sleep because I was fixating on things that might, but probably wouldn't, happen.

I'm pretty sure I had one of those movie moments, when a slow realization slides across the protagonist's face, when our hero understands something deep and ancient that has been eluding her until then.

The leggy Dane standing there in her Nordic beauty rolling her eyes at the rest of us made perfect sense. Fences don't teach you anything other than how to get around or over them. And the scrawny representative from the bus company? It took him less than five minutes to dismantle a lifelong propensity for looking for solutions to problems that don't exist.

Sitting in a stuffy auditorium I wondered if maybe, just maybe, I was more Danish than I thought. At the very least, maybe I'd been marinating like a herring in curry sauce long enough that it had started to rub off on me. Heck, I'd even started waiting for the light to change—even when there wasn't a car in sight.

For most of my life, I've needed, if not demanded, the answers to whatever 'what if' question my overactive brain could come up with. I'm the one who knows what to do if we are chased by a horde of African bees or how to escape a sinking car, the one from Free-fall Tuesdays who demanded when, where, how, and why. The problem with demanding answers for issues that don't exist is that once you start solving one hypothetical problem, three more follow. It's like the Hydra—you chop off one monster's head and two more take its place.

The bus guy could have deftly answered the question, but it would have been replaced by two more. Which would have birthed four more. Instead, he shut us all down. The Viking parent could have let the assembled group continue arguing, but instead, she made an important point.

Fences are a false sense of protection, a band-aid. Kids can climb them. They break. Cars hit them. They're not impenetrable. But if you teach your child that the water's edge is something to stay clear of because it's dangerous, it doesn't matter if there's a fence or not. It's a lesson that travels beyond just one situation, beyond just one fence.

Maybe there'll be a rush hour bus frenzy, maybe there won't be. Maybe a later option for kids who are playing basketball and take too long in the locker room will be necessary, or maybe they'll hustle to make sure they get on the last bus before they are left behind with nothing more than hoop dreams in the dark. Maybe your kid is going to get someone pregnant and not have a nationality to pass on, but probably not.

Why freak out something that might not happen?

Really, it's brilliant in its simplicity.

Like many women I know and especially most mothers, I do the heavy worry-lifting for my family so the rest of them can skip about extolling the virtues of spontaneity.

What's going to happen to the kids, will they be okay? Will they need lifelong therapy? Will they have deep friendships?

When are we going to move? Will it be timed right for school? What if it's an exam year? What will we do if a parent gets ill?

Where will we go next? What if it's further away from family? What if one kid is in college in one country and the other kid in another? Where will they settle?

And, after nearly a decade away, "Have we made a terrible mistake?" was finally replaced, or rather supplanted by the new yet equally angsty "Is there a home to go back and if we do, will we fit in?"

■ ■ ■ ■ ■ ■ ■ ■ ■ ■

A few years later I found myself in another gaggle of parents at a meet and greet for a college consultant the school had brought in. It reminded me, more than anything, of those Brooklyn pre-K tours, when it just takes one high-pitched question to tip the concerns of a group of parents over into crazy. If a group of crows is called a murder, then a group of parents discussing school options should be called an asylum.

As I listened to the consultant talk about kids creating a brand for themselves to attract the attention of universities, I felt the panic rising, like a tsunami of worries coming toward me. Suddenly every decision seemed fraught with importance. I could feel myself getting pulled feet first into that vortex of anxiety, one which I'd managed to avoid for a long time. Grades and recommendations and extracurriculars and volunteer hours and flute playing for Peruvian orphans. Countries, courses, scores, tests, exams, deadlines and the schematics for the patented invention from sixth grade.

I had poured myself a cup of coffee but was starting to rethink that decision—the last thing I needed was bad school coffee.

I needed a timeout. I needed a frappe.

A few weeks earlier we'd had parent/teacher conferences. We sat across from our son's history teacher, who had known him for a while. I was interested in what he could do to make sure he maximized his exam scores, what he needed to do to give him the best opportunity moving forward, and what he should be focusing on.

My son was…not interested in any of those things. He was relaxed and joked with the teacher, their easy-going relationship evident. She asked a few questions, and he

answered, able to articulate where he thought there was room for improvement and where he had no chance of swimming to catch the ship that had already sailed. She asked him if he knew what he wanted to study at university and he told her that honestly, he had no clue. She nodded thoughtfully. As we were getting ready to end our conversation with her, she gave him a few tips for studying, but before we stood to move on to the next teacher, she looked at him and said, "You know, whatever you choose to do you're going to do just fine. You're going to be fine."

Back in the asylum of worried parents, the college consultant's talk was wrapping up. Her sole job was to advise as many students as possible on how to get into the best universities available to them. And she was good at her job, that much was clear. I could tell she was getting ready to open the room to questions, and I could also tell there would be approximately six hundred thousand of them. The tension in the room was palpable as parents jiggled from one foot to the other, waiting to thrust their hand up to ask a question of their own, each question opening the door to six more.

I myself had a hundred questions and they all started with *what if*.

What if he doesn't do well on his exams? What if he doesn't figure out what to study? What if he decides college isn't for him, what then? Where will he live? What will he do? And holy Jesus, what if he gets someone pregnant?

I could wait my turn, hopping from one foot to the next. Or, I could stop demanding solutions to problems that didn't exist yet and might never come to pass.

I was right about the coffee, it had been a terrible idea. More importantly, my son's history teacher was right about his

future.

Whatever he chose to do, he was going to be fine.

■ ■ ■ ■ ■ ■ ■ ■ ■ ■

There was a secret card I kept up my sleeve for whenever I needed to slap myself out of a spiral of unnecessary worry, but it was an ace I didn't use often.

When we were living in our first Copenhagen apartment, closer to downtown, I had booked a babysitter. The plans we had originally made had fallen through, but I'd decided to keep the sitter anyway, figuring Richard and I could log some time alone, a Copenhagen date night. We weren't planning anything fancy, no dinner reservations or heels required. We were going to walk to Tivoli, grab a beer and a hot dog, and maybe ride the roller coaster. The trees would be lit up and we could sit and talk under the illuminated boughs.

All of that would have been fine…aside from the fact that we weren't on particularly good terms that night. In fact, we were hardly speaking to one another. Long story, not part of this one. Neither of us particularly wanted to be around the other that night, but the sitter showed up and we smiled some fake, tight smiles, kissed the kids goodnight, and left.

We walked toward Tivoli in relative silence. The lights in the park were just starting to blink on when we arrived and by the time we'd pushed through the turnstiles, the silence between the two of us was deafening. To anyone passing us by, I'm sure we looked as miserable as I felt. Too much time has passed now for me to remember if it was a dare, or maybe one of us just wanted to make the other one uncomfortable, in that way married people sometimes do. At any rate, we found ourselves standing at the foot of the Golden Tower, otherwise known as the Drop Zone.

The Drop Zone is one of those amusement rides with a central tower that stretches high into the air. An apathetic teenager straps you into a hard plastic seat and in halting, jerking motions, you're hoisted to the top. Up and up and up over the building tops until you're left suspended, your feet dangling in the air. And then you fall.

"I'll do it if you do," one of us said.

"Fine."

"*Fine.*"

The worst part of a ride like the Drop Zone is the moment you belatedly decide that *no, I don't think I want to do this after all*, which is a split second before you realize there's only one way down. In that split second, I looked over at my husband, the man I loved with all my heart, and said, "Shit. I love you!"

There was a loud, pneumatic hiss, and then we plunged downward like an arguing couple with wax wings who flew too close to the sun.

There's nothing like mainlining adrenaline with a fear chaser to make you realize what's important and what isn't. As we walked on wobbly legs toward the beer hall, Richard reached out and took my hand and if all wasn't forgiven, we were at least both sure that if we were going to die on an amusement ride, there was no one we'd rather be with.

It really puts things in perspective.

A year later, as we were packing up to move further north, some New York friends came to visit. Adam and Melanie were young and had been a couple for some time, but they'd also been traveling together for weeks by the time they hit Copenhagen. After a day or so we noticed there was definitely some testiness in their interactions with one another, in the way that people who love each other sometimes get.

We took them to Tivoli.

"You have to ride the Drop Zone," we told them, steering them toward the illuminated tower. "You'll love it. Trust us."

As they rose, we watched the comical look of horror on Adam's face as it slowly dawned on him what he'd strapped in for. Melanie was laughing. With him, at him, in fear, it was hard to tell.

Richard and I stood at the base of the tower and waved up at them, giggling like kids. Up and up and up they rose. I don't know if they spoke to one another while they hung suspended in the air before they plunged downward, but I know this: they come off that ride laughing and clutching one another's hands, all their earlier bickering forgotten in a loud pneumatic hiss.

Don't create solutions for problems that don't exist is preferable. But if you're desperate, I can attest to the fact that most problems don't seem that important when you are dangling 210 feet in the air.

■ ■ ■ ■ ■ ■ ■ ■ ■ ■

Do I think like a Dane? I do not. There's not enough remoulade in my blood for that, and I am convinced it's the remoulade that holds the secret to Copenhagen sidewalk chicken. I don't think like a Dane, but sometimes I think like someone who is Dane-adjacent.

All the time and energy I've spent throughout my life worrying about hypotheticals, about possibilities, everything from food to bedtimes to my weight to birthright citizenship to the value of being a thing. Sometimes the waste of it makes me weep. Other times it makes me rage. Sometimes at night when I can't sleep I wonder what I might have achieved with all of the space that's taken up by the heavy worry lifting.

Maybe I could have been a Rockette, high-kicking across the stage at Radio City Music Hall; or, maybe, at the very least,

an accountant.

There are still times I have to pry myself away from the precipice of unnecessary worrying, when I can't stop the whirling, swirling eddies of doom. The last time it happened I quite literally took to my bed. I hid under the covers and hogged the Netflix account for days. My family refers to these episodes as my *broken times,* which is somewhat kinder than what they could say.

There are other times though, when the winds of worry whip up and I'm able to conjure up an image of that bus driver, standing on the stage with nothing but his Viking wisdom and a microphone. I think about the Danish mom and the sensible solution she used to try to calm an auditorium full of over-anxious parents.

And then I do my best to stand like those trees in the grass across from my kitchen window. Why worry about Windstorm Astrid when you know your leaves are going to grow back?

Sometimes it even works.

KARMA CHAMELEON

You come and go, you come and go

In the spring of 2019, I went home.

For the first time since we'd left Brooklyn all those years before, I traveled back to NYC on my own. We'd been many times as a family, most summers, but despite a decade of hints as to what could go in my Christmas stocking, this was my first solo trip. I could have booked myself a flight at any time. I could have left behind a color-coded list of who needed to be where on what day, who liked carrots, and who preferred cucumbers, but I always had an excuse. The kids were too little, there was too much happening, there was too much to do. Sometimes I felt ashamed that I wanted something so big for just me; it felt selfish.

Instead, I pined from afar—after all, it's much easier to keep things pristine and shiny in your memory. What happens if the reality doesn't match the fantasy?

Yet there I was. Start spreading the news, because soon enough I was gonna wake up in the city that never sleeps.

As the new year ticked over and the trees started to bud, my excitement for the trip grew, but so did my trepidation. There was a lot tied up those four thousand miles. More, I think, than

Richard could have known when he'd booked a flight and wrapped it up with a bow.

It had been a long time since I'd been truly by myself, let alone by myself in the city where it all began. In the nearly eleven years we'd been gone, I'd lost sight of much of the independence that defined the motorcycle-boot-wearing woman who lived in my memory. Some of that independence I'd traded in when my babies were born; two lives tethered to mine meant their needs often came first. Some slowly eroded over the years—it had been a long time since I'd been financially independent. It had even been some time since I'd gotten in the car and driven myself for meatballs and lingonberry sauce. And though I truly did feel like an equal partner in our expatriation adventures, my official status as 'dependent' still sometimes rubbed a raw spot on my skin.

At times it was hard not to feel like the life we'd chosen had cheated me out of some of that independence. No one tells you these things when you sign on the dotted line.

This trip was an escape, a way to reconnect, but it was also a way of proving to myself that the girl who had stormed the city barricades all those years ago without a second thought was still in there somewhere. That the woman who'd bought a plane ticket and flown across an ocean on a hunch to meet a man she hardly knew could still navigate the world on her own.

As the landing gear engaged and we began our descent into JFK, there was a knot of something in my gut. The runway lights danced below and I couldn't figure out why I was feeling so anxious about going *home*.

Would I remember where to go, how to act, how to walk and talk? Would I be too slow, stand out, or—God forbid—look like a tourist? Did the MTA still use Metrocards? Did taxis take credit cards now?

My city, the one I knew like the back of my heart, the place I talked about incessantly, the place where everything started.

Would things seem the same? Would it feel familiar?

You'll be fine, I whispered to myself.

On those family trips back to New York, we always made sure the kids were fed and entertained. There were melting summer mornings on the deck of the Intrepid and ferry rides out to Staten Island and back, the spray of the river keeping us cool. One year we waited hours to take our eldest to the top of the Empire State Building, another time we took them both to Rockefeller Center. On both occasions, we complained that we were nothing more than tourists.

This trip though, this trip was mine. The city was there for me to take a bite out of—if I could remember how.

I got off the plane, a brand new carry-on clicking behind me. I was poised to get a slice of all of that back, and I was terrified.

What if the city had changed beyond recognition?

What if I had?

■ ■ ■ ■ ■ ■ ■ ■ ■ ■

In the depths of Brooklyn, I met up with my poet friends and did a small reading, a poem about wings and women. I tried to make sense of the proliferation of Chipotle and Zara and Starbucks I saw all over Manhattan, where everything looked shiny and new and chrome-plated. I stayed with CeeCee in Jackson Heights and rode the 7 train back and forth, increasingly convinced that the New York City of my memory had migrated even further into the outer boroughs. It was there, under the shadow of the 7 and the F and yes, even the JMZ, amongst the sellers of saris and saffron and cheap iPhone knockoffs, that felt the most like the New York I had

fallen in love with. I had brunch with artist friends in the West Village, walking along the curve of West 4th Street where it meets Christopher. On a gloriously sunny day, I sat by myself in Madison Square Park with an iced coffee scribbling in a notebook. I went to the Guggenheim with an old friend where we gushed over Hilma af Klint and had pastries in a Viennese coffee house. I had brunch with the family I used to babysit for. The kids I used to read bedtime stories to were now all grown up, two of them married and getting ready to start families of their own.

And through it all, I was carefully trying bits of my city persona back on. Does she fit? Does she still know where to stand on the platform to get off at the right exit? Does she stand out? Some of it was like breathing, I didn't have to think twice.

The Columbus Circle exit was seared into my memory from countless early morning subway rides to the fertility clinic where I'd had so many blood tests that the crook of my inner elbow was almost permanently black and blue. At 96th Street, muscle memory guided me up the steps toward Broadway, passing the Duane Reade and the nail salon, and to the Upper West Side apartment where I had rocked someone else's babies to sleep.

Other things threw me. The restaurant and bar where we had spent so many nights on bar stools, the one where we'd gone the morning of 9/11 to be with people we knew, all of us trying to make sense of the world, had closed. Union Square looked different. Macy's was gone. When I traveled back to my old stomping grounds in Williamsburg, the exit at Bedford and N. 7th had moved. I followed the throngs of people up the stairs and ended up in a place I wasn't expecting to be. I was disoriented and confused.

Then I was standing in my old neighborhood, yet it wasn't my old neighborhood. There were mirrored high rises along the water's edge and new condos squashed between the vinyl-sided houses where Tommy and Rachel used to live, where they would sit in their canvas lawn chairs and shout over one another. Kenny's Brick Oven Gallery was gone. There was a Supreme shop on Grand Street not far from the playground where I'd spent marathon summer days. Where there had been empty shop fronts there were name-brand stores and chi-chi boutiques. There was a chocolatier on the corner where the drug dealers used to sell their wares. *A chocolatier.* I went in to buy something for the woman who was hosting a dinner for our Mama friends and nearly had a stroke when the cashier rang up my tiny box of 8 chocolates at 45 dollars.

I passed my credit card over, too stunned to ask her to return them to the shelf.

When you move away time moves in a different way. The months and years move more slowly, or perhaps more quickly. Living abroad is its own form of time travel.

The streets of my old hood were unrecognizable.

But then again, so was I.

Right before I was ready to head back to Denmark I got a message from an old poet friend, Walter. Like me, Walter had left the city for pastures gentler and greener. He missed city life, but he was also, like me, very much enjoying the peace and quiet of his gentler, greener days. He told me about his niece who had moved to the city the year before. She was tripping along her own cobblestones, presumably looking for herself in the cracks of the pavement, loving every minute.

While I'd been zig-zagging the avenues seeking the recognizable, I'd also been astonished at how much was unrecognizable, so many new things and places, so much

change. Reading Walter's message, I felt a small piece of my heart tear away.

New York wasn't mine anymore. It belonged to people like Walter's niece who was out there writing her own story in *her* New York.

Exactly as it should be. Cities are meant to be eternal, there for the next young woman to come and find herself.

When I got on the plane to go back to Copenhagen I was ready to say goodbye. Not just to New York, but to the idea of going back. Of moving back, but also of going back in time. Standing in the shadow of those skyscrapers felt like visiting a first love, one that I would hold in my heart forever. And even though I had known for a long time that we'd grown apart, it took being there before I could admit it to myself.

It's not you, New York. It's me.

It was the closure I had needed for a long time. I'd dug up the small-town girl who had discovered herself on those city sidewalks all those decades before and then I told her all about the woman she had become, and how far those wings had taken her.

And then I closed my eyes for the flight *home*.

■ ■ ■ ■ ■ ■ ■ ■ ■

While we still lived in the pink house under the orange trees, we once got an unexpected phone call from a Brooklyn friend. A few years prior, Pedro's father had retired to his native Cyprus, but just recently he had passed away. Pedro was flying into the island and going to be there for a few days. Would we be around? Could we make some time to see him?

It was one of only two times while we lived in Nicosia when there was a collision of spheres, when a New York City ghost stepped out of the shadow into the bright Cypriot

sunlight.

Of course we wanted to see him! We traded numbers and arranged a time for him to come to the house in Strovolos. We showed him around and he met the kids and tousled their hair and marveled at how big they were. When we had last seen him, before we'd sayonara-ed Brooklyn, they'd been babies, our youngest only five months old.

It was strange to have him there, this bit of our past suddenly in our present. He had stood in our tiny Brooklyn kitchen many times, and now here he was, standing in our kitchen again, seven thousand miles removed. By then New York was already starting to feel a little bit dreamy and gauzy, like a landscape in the rearview mirror. Now here Pedro was, solid and real.

"Listen," he said, "The funeral is tomorrow, but after the service, there's a dinner thing. You should both come."

"Oh, we can't do that," I said. "It's for family, we can't intrude like that."

"No, come," he insisted. "It would be nice to have some familiar faces there. I haven't seen most of these people since I was a kid."

And that's how we ended up at our one and only Big, Fat Greek Funeral.

In general, Cypriot celebrations are big. And fat. The kids had been invited to birthday parties where we'd driven miles out of town, down dusty country lanes, thinking we must be lost only to find a Kennedy-style compound shimmering in the distance. Surely not…but surely, yes. The souvla was on the grill, the pool had a lifeguard, and parents were lounging with drinks in the shade. We grabbed a bottle and sat in chairs under a big umbrella while we tried not to gawk at the size of the

place.

Another time the real estate agent who showed Richard the house dropped off an invitation to his daughter's wedding. We found it odd until someone told us that Cypriot wedding receptions are for all and sundry. Anyone you knew, may have known once upon a time, might know someday, the coffee clerk at Gloria Jean's—everyone got an invitation.

"My God, how much does it cost to throw a wedding that big?" I asked.

"Oh no, you're not invited to the actual wedding," a friend informed us. "It's more of a reception line. You go, you hand over an envelope of cash. Maybe you get a glass of juice."

In the end, we decided that the relationship between us and the man who found us a house was too tenuous to make the effort. In other words, it wasn't worth the fifty euros we'd have to withdraw from Laiki Bank.

But Pedro's dinner was different. There was a personal connection, a shared history of pints of beer on Lower East side bar stools. We'd been to his wedding in New Orleans. His wife had designed my wedding gown. This wasn't fifty euros worth of decision-making, this was friendship and history.

We asked Marie to stay with the kids, put on some black and braced ourselves for an evening of awkward explanations.

How wrong I was.

There are a few memories over the last fifteen years that stand out as something special. That evening, sitting in the warm night air, surrounded by a family that wasn't mine, was certainly one of them. I was worried it would seem like we were intruding, interlopers in their grief. Far from being politely ignored or awkwardly accepted, however, we were embraced by Pedro's family as fully as if we shared blood.

Though it was a somber affair, it felt more like a wedding than a funeral. Kids ran around, circling tables and diving under the tablecloths. There was a soundtrack of low music, melodies I didn't quite recognize. Plates of food were deposited in front of us, grilled meats and vegetables, and thick slabs of halloumi. Someone, an old uncle perhaps, told us about how he had shot the rabbit that was now swimming in gravy on a plate in front of us. Later there was Cypriot coffee and baklava and smoke from cigars and cigarettes spiraled into the night.

As the sky darkened and stars shone, we were pulled into their stories, not just of Pedro's father, but of Pedro and his brother when they were young. We watched and laughed as our friend and his brother were passed around and pulled into the embrace of old talcumed bosoms. The prodigal grandson returned to his roots, back to the dusty land of his father's birth. It was a homecoming as much as it was a farewell, and we were generously allowed to be a part of it.

All night distant relatives pressed envelopes of cash into Pedro's hand. For you, they would say, before they grabbed him by his face and brusquely kissed him on each cheek. By the time we said goodbye, we were embraced just as tightly as anyone else.

I had grown up with gatherings like that, the booming voices, the mouths full of food, and emphatic gesticulations. Trays of food were always passed over people's heads, conversations were regularly interrupted. Voices were always raised, though not in anger. Hands and fingers plucked food off other people's plates. And always, echoing laughter and old women pinching your cheeks just a little too hard.

The whole evening was like an embrace of an old auntie's pillowy bosom.

It was magical.

Maybe Pedro brought some Brooklyn ghosts with him. Maybe he unpacked them with his good shoes and tie. That night under the stars with a family that wasn't mine felt an awful lot like familiarity and comfort and home. Like all the things I'd been longing for.

It took a long time—and a funeral dinner—to help me understand what I had been missing. It wasn't a magic ingredient. It wasn't hiding with the shamrock marshmallows. It was the warmth of family and community. It was the comfort of belonging to something bigger than me, something outside myself. Something comfortable and billowy.

I had been exhausting myself trying to do everything without that cushiony pillow to catch me when I fell. I'd been killing myself trying to prove to absolutely no one that I didn't need to belong to anything to make this dumb move work.

Perhaps one of the things I loved about my city persona—the toughness, the thick shell, the armor—was also the very thing that held me back for so long. It held me back from diving in, from seeking out a community, and even from accepting invitations right into the heart of them. I thought I had to be tough. I thought admitting that everything was hard would make me seem weak.

I thought I'd be able to put those motorcycle boots on, kick the door in, and do it all on my own.

The embrace of Pedro's family felt special—even in the moment—but at that point I didn't really understand that no one has to do this crazy shit on their own. There was no medal waiting for me at the end if I did, just a lot of angst and tears along the way.

I didn't understand that I was making my life harder than it

needed to be—an infuriating trait which, it appeared, I carried with me from one country to the next.

■ ■ ■ ■ ■ ■ ■ ■ ■ ■

"Can we even call ourselves expats anymore?" I asked Rob and Cassie at one of the many Sunday dinners our families shared. We were sitting on their kitchen stools in Østerbro, drinking wine and eating cashews. "At what point does one stop being an expat?"

No one had an answer.

"If you died, would you want to be buried here?" I asked. The question had become my litmus test. What soil do you want tossed on top of you when it's all over? When the Ghost of Expat Future shows up and leads you to a mossy gravestone with your name on it, which flag is flying overhead?

By then Rob and Cassie spoke perfectly passable Danish. Their youngest was in the local school and as a whole, they were much more assimilated into Danish society than we had ever been. Yet even they admitted it felt strange to think about being laid to rest in a land that's not really yours. Like despite the roots and the language and even sometimes the piece of paper that grants you things, we're all just living on borrowed land.

So we were still expats, but long-term ones. The shine of living somewhere new had worn off and we were just living everyday lives in a place that we were borrowing. The friends we had were, like us, old-timers, and the idea of making new friends was exhausting. We had what we needed. We traded off Sunday dinners of chili and lasagna with Rob and Cassie and a few others. We had a slightly larger circle when we wanted to celebrate, Moms of the Ring we had called ourselves after our sons had gone through a marathon movie month of the

Hobbit canon. Later we changed our message group name to Wonder Women. We were happily settled and burrowed into our international lives.

We were in calm waters. The boat was still.

But even still lives have a fault line and for us, the fault line was always Richard's job.

My husband had made good use of our decision to settle into our years of living Danishly and ended up with a fancy new set of letters after his name. But those new letters also exacerbated a seven-year itch that had been getting worse for a while.

If my initial yes all those Sundays before had been about recognizing a dream that belonged more to a person I loved than it did to me, then the inverse had been happening for some time. Richard wasn't actively unhappy—yet—but he was squashing down a lot of work frustration so that we could stay rooted in our Danish topsoil.

Promotions were floated but never materialized. He'd been doing the same job for a long time and was bored. He was twitchy for something more challenging. The surest way for him to move *up* was for us all to move *out*. Yet none of us were ready to move.

Some of us were less ready than others.

We buried our heads in the very comfortable Danish sand. Because sometimes that's what you do for the people you love.

The cherry blossoms bloomed in Bispebjerg and the bonfires burned and Wind Storm Valdemar blew the leaves off. Suddenly our oldest was in high school and moving became trickier. Our youngest was just about to go into middle school and was captain of his football and basketball team. We did the school math, we did the money math; we could stay until the older one finished. Maybe with some tweaks, a little job Botox

here and there, we'd even stay until the younger one did.

We kept our heads in the sand.

And then in 2020, the world changed overnight.

■ ■ ■ ■ ■ ■ ■ ■ ■ ■

"What do you think?" Richard asked me.

I looked around. We were walking through the Charlottenlund woods and the spring sun filtered through the new leaves, making patterns on the ground. When Denmark went into lockdown in March of 2020, Mother Nature threw us a bone. The day after Mette Fredericksen announced we'd all be staying home for a while, the sun came out and stayed out. It was an unprecedentedly sunny spring.

Richard and I were walking side by side, happy to be able to get outside.

I remember the claustrophobic panic that rose in me as it became clear where things were heading. In Italy, in Spain, in Asia, people were barred from leaving their houses. In France, you needed papers to go more than a kilometer away. Our apartment was gorgeous, but it was an apartment, with no more than a balcony to feel the sun on your skin or the breeze in your hair.

"I will do whatever they want," I whimpered, "as long as we can go outside."

We were fortunate. Throughout, Mette never stopped us from walking outside, and so along the coast or in the woods, we walked.

The ground was dry under our sneakers, the ferns just starting to unfurl from their tight coils. Every ten minutes a twig would snap and we'd become aware of another family or couple doing the same thing, and we would wait, careful to keep our distance, nodding at one another. Sometimes we'd

hold a finger up, signaling toward the direction we were headed.

Looking out for one another.

There was a job, my husband said, a pretty solid opportunity. It was a promotion. It was in another city.

What did I think?

I thought life has a funny way of making sure you don't get too comfortable. I thought about how over a decade before I'd left my heart on a Brooklyn sidewalk hoping that whoever found it took good care of it. I thought about how here we were in a country that wasn't mine that I had grown to love like it was.

I thought *I don't want to leave, not yet.*

I knew the time was coming, that soon there would be too many obstacles to overlook. It really would be an Øresund Bridge too far. But standing in the dappled sunlight of the Charlottenlund woods? It wasn't then.

We set off on a path through the trees, talking pros and cons. Was it worth it to uproot our lives for something not so different from what we had? Was it worth moving our oldest for his last two years of school, not even knowing if there would be a real, in-person school to go to? Was the job worth it? Was it a job he wanted? Were we ready to leave?

Was I?

"What do *you* think?" I asked him. We had always made these decisions together, but I was also keenly aware that he was the one who was going to work every day, even if it was out of our bedroom. He was the one who was getting more frustrated by the day.

"I think it's not the right time," he said.

I let out the breath I'd been holding.

Deep down, I knew that the decision to say no was just a reprieve. Things we couldn't control were shifting, bad weather was on the horizon and I'm not sure the right clothing would have made any difference. Our goal became simple: get our older son through the last two years of high school.

In that way, Covid worked in our favor. Everything ground to a halt, including any talk of moving or jobs. No one was going anywhere. Working from home was a sanity saver, in no small part because it meant we could get outside and march up the coast whenever I caught Richard pacing up and down the hallway, which was happening with more regularity.

We bubbled up with Rob and Cassie and started marathon Sunday walks through the city, getting to know neighborhoods we'd overlooked in our time there. We must have logged a hundred kilometers, looping around the harbor and seeking out street art. We walked through the overgrown alleys of Christiania and the narrow ones of Nordhavn and the new streets of Sydhavn. We trudged through the mud in Vestamager and along the beach at Amager Strand, watching the kite surfers catch the wind. We walked down paths and around lakes through clouds of midges. We walked all through the following winter and into the next spring. When restaurants opened we sat outside and sipped a beer or a coffee, always grateful for the company of each other and the city.

In the summer of 2020, we did the Great Danish Roadtrip, determined to visit a few of the places on our bucket list while we could. What better time than the summer when we couldn't go anywhere else?

We piled boys and bags in the car and set out across the country. We poked around Viking ships and burial mounds and the boys ran up and down the pier in a tiny town by the sea. In Jelling we walked around the stone erected in 965 BCE by

Harald Bluetooth in honor of his parents, good old Gorm and Thyra. We stopped for two nights in Lokken where the beaches are so wide you can drive your car right onto them. We made our slow way to Skagen, the northernmost city in Denmark, where the North Sea meets the Baltic. After a rainy, cold July, the August sun was out in all her Scandinavian summer glory and we carried our shoes in our hands, laces dangling as we walked along the sand. Behind us, the dunes rose and fell in gentle waves that matched the motion of the ocean. The waters stretched gray before us. We waded in, bracing ourselves against the cold, and felt the tide from two seas lap against our calves. We snapped a photo of our younger son who walked just a few feet further so that he could be, for a moment at least, the northernmost person in Denmark. We took our time walking back down the beach before we headed back, stopping for ice cream cones in town before making our way to the small, family-run B&B we'd booked for the night.

The man behind the desk was flustered. Before we could give him our names, he told us in serviceable English that he was sorry, but the restaurant would be closed that night.

"Our daughter, you see, is in the hospital."

"Oh no!" We started to deliver our sympathies before he interrupted us.

"No, no, all is well. She is about to have a baby and my wife and I, we are waiting for the phone call."

"Ah well, congratulations!" we said to him as we took our keys.

When we returned from dinner later that evening, there was a small table of guests in the garden. We approached the owner. "Any news?" but he shook his head. We asked if it would be okay to buy a bottle of wine from him and sit

outside. It was a gorgeous evening and we'd brought a deck of cards.

He nodded to us. "Go and sit and I will send it out," he said.

We made our way outside and passed the lone table, which appeared to be a family. They were having a grand old time, joking with the young waiter, who would stop and pause to talk with them in between delivering drinks. Aside from the family and us, there were no other guests in the garden, and we were perfectly content with our bottle of rosé and our deck of cards. Our older son had retired to the room, but our younger son was with us, honing his card skills.

We were in the middle of a hand of gin when we heard the unmistakable sound of a champagne cork popping.

"Come! Come!" the matron of the hotel said, ducking her head outside and gesturing to us all. "Come inside!"

And so we followed the other family and the waiter into the large dining room. We were each handed a glass of champagne. Kransekage cookies, heavy with icing, were lined up and we were each encouraged to take a piece of the traditional marzipan treats. The new MorMor and MorFar beamed as we all congratulated them on their new grandchild. More champagne was poured and more cookies consumed and eventually, they told us they were off to the hospital but we were welcome to stay in the garden as long as we liked. We walked back outside in the company of the other family, everyone smiling from the celebrations.

"Come and sit with us." They gestured to us and we pulled our chairs to their table. We quickly learned they were from a suburb of Copenhagen not too far from where we lived and that it was their son doing the owners a favor by acting as a waiter for the evening. Ah, we said, that was why they all

seemed so familiar with one another! They had all traveled to Skagen for a birthday, and as we talked they walked us through the complicated relationships of those at the table.

We ordered another bottle of wine and talked into the night, slapping at the mosquitos that were starting to nibble at our skin. They asked how long we had lived in Denmark and whether or not we liked it there.

"We love it here," we said truthfully, and the band around my heart tightened just a little bit.

Eventually, the mosquitos grew too bold and we got too cold. We'd had too much wine and the sky was dark. We said our goodnights and went up to our rooms.

Much like our evening with Pedro's family, the night in Skagen left me feeling wrapped up in something warm, a sense of being part of a community that I lived among, but that wasn't really mine. We had been invited in and asked to be a part of something that wasn't ours. Burrowing down into the bedcovers I felt a pang of regret that we hadn't done more to assimilate into the Danish community, the same regret I had when we'd left Cyprus, that we hadn't done more to be a part of things.

Yet that wasn't fair. We *did* have a community. One that maybe we but definitely I had created from scratch. A community made up of people like us, of our friends, our school, and yes, even a Danish neighbor or two. I had crafted something just as rich and fulfilling as what we'd been invited to join that evening.

Getting caught up in the euphoria of a birth or in the sadness of a death isn't the norm, but maybe it's enough to take those moments as they come, to accept them for the small gifts they are.

There was something satisfying about it all, as if we'd come

full circle. It almost felt as if we'd completed something important, a quest of our own.

■ ■ ■ ■ ■ ■ ■ ■ ■ ■

In the fall of 2021, our eldest son started his final year of school. At long last Covid vaccines had been rolled out and life was slowly rolling back to yet another new kind of normal. We were nearly there. So close we could taste the lingonberry sauce. The thought of leaving behind everything that we'd worked to craft and create—that *I* had worked to craft and create—didn't make me feel any less queasy, but in terms of timing a move, it wasn't going to get much better. Our oldest would graduate and our younger one would be starting high school.

So much for those initial two years.

In the meantime, all I had to do was make sure Richard didn't hurl his work laptop—or himself—off of our balcony.

In the park, the leaves were still clinging to the boughs of the trees. We kept up our strolls, though they had turned into fast and furious walks up the coast, the wind sometimes bruising our skin. While the salt spray arched over the sea wall and cyclists whizzed past, we tried to map out the future. We'd cut into the woods and march along the train tracks, working our way through the options while we worked through the trees. There were too many possibilities, too many what-ifs.

One city kept coming up as a possibility. It wasn't our first choice, but it would be an easy enough substitution, and it was certainly better than some of the other options. We knew people who lived or had lived there. The school was similar in size and curriculum. As far as transitions, it would be as easy as we could make it.

The foliage closed over us and we stepped over high grass

to get back onto a path. We would figure out a way to make it work. Worst case scenario? We'd stay in our comfortable lives. Not bad as far as worst-case scenarios go, and definitely better than being trapped in a sinking car or chased by angry bees.

"Ok, so if it comes up, we go for it," my husband said, looking for confirmation from me.

I smiled with my mouth, swallowing everything else I felt.

"We go for it," I said, and then we walked down the path toward home and I pushed it all out of my head.

The wind came. The leaves fell.

■ ■ ■ ■ ■ ■ ■ ■ ■ ■

"Let's go for a walk," Richard said.

The day before he'd returned from a work trip, the first in a long time. It wasn't unusual for us to walk in the mornings, but that morning he seemed antsy and eager to get out of the house. I pulled on my leggings and laced up my sneakers and scribbled a note for the kids, who were no longer really kids. I used to long for them to sleep in the mornings, now I longed for them to wake before noon. The sky was gray but the ground was dry. The trees, the same ones I admired from our kitchen window, were nearly bare, a few stubborn leaves clinging on.

Ten meters from the apartment building, under the nearly naked boughs, my husband stopped short. I turned back to him.

"I have news," he said.

I stared at him and sputtered. "Nope. Absolutely not."

The dumb job had thrown us a curveball: the office was relocating and the job was packing up and moving with it. To a place none of us wanted to go.

We'd been working toward moving the following summer, but only if the right job in the right place came up. The card we'd always held in our back pocket was that we were happy enough to stay living our awesome lives in a place we loved—or at least I was. But now that card was gone, the backup busted and suddenly, the clock was ticking. What I hadn't admitted until that moment, not even to myself, was that like the last of the leaves, I'd been clinging to the hope that we'd just quietly spend the next four years with our heads in that comfy Danish sand.

We'd signaled in the bike lane, but Magnus still crashed into us.

We'd gambled on the wrong clothing and now Windstorm Mathilda was coming.

We'd exhausted the substitutions.

We were going to have to move. And soon. The big question was where.

"Do you want to talk about it?" he asked as I stomped away toward the gates of the park. The cloud cover shifted and the sun broke through for a moment.

"Nope."

And I didn't. At some point soon we'd have to sit down and have a talk about the finances, a phrase which elicited dread in my husband whenever I said it. If you ever want to ruin a sunny Sunday, just lean over to your husband in bed and tell him you want to talk about money. We'd have to create some contingency plans, consult the calendar, and line up some ducks.

But all of that could wait.

There was one thing I knew, however, and it was this: My husband, the man who gate-crashed my Thanksgiving dinner all those Thursdays ago, the one who had sat up and asked me

how I felt about moving to Cyprus a decade and a half before, *that* guy could not keep doing what he was doing. And I couldn't ask him to.

The job had been suffocating the dreamer in him for a long time now. This relocation would be a pillow over that dreamer's face. Sure, at times the over-the-top fantasies drove me crazy— a forty-seven-day cruise around the world, really?—but you put up with the crazy bits when you love someone.

And sometimes, you learn to love their dreams yourself.

Like a dumb job that lets you see the world and find yourself in the process.

"We'll figure it out," I said to him as we marched through the park, because we would, whatever that meant.

"Maybe it's time for a change."

WIND OF CHANGE
Deja Vu

A few years before the Great Danish Road Trip of 2020, we'd piled in the car for an international one.

Our summers were always spoken for, but usually, we tried to do a long weekend with just the four of us. On that trip, we drove past endless fields of rapeseed that stretched into the distance like sunshine. Rows of wind turbines loomed on the horizon, slicing through the sky. We drove the car onto the ferry and stuffed our faces with salty fries and when we docked, we were in Germany. We spent the day in Hamburg where my younger son, who had never had an allergy in his life, suddenly developed one. As his eyes puffed up and we searched for a drug store to help alleviate his stuffiness, we joked that he must be allergic to Germany.

We rode a glass-topped boat along the canal and later had burgers on the quayside…because it's funny to have hamburgers in Hamburg. Germany's second city is lovely, and similar to Copenhagen in many ways. But for me, it was missing some of the HC Andersen fairy tale dust that makes Copenhagen so magical. Or maybe it just wasn't home.

The next day we woke early and got back on the road,

driving along a boring stretch of highway to Berlin. It was early June and the skies were dull, holding the promise of rain. We approached the city and made our way to the hotel, where we dumped our bags, and went out to explore.

The kids would have been happy to stay at the hotel and swim in the pool, but there was too much city and too little time. We only had two and a half days, and who knew when we would be back? Berlin is big, much bigger than Copenhagen, and as much as I loved our Goldilocks city, I was looking forward to getting swallowed up in something larger for a few days.

There's something about standing in the shadows of monuments and buildings that humbles you, I think. A few weeks later I would do the same in Washington, DC, driven by the need to see the solidness of those American institutions, to assure myself that they would weather the storm, much as the buildings in Berlin had weathered not just storms, but wars.

Berlin had a 70s film quality that weekend, like a Polaroid Instagram filter draped over the city. The streets were slick with raindrops, and we all bought cheap plastic ponchos to keep dry while we walked. We took photos by the Topography of Terror, near a large section of crumbling wall. Back in the US, Trump and Fox News were screaming about building a wall. Thousands of miles away we were looking at the aftermath of what happens when you do.

We walked toward Checkpoint Charlie where the American and Russian sectors of the city had once met. More photos near the Brandenburg Gate topped with the statue of Victoria in her chariot. From there, you have a straight line of sight to the Victory Column, nicknamed Goldelse by Berliners.

You can't escape history in Berlin, and the city doesn't want

you to. Instead of being met with a sheepish glance and a mealy paragraph in a textbook, Berlin looks its history directly in the eyes. It felt brash and bold and confrontational. Everywhere we went there were sections of the wall left in varying degrees of decay, covered in graffiti, covered in art, covered in gum, half-crumbling reminders of the man-made things that divide nations and cities and selves.

We took the train out to the Olympic stadium where Jesse Owens won gold in 1936, the same stadium where only a few years later hundreds of thousands of Germans would meet in rallies to cheer on the Third Reich. Tucked in the trees near the stadium was a small museum, not more than someone's home really, filled with artifacts and newspaper clippings and memorabilia from a divided city. We went because we had time to kill before our tour and because it was raining, and because our younger son was a military vehicle buff. We stayed because it was fascinating.

We went to the zoo, we walked up and down the undulating paths of the Holocaust Memorial, concrete stelae towering over us. We snapped photos all along the length of the East Side Gallery, a long stretch of the former wall covered in colorful murals that were commissioned in the early 1990s.

After a few years in Copenhagen, Berlin felt wide and tall and big. It felt urban and rough around the edges. It felt a little familiar.

After a few days, we piled back into the car and drove back to the ferry. We had dinner and played cards and sat on the deck as Germany receded behind us. Back in Denmark, we drove past the wind turbines and the rapeseed fields. The kids dozed in the backseat and Richard and I talked about the weekend.

"What'd you think of Berlin?" he said, more to make

conversation in the dark than anything else.

"What a cool city," I said. "I'd definitely go back, I feel like we only saw a tiny bit."

"Me too," he said.

In early 2022 Richard once again turned to me and said, "So, there's a job."

I looked at him, and honestly, I wasn't sure what I was hoping he'd say. New York? Copenhagen? Somewhere else entirely?

"How do you feel about Berlin?"

Huh. That was a new one.

Berlin ticked a lot of boxes for us. It was an easy drive to Copenhagen, we could come back for long weekends and parties. The land of BMW and Bratwurst had a lot of things going for it, first and foremost that it wasn't the US, and let's face it, it was 2022 and things hadn't gotten any less weird over there. It was still in Europe. There was the whole German thing, but no place was perfect. Until that moment, it hadn't even been a box on our dumb job bingo card.

"Berlin's great," I said, without missing a beat.

"Really?"

"Really."

It's never exactly the right time to move, but some times are more right than others.

We'd prepared for this, we had mostly the right clothing to make it work, including a pair of boots that were looking for some big city sidewalks. That's what I told myself. Berlin had come out of left field and the city was a far better option than anything we'd been considering.

On the inside, my heart cracked just the tiniest bit.

I knew that feeling. It was the same one I'd had when I knew for sure we were going to say goodbye to Brooklyn.

KEEP ON MOVIN'

Life Moves Pretty Fast

That day it was me who turned to him.

It was January 1st, and we'd just flipped from the Year of the Plague to the year of what we hoped could only get better. Outside it was eerily quiet, Danes sleeping off the excesses of the night before. The sulfurous smell of bottle rockets still lingered in the air. The sky outside was gray, but the temperature felt mild enough. The curtains fluttered just a little from the open window. The kids were asleep, not a miracle as much as a given.

"Let's go for it," I said to him.

My normally adventurous husband looked dubious.

"Come on, we've been talking about it for years. What better time than New Year's Day?"

And so we made a plan while we had our coffee. We grabbed towels and boots and my fuzzy leopard print bathrobe and bundled them into a bag. We left a note for the kids and then we got into the car and drove to the nearest bit of beach. The streets were littered with firework detritus and empty champagne bottles. There was still a fog of morning mist in the air.

We parked, grabbed our things, and half-jogged to the beach. The wooden pier was slick with spray and dew and we walked until we reached the end, where the only thing between us and the sea was a slice of sky stretching to Sweden.

"Okay," I said.

"Okay," my husband said.

"Okay," I said again, not moving.

Even in the heat of summer, I don't love swimming in the sea. More often than not I'm content to wade in up to my knees, cupping water with my hands and anointing myself like the old ladies I used to giggle at when I was a kid. Now it seemed, I was nearly one of them.

Go big or go home, I thought as I stripped down to my swimsuit. Dithering just prolongs the agony. You're in, or you're out. I walked down the metal ramp straight into the icy water. Without giving myself time to think too much, I dunked to my shoulders, did a quick paddling circle, and then sprinted back up the ramp, the metal so cold it felt like it was burning the soles of my feet.

"Your turn!" I said to Richard, toweling off and hunkering down into my fuzzy robe. I slipped my feet into my fur-lined boots.

My face was numb, my lips were blue and my flesh was covered in goosebumps. I grinned as I watched Richard plunge straight in.

Life moves pretty fast, if you don't stop and dunk in the frozen sea every once in a while, you could miss it.

■ ■ ■ ■ ■ ■ ■ ■ ■ ■

Once upon a time, I lived in New York.

I'd called our Brooklyn apartment home for twelve years when we finally drove off in our two-door VW Golf with two

kids, a hatchback full of crap, and two decades of memories. I waved goodbye. You turn over the keys and boom, that's it. Your ties are severed with one final twist of the key. There's no going back.

My husband and I met in that apartment. It's where we brought our boys home after they were born. Saying goodbye was brutal.

After three years in the big pink house in Strovolos, saying goodbye was not as fraught with emotion, though saying goodbye to friends and Marie and the butter-soft pace of island life was tough. You say you'll be back but in over a decade, we haven't.

Saying goodbye to Copenhagen was almost as hard as it was to say goodbye to New York. It's the place where my children grew up, it's the place where Richard and I started to grow old. Our extended families got to know our friends and their families. My mother and sister and in-laws spent Christmas Eves drinking champagne with Rob and Cassie at their annual open house. I've watched my boys' friends grow up with them, and I love them like they're my own. All my bonus boys. We spent a Christmas in Dubai with Tamara and Carl—we love them so much we smuggled two hams into the country for them. A few years later, we spent an unforgettable Christmas with them in Australia where they had repatriated.

Once the Empire State Building was in our rearview mirror, we set in motion a series of events that have continued unabated since. Our very own perpetual motion change machine. We have changed and the world around us has changed. Our children have grown up and we have grown gray. I'm not sure I'd call what we have roots as much as sapling seeds planted in different soils. Some have grown more robust than others.

After more than two years of dodging Covid, including nursing the rest of my family through it, it finally caught up with me. As I was recovering on the sofa under a blanket, the official job offer for Berlin came through.

We were a week away from my son's graduation and all the Danish traditions that surround it, most of which include copious amounts of drinking. My mother and sister were flying in. Two days after the graduation was someone's 50th birthday.

Richard sat on the end of the sofa where I was camped out with hot tea and simply said, "We got Berlin."

I put my head under the covers and slept.

The timeline for the move to Germany was tight. The Berlin school year started in mid-August. That gave us a twelve-week window, hardly a lot of time to pack up a home, two childhoods, and a decade of memories. Though we were prepared, though we expected it, it all felt too quick. Too sudden.

How do you start writing the end of one chapter while at the same time sharpening your pencil to start the next?

Once upon a time, I lived in New York.

The end—or just the beginning?

■ ■ ■ ■ ■ ■ ■ ■ ■ ■

Into the big shipment go the kitchen goods and the clothing you won't need for a while, including the motorcycle boots. The photograph albums and the books and the bins of color-sorted Lego. The art that we've collected from around the world, prints from our NYC photographer friends, the wooden breadboard from Cyprus, the two paintings by the Italian ambassador's wife, and the ridiculously giant piece of art we bought on a whim during lockdown. Then the furniture

we've amassed over the years and places: the Tiffany-style lamp from an auction in upstate New York and my desk from Brooklyn, the teak sideboard and Eames replica dining chairs we bought in Denmark. The souvenirs from our travels, the tapestry of birds from Cairo and the Chinese dragon puppet from Singapore, the embroidery from Istanbul, and the hot pink Aboriginal print we bought in Australia.

In the temporary shipment go the things you think you'll need for the first few weeks, but usually don't. The cafetière—a gift from Tamara—allergy medications, the good knives, extra bedding, extra shoes, my stash of recipes, the everyday spices, and all our birthday bunting.

Into my suitcase went enough summer clothing for two weeks, my green slippers in need of replacement, lotions, potions, and my two favorite kitchen spoons.

In my carry-on: the diploma my son just earned and all the paperwork you need to start a new life.

We culled and packed and downsized and I pouted. We cleaned the baseboards. I called schools in Berlin, patiently explaining that I knew it was very late in the year, but that's how this life rolls sometimes. We sold or gave away or donated things we'd outgrown. The kids went through their boyhoods and we bagged most of it up and donated it to the local daycare. I kept pulling tiny things aside to keep, the 'goodbye' plane, the tiny figure we called 'Man' who was lost for years, only to be found when we moved from Brooklyn, nestled in the printer. 'Man' had been with us since the beginning, it felt strange to set him adrift now, so into a box of keepsakes he went. I filled in nail holes. I tried to not be angry. Richard made endless trips to the recycling center where you could leave housewares and furniture for others to pick over. I moped.

The last thing I did was to wash the penciled height marks

from the kitchen door frame.

Centimeter by centimeter, inch by inch, I said goodbye.

Expat geography is so much more than the pins that mark where you have lived, more than the coordinates or the Google Earth images. Expat geography is all the living we have done in each place, the people we were when we arrived and the ones we are when we leave, the things we carry forward, the physical and the emotional.

It is the latitude of friendships and the longitude of memory. It's new traditions and different ways of doing things. It's the winding course of all the ways you've changed. It's the topography of lifetime friendships and a terrain of resilience, growth, and experience.

It's all the stuff that gets written in permanent ink upon our expat souls.

It is the atlas of us.

■ ■ ■ ■ ■ ■ ■ ■ ■ ■

In August 2022, we turned over the keys to our glorious apartment by the sea, the one with the crown moldings and the front hallway which sloped so much that our suitcases slowly rolled toward the wall. We booked a night in a hotel by the train station. Rob and Cassie helped us transport suitcases and bags before we had a final drink with them in the sun on their balcony. The kids were saying their own goodbyes but we'd arranged to meet for one last dinner at our favorite burger restaurant, a nod to the first meal we'd had when we arrived more than a decade before. After dinner, we left the boys in the hotel and Richard and I went for a walk along the water. We passed the old, wooden windmill and the English church, past the statue of the Norse goddess Gefjon and her team of oxen. We walked up the grassy embankment to look out over the

water. The sun was starting to sink into the horizon and the sky was streaked with pink. We looked out across the sound and watched the boats of tourists on their way to snap photos of the Little Mermaid and the yellow water taxi making its way across the waves. Eventually, the midges got too thick and we walked back through the fading light, swatting at mosquitoes along the way. At the hotel we both fell into bed, exhausted.

There comes a point in any move when you just want to be gone, when you need the view of everything to be behind you in the rearview mirror because if you stand in the sadness or the worry or the sixty-two other emotions for one second longer it's going to swallow you whole.

By the next morning, I was at that point. I needed to stop saying goodbye. I needed to stop feeling sad. I needed all of us to be on our way, to take that first step into the next chapter.

Then I stepped outside.

When you live away from everything you thought you knew, including who you thought you were, the only way to survive is to create a life from scratch. And so you build your own community. Expat friendships are broad and deep. These are the people who look after your kids when you have to fly home for a funeral. They are the people you pop champagne with when your kids graduate together. They're who you have Sunday dinners with. Who you cry and laugh with. They are who you turn to for guidance and advice. They are your emergency contacts and your Thanksgiving guests and Christmas Eve hosts. They are the people you hunker down with during the long winter months and the ones who remind you not to stand so close to the Sankt Hans bonfire. They're the people who would put you up for five weeks if you needed a place to stay. They are your hygge. They're your people.

Now some of them were outside the hotel, waving their paper flags to see us off.

During all the goodbyes and all the coffees and dinners and drinks, I had done my best to keep my eyes dry. During all the conversations and preparations and celebrations I had swallowed the growing lump in my throat.

But now, faced with what we were leaving behind, it was too much.

I turned and wept into Richard's chest. And when I could catch my breath, I was passed from person to person, like Pedro had been passed to all those old aunties years before. We crossed the street to the station and when the train pulled up to the platform, they loaded us on and stayed there waving until we couldn't see them anymore.

And then we were gone.

■ ■ ■ ■ ■ ■ ■ ■ ■ ■

Cyprus was olive groves and bitter oranges and sandy beaches. It was Turkish coffee sipped in the shadow of the Venetian walls of Famagusta and a shower of bougainvillea petals on our shoulders. It was plates of mezze at our favorite restaurant nestled in the old town. It was Ledra Street and stray cats and slices of grilled halloumi drizzled in oil that came from an olive grove down the road. It was where my youngest learned to walk, where my oldest learned to ride a bike. It was the endless expanse of Golden Beach and donkeys in the road. It was where we took our first steps as expats.

Denmark was fairy tales and Viking horns and houses like crayons on the canal. It was a kanelsnegle shared on the beach wall looking out over the Øresund Sound. It was a million red hearts strung from the trees at Tivoli, the Queen's guards marching down the street, the barren beauty of the frozen sea.

It was the cobbled streets of Strøget and Hamlet's castle. It was the reedy dunes of Jutland and cycling along the coast, the wind behind. It is where our boys grew up and where we made friends for life. It was the dragon scale school on the water and studenterhue and trucks full of teenagers celebrating on the streets. It was where I started writing again. It is where I reclaimed my *thing*.

And Germany?

Berlin is art and cigarette ends and trains that scream by while you wait on the platform. It is punk rock kids with studs in their Adam's apples with fat Rottweilers on chains. It is streets full of vintage stores with gorgeous jumpsuits in the windows that I long to buy. It's endless brunch restaurants. It is the urban perfume of too many bodies and hundreds of museums and wide city blocks and beer gardens with tables and benches under strings of fairy lights. It's the brown water of the Spree and shiny bronze Stolpersteine. It's carpe diem and anarchy. It's like NYC in the late 1980s. It's a blank slate.

It is gritty and dirty and sharp.

It is a bit like coming home.

Or going home.

Or being home.

I just don't know which one.

■ ■ ■ ■ ■ ■ ■ ■ ■ ■

If my first impression of Cyprus was muted tones of olive and sand, and Copenhagen was a Crayola box, then Berlin was fifty shades of gray.

Berlin is the most landlocked location I've called home, the furthest I've lived from the ocean. There are lakes, I've been reliably informed, (in fact, one-third of the city's area is composed of green spaces, rivers, canals, and lakes), but lakes

are not the same as seas, the same as one city is not the same as another. After so long in Copenhagen, I feel dwarfed by Berlin. If my motorcycle boots were a city, I realized, they would not be New York, but Berlin.

It is definitely a city for stomping.

Before we moved, my friend Nora, who had once lived in Hamburg, sent me a picture. It was a map of Germany, with US cities and states superimposed over the top. Hamburg as New York City? Not sure I agree, Nora. Bavaria as Texas? Far more believable—a full third of Bavarians support an independent state. I was flummoxed by Berlin, though. It was labeled *Los Angeles*, but it was smack dab in the middle of Alaska.

"I don't get it," I said to Nora.

"You will," she said.

The history of Germany is songs recited by monks and inked onto parchment by nuns in the candlelight. It is complex and convoluted and full of plot twists and turns. Germanic tribes have lived in the northern part of what we now call Germany since classical antiquity. By 962, the Kingdom of Germany made up a huge part of the Holy Roman Empire, a conglomeration of duchies, ruled by many different men called by many different titles.

In 1237, the city of Berlin, which sat at the intersection of two important trade routes, was established. By 1415, Frederick, first of his name, elector of Margraviate of Brandenburg, father of the Hohenzollerns, had established himself there, cementing Berlin's capital status—a status which has continued in one way or another ever since.

In 1448, the city's citizens rose in protest against Frederick II, Irontooth, who wanted to build a new palace. The Berliner

Unwille—the Berlin Indignation—was quickly quelled and the city citizens were stripped of rights they'd had before their revolt. In some ways, it feels like the Berliner Unwille was merely the beginning of an uninterrupted protest that has never really ended, as if the city rests on a bed of simmering outrage and energy which every so often rises like a roar before it hibernates for a few decades more.

In the 16th century, Martin Luther decided that the Catholic Church was a pyramid scheme, and, with the advent of the printing press, his 95 theses went Middle Ages viral. The Protestant Reformation swept through Europe. Luther was excommunicated from the church, but he had the last laugh. In 1539 Berlin declared itself Lutheran.

Luther:1: Catholic Church: Nil.

The next few hundred years resemble an epic game of Risk: land grabs, trades, treaties, and invading armies coming from all directions. Berlin was destroyed in the Thirty Years War and rebuilt with an influx of immigration. In 1815, after Napoleon finally faced his Waterloo, the German Confederation was established, loosely linking 39 sovereign states. The Industrial Revolution revitalized the city and it became the economic center of Germany. Through all of it, Frederik's successors, members of the Hohenzollern family ruled in Berlin; as electors until 1918, then Kings of Prussia until they eventually upgraded themselves to German emperors. There was an Otto and a Wilhelm or two, Austria was almost always involved, and a fairly constant stream of feuds and changing alliances and borders until 1914 when Archduke Ferdinand was assassinated and triggered the war to end all wars.

After the war which did *not* end all wars, Berlin rose again as a center for art and music, architecture, and expressionism.

Then the Nazis came.

Berlin is further east than most people think, or perhaps it was just me. When we started to do our due diligence for the place we were about to call home, I lost myself for half a day googling the driving distance between Berlin and other cities.

"How far is it to Amsterdam?" Richard asked. I looked it up.

"Six hours."

"Warsaw?"

I plugged it into Google Maps. "Six hours."

"We could go and visit Grant and Lila in Dusseldorf," I said, typing it in. "Huh. Six hours."

It's almost as if someone took a compass and drew a circle and said, Let us put a city here, in the middle of nowhere. Let it be six hours from all in every direction. So it shall be done.

Even today, if you drive thirty minutes out of the city you're surrounded by farmland and forests and cows. When we drove 30 minutes out of Williamsburg, we were lucky to hit Bushwick.

Berlin is a major international city parked in the middle of the giant farm that was formerly East Germany.

Nora was right, I get it now. Berlin really is Los Angeles in the middle of Alaska.

"You know," I said to Richard on one of our walks, "The population of Berlin is not all that much smaller than the population of the whole of Denmark. And, come to think of it, the population of Copenhagen was almost as much as the entirety of Cyprus."

"What's next?" he asked, "India? China?"

"New York?" I said.

I'm pretty sure neither of us was serious.

We haven't been in Germany long enough for me to opine on what makes up that special German sauce, though I suspect it might be whatever they serve with currywurst. Even more though, I haven't tripped down Berlin cobblestones long enough. I can't paint the shapes, only offer impressions, my words pressed on the paper, hoping they're recognizable.

Like New York, Berlin is a city that belongs to itself, an urban island that just happens to find itself in someone else's country. It is a city of wary scrappiness and fierce resilience. It's a city of contrast, of juxtaposition. It is black and white and yet loud and vibrant. It is a delicate alt-bau building next to brutalist high rises. It is old and young. It is the green space of Tiergarten and the graffiti of Görlitzer.

I was anticipating order and rules, but what I got was grown people who should know better riding their bikes on the sidewalk when there is a perfectly good street. I was expecting exactitude and efficiency, yet there is a sense of lawlessness and rule-breaking that bubbles and spills over onto the sidewalks. Maybe Berliners seize the day and live it to its fullest because they know what can happen if you don't.

Captain, Oh my Captain, I want to shout, standing on a park bench.

Every other day the drumbeats and whistles and chants of one protest or another float up to my windows. Labor marches, climate protests, take back the streets. Berliner Unwille. Our apartment is tucked away in a hidden corner in the shadow of an embassy, within a stone's throw of the Brandenburg Gate. On New Year's Eve, we rode the elevator to the roof and watched the fireworks explode over the skyline while the Scorpions played *Wind of Change* a few blocks away.

"Huh," I said to Richard. "I didn't know they were German."

"I didn't know they were still alive," he answered.
We've been whistling that song for months.

■ ■ ■ ■ ■ ■ ■ ■ ■ ■

There was something else I'd packed in our temporary shipment. Wedged among the coffee pot and the printer was our table-sized Dannebrog.

The legend of the Danish flag dates back to 1219 when crusading Danes were about to lose their Viking shirts in Tallinn. It is then, the story goes, that the flag magically fell from the sky, where it was plucked up by King Valdemar II who carried it to victory. Thus, the Danes stake a tenuous claim to the oldest recognized flag in continual use. And while Danes don't rival Americans in their feverish flag frenzy, it's everywhere. Families wave paper flags in the arrivals hall at the airport—and friends wave them at the train station. There are flag-emblazoned napkins, paper cups, tablecloths, and cupcake toppers for celebrations. And there is the table flag: a small Danish flag on a stand that takes pride of place on birthdays and other special occasions. Most people have their own, ranging from dollar store cheap to a silver-plated Georg Jensen beauty.

Over the years our table Dannebrog has become as much a part of our birthday celebrations as my vanilla and chocolate espresso cakes. There were two family birthdays on the calendar before our regular shipment would arrive, and I wasn't going to let a little thing like not living in Denmark get in the way of our adopted traditions.

Into the temporary shipment it went.

A few weeks later we planted the birthday flag in Germany for the first time. Our cheap dollar-store Dannebrog is a placeholder—it marks the spot where the cake should go, yes,

but it's also a reminder to hold a space for all the memories and experiences we pack up and take with us from home to home.

Like the beach towels we still have from Alpha Mega though they're threadbare in spots, like the recipe for Banana bread given to me by Lisa in Cyprus, and in turn, passed on by me to Alice in Denmark, like the game of pakkeleg we play every Christmas and the countless words and expressions we use, they are all firmly folded into the mixed up batter of our family history and traditions.

■ ■ ■ ■ ■ ■ ■ ■ ■ ■

In our first few weeks in Berlin, I met an American woman who was on the verge of moving back to the US. A few nights before she left, we met her and her husband for pizza and beer. At some point between the mozzarella and the Weißbier, the conversation turned to houseplants. We gave them a brief overview of our foliage history. The rubber tree plant in New York. The Bonsai that started in Brooklyn and ended in Boston. The bitter orange tree outside the house in Cyprus. The lockdown jungle we cultivated in Copenhagen.

We had to leave all of them behind. All of those living things we took great care of before passed them on to someone else, before we said goodbye.

I didn't expect to get so emotional talking about leaving behind our plants.

About mid-way through the conversation, it became apparent, at least to me, that my sadness wasn't really about mourning the aloe. The houseplants, like the table flag, are just a stand-in.

Those plants are a placeholder for the lives we tended and created while we were there, the ones we watered and turned

and pruned. The lives we moved if they started to yellow around the edges or repot when they outgrew their original containers. All to make sure they grew and flourished and put down their own kind of roots.

And so here in Berlin, we start again, adding greenery to a new windowsill, one plant at a time.

I'm not the green thumb of this household, that job falls to my husband, the plant whisperer. But all the other stuff? Tending to this life, watering our family, even moving them when they start to yellow around the edges? Making sure they grow and flourish, making sure they know they have roots, even if those roots are just the four of us.

Well, that job falls to me.

And I am really, *really* good at it.

ANOTHER BRICK IN THE WALL

When does a journey become a life?

If you stand on the windswept Blåvand dunes in western Denmark and look out toward the sea, you will see four strange shapes in the distance. If you have two young boys with you, they may race ahead, teasing the foamy tide that laps the shore with the toes of their boots. Or perhaps you'll pick your way over colonies of broken shells and rocks down toward the shoreline, where the waves lap.

Standing guard where the sand meets the ocean, four mules gaze out toward the horizon, their steel heads and tails riveted to old concrete bunkers dating from the Second World War. The bunkers were part of the Atlantic Wall, a German system of fortifications that stretched more than 1,500 miles along the European coast. The mules, however, are the brainchild of a British sculptor named Bill Woodrow. Woodrow was part of an international effort to mark the fiftieth anniversary of the end of the war. His choice of animal was intentional: Mules are infertile, they can't reproduce.

So there the steel mules will stay, guarding the coast, until the sea spray causes their rusty decline, until enough time has

gone by that people forget what they were and why they were there.

The Blåvand mules are haunting and beautiful and clunky and monstrous. From one angle they are grotesque reminders of war. From another, say high on a dune when the tide is out and the sun breaks through the cloud, they are beautiful. As they face whatever the horizon brings, they look like something approaching hope.

The tide comes in, the tide goes out. The leaves bloom, the wind blows.

Standing at the end of the world, those mules are a stark reminder of how over time, everything can change.

■ ■ ■ ■ ■ ■ ■ ■ ■ ■

In our first home away from home, the thick limestone walls of Nicosia created a city within a city; old within new, ancient within modern. Within the walled city is another barrier, like a set of nesting dolls. The division within the old city of oleander and stray cats is not as thick as the outer ring wall. In fact, in most places, the buffer zone that winds through the alleys is nothing more formidable than a chain link fence. The biggest obstacle is psychological.

It is the separation between us and them, between then and now.

Mirror, mirror on the wall, if you take the gal out of New York, is she still the same gal at all?

I thought it was all about geography: the place I left and the place I landed.

If we'd stayed in New York I would have remained exactly who I was before that momentous Sunday morning conversation. Or at least that's what I thought. Glancing into that mirror/mirror on my wall, the woman reflected back

would have been recognizable.

But when we drove by those thick Venetian walls on the way to our pink house with the Hari Krishna sheets, I put up a wall of my own. It wasn't as solid as that ancient limestone barricade, but it had the same divisive effect.

On one side what I thought of as the "real" me: independent, motorcycle-booted woman—confident, loud, bold, and unmistakably New York. And on the other side?

Just a mother, *just* an expat wife, *just* a dependent—lonely, sad, confused, and scared.

When we moved, I felt as if I'd been tricked into trading my old life for a new one, and that new life was *less*. It was less exciting, less edgy. It was less me. And it sure seemed like it was worth less.

I spent a lot of time and energy running headfirst into an imaginary wall trying to get back to the other side.

As it turns out, the universe still has a wicked sense of humor. Fifteen years after driving past those Nicosia walls, we took a short flight out of Copenhagen with four suitcases, two kitchen spoons, and a ziplock bag full of documents. Fifty minutes later, we landed in another city famous for its wall.

In Berlin, the wall is gone. It's dismantled and broken, or at least the physical length and breadth of it is. There are plenty of scars left behind, both physical and emotional. When you stomp down the gray and gritty streets, a reminder runs like a vein through the heart of the city.

Inside a double row of cobbles, it reads Berlin Mauer 1961-1989.

For now, the embossed letters are easy to see. Eventually, they will wear thin under the weight and time of a city's footfalls and the words will become harder to make out, harder

to read, until, like the bunker mules on the edge of Jutland, no one will remember why they were there.

The wind blows, the leaves fall, history fades. Everything can change.

■ ■ ■ ■ ■ ■ ■ ■ ■ ■

As I ponder how to describe Berlin, we're still orienting ourselves to our new home, still making mental maps to understand the history of the place we've docked. In Denmark the history of the land was muted and musty, tucked between the pages of books that line university shelves. It's a history told in stones and runes, but for me, it was cold, long since put to bed and accepted, the thing of museum exhibits and folklore.

In both Nicosia and Berlin, however, the walls are recent and the history is a vivid, living thing. It's not told on the pages of old, yellowed books, but overheard in hot scraps of conversation over shots of Zivania or pints of Radler, over games of Backgammon and in leafy Biergartens.

It's a history that still beats in the space between grandparents and grandchildren.

For the first time, we moved as a family, all of us together, stepping foot into a new country home at the same time. We also stepped into the middle of a housing crunch. A series of *not* unfortunate events led to us finding our current apartment, in the former East. Not long after the movers showed up with our furniture and books and my less-favorite spoons, we nearly collided with an older man in the basement trash room.

There he stood, clad in a white undershirt and a pair of work pants, hurling garbage bags from one dumpster to another. When he saw us, he unleashed a torrent of rapid-fire

German.

Richard and I did the awkward dance you often engage in when you live somewhere and don't speak the language. A quick two-step backward, a closed-mouth smile, and a nod. We tried to backpedal out of the room before we gave ourselves away, but he kept talking.

"Something something Deutsch something!" he said as he angrily rearranged piles of recycling that had been tossed in a messy heap.

"Our German," Richard finally said to him, "it's not so good." He shrugged his shoulders.

I smiled my close-mouthed smile and shrugged too.

"You are new here," he said, switching to halting but decent English.

"Yes, we just moved to Berlin," I said. Sometimes when you give away your outsider status you get a welcoming smile. Other times you get thin lips or a furrowed brow.

"There is too much new," the man sighed at us. I mentally prepared for the thin lips. He stood in the dim light of the overhead bulb and continued to move bags of trash.

"I am too used to the old ways of doing things," he said. "We old people are too stuck in our ways."

I side-eyed my husband, my non-verbal admonishment that now he'd gone and done it—we were well and truly stuck in this trash room conversation. There was no escape.

Carefully depositing our small bag into the correct bin, Richard asked the man if he had grown up in Berlin. The old man nodded. He had lived his whole life there, he told us. Berlin, and then East Berlin, and now once again Berlin.

"We had our own ways in the East and they worked," he said, pausing, "but we were not able to keep up with the outside. The outside moved on and we did not. It will be better

when people like me are no longer here. It's too late for us to get used to new ways," he repeated.

There was no regret in his words, just the weight of exhaustion that comes with being a witness to that kind of still-warm history.

It is a city full of living stories, Berlin.

Some stories we learned on the streets. The best way to get to know any city is to walk it, and so that's what we did. In the stonking heat of late August, we walked, venturing out in bigger and bigger circles. In Prenzlauer Berg, we marveled at the resemblance to Park Slope in Brooklyn, right down to the parade of strollers blocking the sidewalk cafes. We walked up one street and down another, memorizing new directions and new street names. Torstraße, Gartenstraße, Rosenthaler. In Cyprus, I used the Turkish Cypriot flag on the Kyrenia Range to orient myself. In Berlin, I've got the Television Tower. Built by the DDR in the late 1960s, it's the tallest structure in Germany. If the Turkish flag was a middle finger from North to South, this was another, but from East to West. You can see that tower from just about anywhere in the city.

"Go East," Richard starts to say before he remembers I don't do adult directions. "Go toward the tower."

For the navigationally challenged it's a Godsend.

I still can't make sense of the wall's path. It seems to be everywhere all at once. The pictures I have in my mind are from old photographs and documentaries. When I try to conjure an image, it is of something straight and imposing, running through the middle of a city. In actuality, the wall meandered and snaked through Berlin like a concrete river, walling off one part from another. On Bernauer Strasse, it was so close to a row of apartment buildings that leaving through

your back door might find you in the East. The barbed wire and concrete didn't just cut through the streets. It cut through neighborhoods and courtyards and families and lives.

Near the intersection of Bernauer and Brunnenstraße is the Wall Memorial. There are small discs on the ground marking where the tunnels were found, dug by those desperate enough to wiggle through the earth to reach the other side. We walked through the garden and played peekaboo amongst the listing metal struts that kept the wall in place. Now coated in rust, they reminded me of the rebar rods in Cyprus, the ones waiting for someone to come along and turn them into something else.

Only this time, the product was finished and then destroyed.

They were not placeholders of what could be, full of promise, but reminders of what not to be, full of warnings.

A few meters away there is a panel of black and white photographs, memorializing the dead, those who tried to tunnel underneath or were caught trying to get over or through, or some who were simply in the wrong place at the wrong time. Some were from the early days of the wall's construction, others were as late as 1989.

Walls, like fences, don't always work. And people, whatever the risk to themselves, will always try to find ways over them, to get whatever dream is on the other side.

It's impossible to avoid the idea of walls and separation in Berlin, to ignore the reminders of division and unity. The history, old and living, is everywhere I look, from my trash room to the streets I walk down. It's baked into the city's very identity.

I'm finding Berlin a hard city to hold, in the way a lover who has been brokenhearted too many times is difficult to love. There are too many callouses to get through. The city pushes you away if you get too close.

Maybe Berlin knows what happens when you give too much of yourself, how easy it is to lose yourself in someone else's ideas of what you are or what you should be. Maybe Berlin longs to return to something it used to be while understanding that you can never really go back.

It is a city of stories, and now one of those stories is mine.

In the shadow of monuments and imposing Bundes-buildings, I can't shake the idea of identity, of before and after, of now and then. Maybe the Berlin landscape is too reminiscent of New York and being here is dredging up old memories. Maybe I'm just a woman of a certain age and this is what we do, look back, take stock, and wonder *what if*. Whatever the reason, my history, old and living, is everywhere I look, baked into my every action.

A thing I know: I am not the same woman who left New York City a decade and a half ago. How could I be? I have grown gray and my kids have grown up. We all get more sleep. We should all eat less of whatever cheese is on sale. I've tended to my marriage, to my relationships, and to my friendships. I've reclaimed a throne made of polished words. I've watched all those things take root and thrive, all in places I never expected nor thought I wanted to be.

When you talk to Berliners about the November night the wall came down, they will tell you that it was both expected and unexpected. There had been long, sustained protests, East Germans coming into the city, that Berliner Unwille spilling into the farmland and the countryside. Something was

crackling in the air that fall. Change was coming. Still, the abandonment of the wall on that otherwise ordinary night was met with shock and surprise.

And then, just like that, it was over.

The fall of the wall between the woman I was trying to get back to and the one doing the trying wasn't as sudden or dramatic as the fall of the Berlin Wall. It took me fifteen years, three countries, hundreds of essays, and two books to figure out that I wasn't a different woman, I was simply a woman of moving parts.

And then, just like that, it was over.

Girl, woman, daughter, wife, mother, writer, expat. Nothing needed to be mended or glued because nothing was broken. Nothing needed to be found because nothing was lost. Each part of me has a role to play. Sometimes it is a leading role, sometimes a supporting player. Every moving part has its own value and each bit adds value to the whole.

Mirror, mirror on the wall, if you take the gal out of New York City…oh stop it you crazy American. Of course she's the same.

The writer in me wants to wrap it up right here.

Let's slap a couple of footnotes and an index on this *Book of Me* and call it a day.

But that's not the whole story.

I'm not the same woman I was when I left New York fifteen years ago, that much is true. But *that* woman was not the same one who moved to New York with her vagabond shoes and a pocket full of dreams.

For a long time, I was waiting for clear skies, keeping time until I got back to the real me. But the vision I was holding on

to as the *real* me was only ever a version that lived in my mind. It was an old photograph in the mists of nostalgia, not unlike the images of the Berlin Wall I see on my walks around the city. What I longed for was a version of a woman who hadn't existed for a long time.

I kept trying to climb over an imagined wall to reach a ghost, the ghost of a small-town girl who hadn't lived enough life to realize that eventually, the world bamboozles us all in one way or another.

I spent so long thinking that I'd been tricked into giving up my dreams that I didn't realize that some of them had come true in ways I wasn't expecting. Some got substituted along the way. Some didn't turn out quite as good as the original, they were a bit too crumbly around the edges. But others turned out even better.

I thought that moving away from New York meant sacrificing my independent self, the one who had been forged in the bowels of the MTA and honed on the edges of Alphabet City. I thought being an expat spouse meant getting so tangled up with my husband's identity that no one would see the parts that were just for me—including myself. I thought that being *just* a mother, a caretaker, a wife, that being a dependent on someone's employment form meant that I ceased to have my own value. As if I were a publicly traded stock and not a unique, jazz-hand-waving Brooklynite.

I spent a long time looking for external validation, a paycheck, and a business card with my thing on it, when in actuality, I've been a thing all along.

I'm the damn support struts. Without me, everything would fall apart.

I'm the thing that holds us all together.

When does a journey become a life? When do you look around and realize that you're already where you were trying to be? Is it when you look at the pile of calendars by your side and think it's not been two years, but many, many more? Is it when you realize that it's not been a stint or an adventure as much as two childhoods and a good portion of a life?

This epic journey of ours. I've never climbed Everest, but I have climbed the bureaucratic mountain that is setting up the electricity in Germany. I haven't been on safari, but I have hunted down peanut butter and black beans in Cyprus. I've weathered the weather, from the scorching sun of Nicosia to the frozen sea in Copenhagen and now the impenetrable gray Berlin sky. I've cried in frustration at the Kommune. I've screamed myself hoarse at delivery drivers in the dusty lots of Strovolos. I've patiently explained to Martin at Deutsche Bank that sixteen bank statements are a bit excessive. Think of the environment, Martin.

When do you stop looking at the road signs and counting down the mileage before you loudly announce *I'm here*?

Landing in Berlin seems serendipitous. It's symmetrical and symbolic. We started with a wall and we're ending with a former wall. I started with the idea of the woman I was and I ended with the one I am.

I'm good if we call it quits here.

Between you, me, and my husband's job, I'm not sure how much more of this I've got in me. The move from Copenhagen to Berlin was…it was hard. Until now all those moving parts could be oiled and lubricated, but they're starting to get creaky. At some point, one of them is going to break

and stop working.

"So what do you think, where should we retire?" Richard likes to ask when we are walking around the city. The sidewalks are full of diners sipping coffee or slurping Pho at one of the hundreds of Vietnamese restaurants.

"I don't know where you're going, but I'm going home," I say. When we walk I like to peer through the open doors that lead to the hof, communal courtyards that sometimes look like secret overgrown gardens. "You can come and visit."

While other people dream of retiring in a foreign land, with golden beaches where turtles lay their eggs or fairy tale cities on the sea, or even in cities full of avenues under the Linden trees, I'm heading in the opposite direction.

I want ease of paperwork.

I want customer service.

I don't want to think too much about the daily dance of life in a place that's not mine or worry about whose toes I might be stepping on.

I want to taste the familiarity of a cultural soup that I'm used to.

I want to go gently into that good night in my own language.

Sometimes I even want fifty types of shampoo to choose from.

"You want to go back to New York?" Richard asks. We cross streets, stepping over tram lines. All around us, Berlin announces its presence like a clashing cymbal. *Look at me, I'm here!*

"No, not New York," I say.

And that's okay.

That's okay.

I am still, and always will be, the loud American. I still have my raincoat with the bright pink flowers. I ditched the pink bootlaces and bought pink boots instead. I still have trouble quieting the urge to stand up to be heard, even in places where the norm is to be squeezed in the middle. My special sauce is still red, white, and blue, though I like to think it's taken on the flavors of all the places we've lived. Cinnamon and remoulade and beer, confrontation and Janteloven and bureaucracy, all whizzed up with a little frappe whizzer I keep next to my olive pitter.

I will never be a triangle, but this journey has forever shaped me in other ways. It's been the most frustrating, exhilarating, educational, difficult thing I have done in my life.

Again. Again. Again.

What do you think? Richard asked me all those Sundays ago.

I think I've learned a hell of a lot in the last fifteen years.

I've learned how to look out for others, how to stop hoarding happiness, and how to change my footwear to suit my environment. I've caught a few white whales. I've written hundreds of thousands of words, some of which are pretty good. I've learned how to make my own buttermilk and lifelong friends, and how to find solutions that don't come from a box. I've learned how to be part of villages and how to nurture and build communities.

I learned that I've always been a thing, I just had a hard time seeing it for a while.

What do I think?

I think maybe the dumb job isn't so dumb after all.

I think that the moving parts that make up the shape of me have always been enough.

When does a journey stop becoming a journey and become a life? The easiest answer is when you reach your destination. But a destination isn't necessarily a pinpoint on a map.

For all my dreams of retiring in a familiar place, it's unlikely Berlin is our final port of call. Maybe there will be one more international move, maybe more, but eventually, my husband is going to stop leaning over on a Sunday morning and telling me about a job. Or I'm going to stop listening. At some point, the act of bubble-wrapping our household goods and shipping them around the world will come to an end. I will unpack my motorcycle boots for the last time.

The journey to figure out who I was and who I am and to tear down the imagined wall between the two? I feel like that particular road trip is at an end. I spent a long time trying to get back to the woman I thought I had left behind until I finally understood that she had always been with me.

Together we've realized that value and worth aren't things you can print on a business card in pretty font. They aren't numbers in your bank account or a specific tax bracket. Value and worth come from within.

Value comes from building a home as much as it does from building a business. Worth comes from giving your time as much as it does giving your money. Both come from doing the things you are passionate about, the things you are good at, the things that make life a little shinier, a little easier, a little tastier for the people you love. It even comes from being able to string a sentence or two together. If you are very lucky, someone might read them and find a piece of themselves they thought they'd lost.

That young NYC woman, the one before Richard, the one before my boys, the one who used to pick up a microphone in smoky back rooms? She's still there, even if she is nothing

more than a memory I carry close to my heart. If she could shadow her eyes with her hand and look far into the future, I think she'd be proud of all that she's accomplished, this making and growing a life in places she never expected to be.

It was that young woman who wrote the beginning of this story, the one that has led me to where I am.

Without her, I'm nothing. Without me, she's a ghost.

Together, we've managed to write something like a life.

ROAM

I end like a song—just a girl dancing down those dirty and dusty trails.

Let's split open the present, but leave all the juicy bits in, they're usually the best ones. There I am, a middle-aged woman, watching her boys grow into men. I'm singing on stage with a group of women with pink satin scarves, and hand-jive fingers. Let's not speed up too much, ok? Time is already flying. A montage, Harry Styles in the background, maybe *Sign of the Times*. I'm wearing flip-flops on an endless beach. There I am in winter boots with bright pink laces looking out over a frozen sea. I'm cycling to Juliet's house on my bike, stepping gracefully off as it glides to a stop. Now I'm in my beautiful kitchen watching the leaves—leaves are always a good indication of passing time. I'm dabbing concealer under my eyes. Now I'm sitting at a desk in the sunlight, typing, typing. I'm on a stage reading from *1001 Nights*. Portraits of all the people, so many people. Then I'm in a small cozy back room, reading out loud; let's zoom out just a little to include my hand holding a copy of a book with my name on the cover.

Home is where the four of us are, the table where we eat Sunday dinner and play cards. Outside the wind blows and the

scenery changes.

Now one son is graduating and the other is close and the dreams have changed from big city lights to cozy nights in. I'll take a well-timed flight going anywhere.

I'm scribbling in a notebook. I'm unpacking boxes. I'm putting a pair of boots into the closet. Now you see me, a writer in a smoky room. What? Kidding. No, in a comfortable green chair with a matching footstool. Here I am flipping through the music, looking for just the right song. *This Woman's Work*? Tempting. Pink? Hmmm. There I am settling on the B-52s, *Roam*.

Roam if you want to, without wings, without wheels.

You see me at a shop counter buying plants. I'm in a long linen dress that doesn't touch my skin. I'm in an apartment in the shadow of a wall. The sounds of Berlin are floating up to my window, sirens and the whistle of climate march. The man from Thanksgiving is next to me. The two young men are still asleep. Everything changed and yet everything is the same.

And that's where this story ends.

■ ■ ■ ■ ■ ■ ■ ■ ■ ■

ABOUT THE AUTHOR

Dina Honour moved from her beloved New York City to Nicosia, Cyprus in 2008. In 2011, she and her family relocated once again to Copenhagen, Denmark, where she fell in love with the fairy tale city on the sea.

Since 2022, has been stomping through the gritty Berlin streets, where she and her family currently live.

In 2012, she started Wine and Cheese (Doodles) as a way to retrain her writing muscles. Since then, the blog has been viewed nearly half a million times. Her prize-winning work has appeared online and in print in places such as Paste, Scary Mommy, and Bust Magazine. In 2017, her essay *1001 Nights* was nominated for a Pushcart Prize. She is the author of *There's Someplace Like Home*, available on Amazon, as well as two fiction novels she hasn't given up on just yet.

She did give up on the leather pants.

She still has the boots.

Find her at Dinahonour.com, on Facebook at Dina Honour Author, or on Instagram, Goodreads, or Amazon.

FURTHER READING

BOOKS

There's Some Place Like Home: Lessons From a Decade Abroad, Dina Honour
Nest: A Memoir of Home on the Move, Catriona Turner
Nothing Like a Dane: A Real Life Search for Hygge in Denmark, Keri Bloomfield
The Almost Nearly Perfect People: Behind the Myth of the Scandinavian Utopia, Michael Booth
The Year of Living Danishly: Uncovering the Secrets of the World's Happiest Country, Helen Russell
Bitter Lemons of Cyprus, Lawrence Durrell

OTHER WRITING

1001 Nights, Hippocampus Magazine, Dina Honour

BLOGS & WEBSITES

Wine and Cheese (Doodles)
Oregon Girl Around the World
Two Fat Expats
20 Suitcases

RECIPES

How to Make a Frappe
https://www.mygreekdish.com/recipe/greek-frappe-coffee-recipe-iced-coffee/
Kransekage Cookies
https://thesimple-sweetlife.com/norwegian-almond-cookies-kransekakestenger/

Christmas Stars (Denmark and Germany)
https://danishthings.com/en/froebel-star-a-classic-danish-christmas-
decoration/
Beatty's Chocolate Cake
https://foodnetwork.co.uk/recipes/beattys-chocolate-cake
"Hershey's" Chocolate Cake
https://tastesbetterfromscratch.com/hersheys-perfectly-chocolate-
chocolate-cake/
Magnolia Bakery's Vanilla Birthday Cake
https://www.cakecentral.com/recipe/2553/magnolia-bakerys-
vanilla-birthday-cake

"Lisa's" Banana Bread

3 mashed ripe bananas
2 cups flour
½ tsp baking powder
¾ tsp baking soda
2 eggs
1 cup sugar
¾ cup milk
1 tsp vanilla
120 gram (40 oz) butter
Dash of salt
Chocolate chips/walnuts optional

1. Cream butter and sugar
2. Fold in all the other ingredients
3. Bake at 180 degrees for an hour

SOURCES

CYPRUS

Evangelos Florakis Naval Base Explosion, Wikipedia
Nicosia, Brittanica
The Coffee Culture of Cyprus, Start in Cyprus
Walls of Nicosia, Wikipedia
You Can See Northern Cyprus's Flag From Space, Conde Nast
Traveler

DENMARK

Amalienborg, Wikipedia
Bunker Mules Blåvand Beach Denmark, Atlas Obscura
Bunker Mule, Wikipedia
Cycling Facts and Figures, Cycling Solutions
Danish National Flag, Estland
**Danes are 'world's second-best' speakers of English as a
foreign language**,
The Local
Denmark, Wikipedia
**How guest Hans Christian Andersen destroyed his friendship
with Dickens,** The Guardian
How to Piss off a Dane, Matador Network
Hygge, Wikipedia
Law of Jante, Wikipedia
King Christian X of Denmark, Encyclopedia US Historical
Museum
Skagen, Wikipedia
The Jelling Stone, Natural History Museum, DK
The Three Christiansborg Palaces, Unofficial Royalty
**What is Hygge Racism and How Did it Become So Pervasive in
Danish Culture?**, The Scandinavia Standard

GERMANY

7 Ways the Printing Press Changed the World, History.com
Berlin, Wikipedia
Federal State Comparison, Yougov DE
Fernsehturm Franz Ferdinand Archduke of Austria, Britannica
Stolpersteine in Berlin, Stolpersteine, Berlin

NEW YORK

Williamsburg, Like a Local Tours
Williamsburg, A Focused History, Abode New York
Dancing of the Giglio, Our Lady of Mt. Carmel

MISCELLANEOUS

Baking Substitutions Chart, Real Simple
Diary of a Mad Housewife or Life in The Age of Extreme
Housewifery, Part I, Wine and Cheese (Doodles)
I Am a Triangle and Other Thoughts on Repatriation, Naomi
Hattaway
Idle Hands, Wine and Cheese (Doodles)
I'm Grateful to be Living Outside of American and That
Breaks my Heart, Medium
Nine Expats You'll Meet Abroad, Wine and Cheese (Doodles)
Resilience, American Psychological Association
Thanksgiving Romance Chance Encounters, CNN Travel
Third Culture Kids; The Global Citizens, Eura Relocation
The World's 30 Happiest Countries & People, Afar Magazine
Welcome to the Happiest Country on Earth, CBS News

Printed in Great Britain
by Amazon